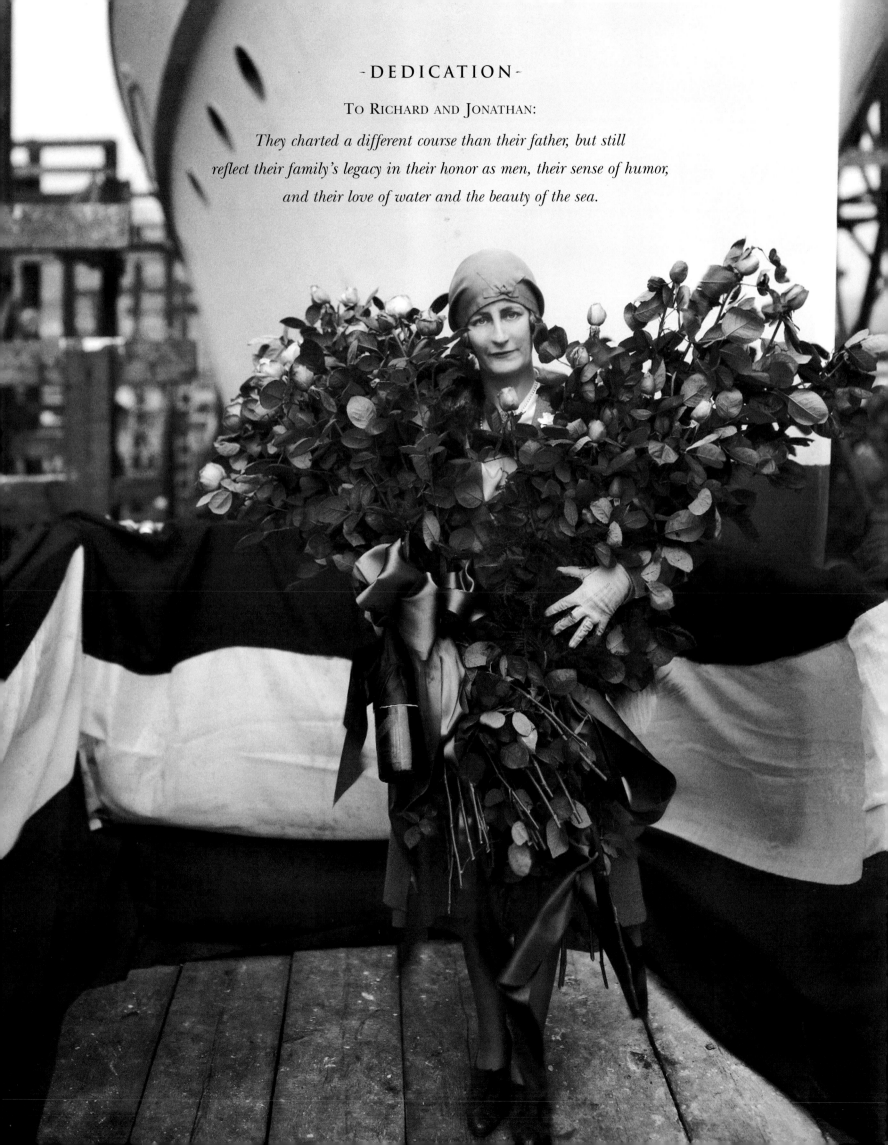

- DEDICATION -

To RICHARD AND JONATHAN:

*They charted a different course than their father, but still
reflect their family's legacy in their honor as men, their sense of humor,
and their love of water and the beauty of the sea.*

"Photographs have their own story to tell. The camera is an unusual instrument. It looks both ways—through the eye of the photographer into his subject and into the mind of the photographer through the subject he captures.

—Stanley Rosenfeld, *A Century Under Sail*

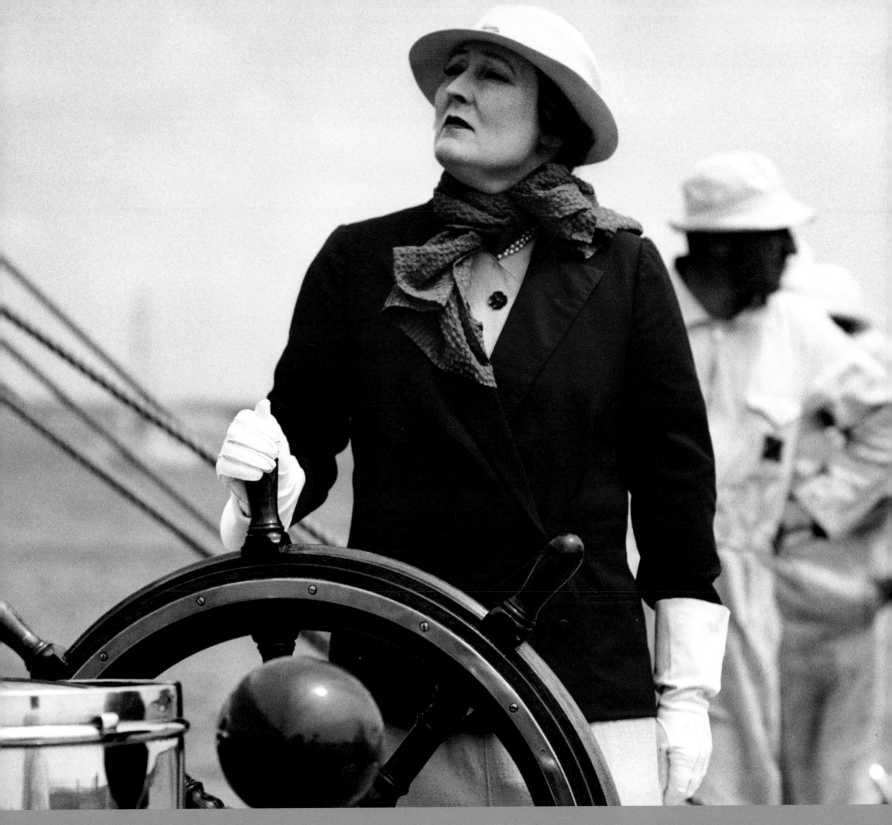

ON LAND AND
ON SEA

A Century of Women in the Rosenfeld Collection

BY MARGARET L. ANDERSEN ROSENFELD

Mystic Seaport
75 Greenmanville Ave., P.O. Box 6000
Mystic, CT 06355-0990
www.mysticseaport.org

All rights reserved. Published 2007
First edition
Printed in the U.S.A

ISBN: 0-939511-19-3

Designed by Clare Cunningham
Printed by Andrews Connecticut an RR Donnelley Company

© Mystic Seaport
Andersen-Rosenfeld, Margaret.
 On land and on sea: women in the Rosenfeld Collection /
by Margaret Andersen-Rosenfeld.—1st ed..—Mystic, CT : Mystic
Seaport, c2007.
 p. : ill. ; cm.
 Includes bibliographic references and index.

 1. Photography of women. 2. Photography of children. I. Rosenfeld
Collection (Mystic Seaport Museum). II. Title.

TR681.W6 .A5 2007

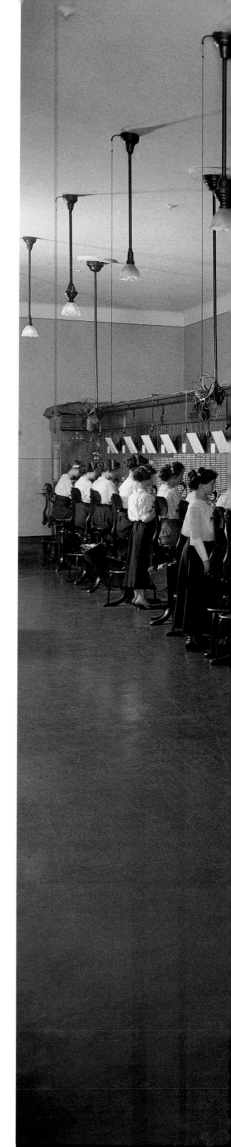

RIGHT:

WOMEN AT THE SWITCHBOARD
(1984.187.5772)

TABLE OF CONTENTS

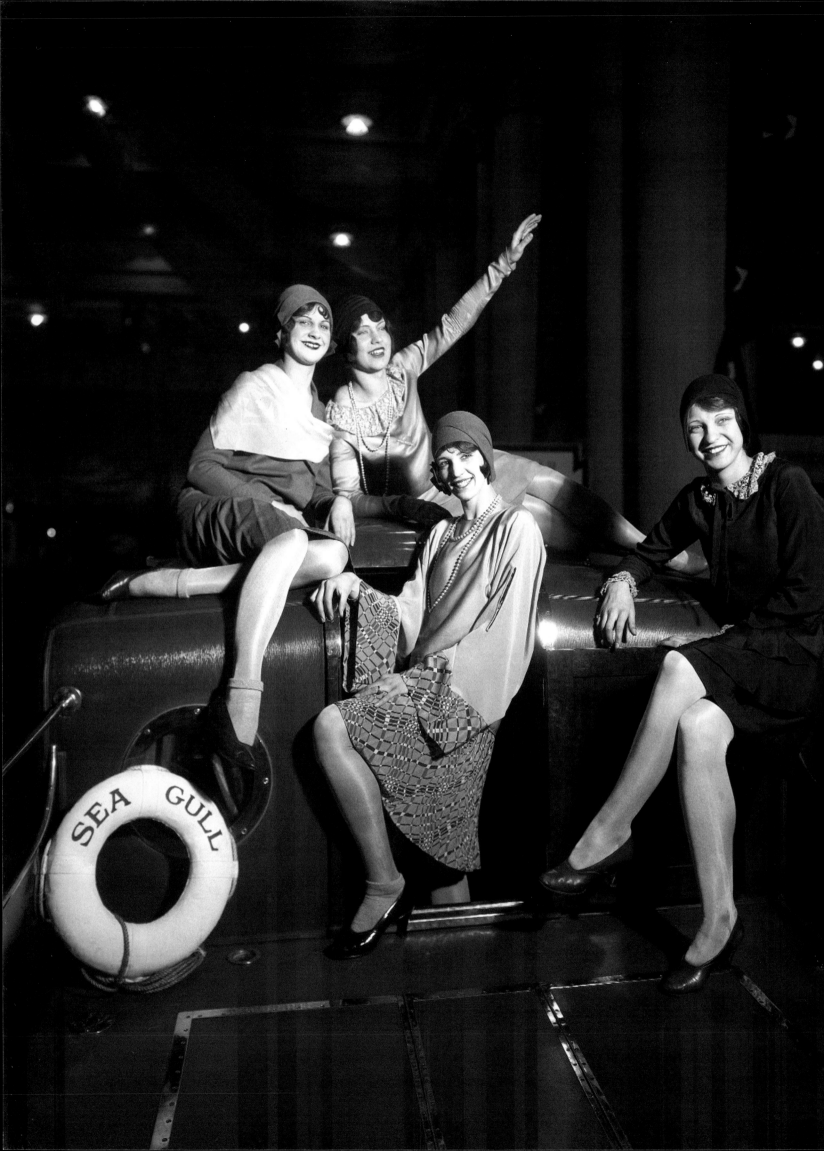

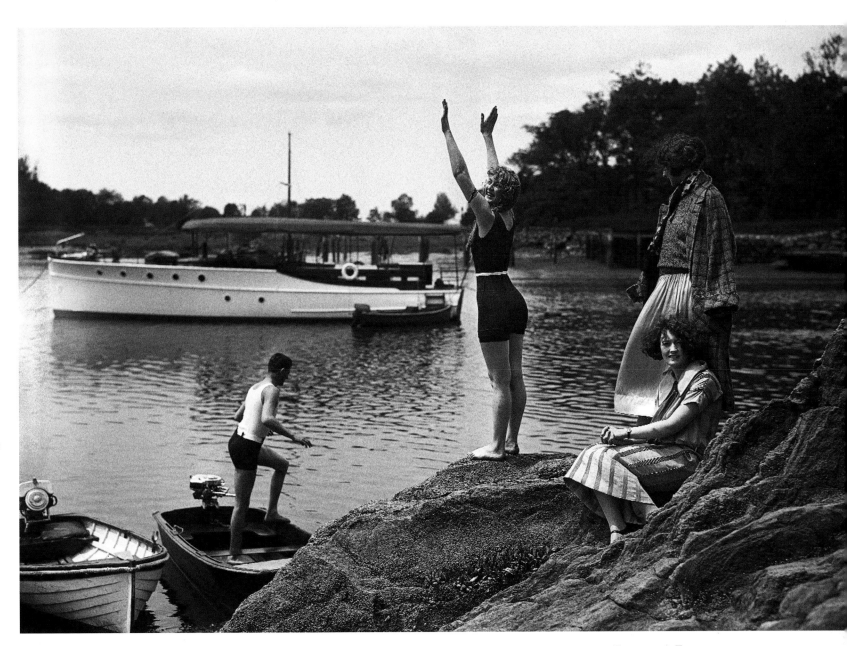

SHORELINE FUN
(1984.187.12226F)

INTRODUCTION

ost people who know of the Rosenfeld Collection know it as a premier collection of maritime photography. The Rosenfeld Collection, now owned by Mystic Seaport Museum, includes close to a million images documenting maritime history from 1881 to the present. World-renowned for their yachting photography, Morris Rosenfeld and his sons (David, Stanley, and William) have provided one of the world's most extensive and beautiful collections of maritime images, now also being carefully preserved and available for research and personal or commercial reproduction from the photographic archives at Mystic Seaport Museum (see www.rosenfeldcollection.org).

Less well known is that the Rosenfeld Collection also includes a rich compilation of other images —images of the history of architecture in New York City, the development of various forms of commerce, depictions of the emergence of modern technology, and—for the purposes here—a chronicle of the social history of women's lives over the course of the twentieth century. The Rosenfeld men, who had an eye for light, for water, and for how their subject was framed by their environment have given us a gift of images that document numerous aspects of twentieth-century life, including not just the world of yachts and boating, but extending far beyond. Images of the early women workers in the telephone companies, immigrants arriving at Ellis Island, young kids exploring

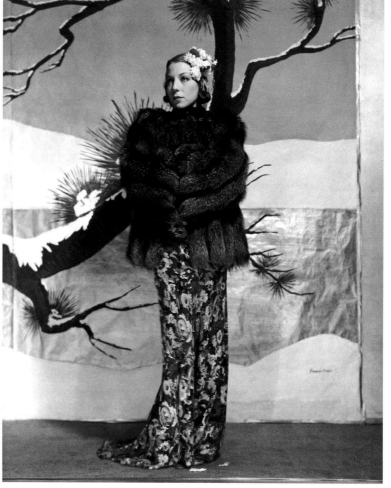

the fascination of nature—these and other images can all be found in this treasure trove of photographic art.

The Rosenfeld Collection is valuable, not just for maritime history, but also for visualizing the history of technology (especially in the early twentieth century), seeing the emergence of women's sports, and depicting the early foundation of women's industrial work. There are images in the Collection of ordinary women and also of exceptional women—those who broke ground during their time. Women are found in the Rosenfeld Collection as skippers, aviators, athletes, war workers—often graced by the resources of their social class and race because of the venues where the Rosenfelds worked—but also seen as workers, mothers, wives, and sometimes girls just having fun.

I had seen many of these images, found them compelling, and had used a few of them in my books about sociology. One day, late in Stanley's life, I asked him if he would work with me on developing a photographic essay of women in the Rosenfeld Collection. With his characteristic twinkle in his eye, he replied, "Oh, those are not our art. We just did them to make a living." This was one of the few times when I disagreed with Stanley's assessment of his work. These photographs, like the maritime images that define the Rosenfelds' art, are captivating, engaging and artistic.

While doing the research for this book, I would sit in front of a screen that displayed 80,000 images from the Collection, all stored on a laser disc. As image after image floated by, I could only begin to imagine the world that the Rosenfelds saw unfold over the course of a century. I

LEFT: FURS
(1984.185.52194)

shared a very small piece of this experience with Stanley, whom I met in 1978 when I started dating his son, Richard—now my husband. Stanley welcomed me into the family, talked to me about his work, and infectiously passed on his joy of seeing light over the water—sometimes from a boat, other times from his window in North Miami Beach, where he spent the last years of his life. Even when his eyesight began to fail him, he would still comment on exactly how the light was shimmering on the water below. One morning he noted a particularly angular light illuminating the Miami skyline, the ocean, and the Inland Waterway below and I asked him how, with his failing vision, he could still see so clearly. His reply was that he had spent a lifetime observing and capturing light—so much so that he could always see and know it.

The photographs in *On Land and On Sea* are those that I have compiled to show some of the different dimensions of women's lives over the course of the twentieth century. Some focus on sailing; others do not. Within the Rosenfeld Collection, you can find many images of different aspects of American social life. In my case, I wanted to highlight those about women. There is much to learn here, especially if seen with an eye to understanding women's history and the unique place of women in maritime history. But you have to see the photographs in the context in which they were taken and not attempt to generalize beyond the scope of what is available. I have written brief introductions to each of the sections of the book to put the photographs into a social and historical context. As a sociologist and feminist scholar who ordinarily works and writes in an academic context, I have written the introductions based on historical and sociological scholarship, but for a general audience. The introductions provide some interpretation of the images, although the photographs also speak for themselves.

Because of the nature of the Rosenfeld Collection, a collection that focuses mostly on yachting, the images in it are primarily of elite and middle-class people. Actually, because of the Rosenfelds' fascination with ships and the sea, most of the photographs in the Collection focus on boats, not people. And, there are far fewer images of women than of men; the women shown are often those of elite society—or women working on behalf of those who could buy and own yachts, such as models and working women. Yet, within the Rosenfeld Collection are images of immigrant women and, occasionally, African American women, some of which I have included here.

The Collection also holds images of women as adventurers and thrill seekers.

There are gaps in the historical periods of women's lives covered in this collection. Morris Rosenfeld (1885-1968) began his photographic odyssey early in the twentieth century and certainly did not imagine himself to be chronicling women's history, although he once compared taking photographs of yachts to taking pictures of a woman's face—studying the subject and finding the best angle. Now we can also see that the Rosenfeld men also knew how to capture a woman's face.

When the Rosenfeld sons—David (1907-1994), James Bernard (1911-1913), Stanley (1913-2002), and William (1921-2006)—and Eleanor (1916-1998), Morris and Esther's (1888-1962) daughter, were young, Morris had to support his family doing commercial work. Thus, many of the images in the collection, especially in the early years, include photographs of women working in the Western Electric Company and other industrial settings. You will find photographs of women in the Red Cross during World War I, women modeling at boat shows, and women engaging in all sorts of water-oriented activities.

While working on this book, it became easy to see the Rosenfelds as giants, larger than life. Reviewing the photographs in the Collection, seeing them repeatedly and for hours on end, reading what Morris and Stanley wrote about their work, and reading what others have said about them was a moving experience. Although I never met Morris, Stanley was a man I knew. He was a giant in the world of yachting photography, but he was also a man who was engaging, had a wry sense of humor, read avidly, enjoyed *The New York Times* every day, and had the darndest twinkle in his eye—maybe that twinkle reflected all of the light he had seen through the camera's eye over the years.

Some of the earliest photographs in the Rosenfeld Collection are by New York photographers James Burton, Charles E. Bolles, and Arthur F. Aldridge. Morris Rosenfeld acquired the Burton and Bolles' photographs around 1910 when he established his own shop on Nassau Street in lower Manhattan. Morris Rosenfeld had worked for a time in the darkroom of James Burton and he admired the way that Burton captured the beauty and vastness of the large boats that he shot (Rousmaniere 2003). At the time, photography itself was being transformed, allowing photographers, including Morris, to

experiment with new techniques, capture faster action, and use different films.

Morris Rosenfeld's first photograph was taken with a borrowed camera, which he shared with several teen-aged friends who took it out of pawn. That first picture won a prize, providing Morris, otherwise known as "Rosy," with his first camera. As he recalls it, he strolled down Houston Street to take a photograph of a square-rigged ship hauled out in a slip. What else might he have seen in the Lower East Side at the time? Streets with sleeping families, tenements, women heading to work—images that relate the history of city life in the early twentieth century. Although Morris focused on sailing ships, this other story is also revealed in the archives of his eye.

Morris Rosenfeld was born in a small village on the Austrian-Hungarian border, but his parents, Adolph Rosenfeld and Lena Kendal Rosenfeld, immigrated to the United States in 1887 when Morris was two. He married Esther Marion Hirsch in 1906, who worked as his assistant as he strove to get his business established. Morris wanted to be either a star news photographer or an artist. He freelanced for *Leslie's Week* and *Harper's* and studied art at night at Cooper Union. He toyed with painting for a while, but found magazine and newspaper photography more alluring. He covered society events, especially tennis, hunting, and sailing, but the family table talk in the evening was all about boats. Long-time yachting editor for the *New York Herald-Tribune*, Everett Morris, has written about Morris Rosenfeld's blending of his interest in photographic journalism and art by saying, "The line between [reporter and artist] is indiscernible because his work, even on what are basically routine assignments, is a characteristic blend of reportorial accuracy, the highly polished photographic technique of the skilled craftsman, and the artist's sensitivity to color and line and mood" (Rosenfeld, M. 1959). Everett Morris also once commented on the modesty of Morris Rosenfeld's title on his business sign identifying him as "Morris Rosenfeld, Photographic Illustrator," which, according to Everett Morris, "is not unlike classifying Fritz Kreisler as a fiddler, or John Singer Sargent as an interior decorator" (Rosenfeld, M., 1959).

As someone who has written academic work about women for years, I found working on this book both challenging and a little intimidating. Given the Rosenfelds' place in the world of yachting, I knew I was entering a space less familiar given my own family background. But I wanted to tell the story of women in the Rosenfeld world. Having heard so much over the years about the life of this family and their work aboard *Foto* (the 33-foot chase boat that Morris had custom built in 1929) I could only imagine what it was like to be onboard while the Rosenfelds worked. Within a long and wide aft deck and shallow V-shaped hull, *Foto* was designed so it would "spin on a dime" and keep up with fast-moving sailboats. The first time I saw *Foto III* on the docks at Cutts and Case in Oxford, Maryland, I burst into tears. I still get chills when I pass by her—now lit up in Cutts and Case's museum only a couple of blocks from where my husband Richard and I keep our boat. Could *Foto* talk, what a story she would tell!

Maritime historians will have to assemble that story, and they can do so now, thanks to the effort of the curators and staff at the Rosenfeld Collection. Until you are physically in the Collection, until you see the state-of-the-art conservation of the Collection, until you see thousands of laser images flashing by you on a screen, and until you surround yourself in a room "painted" with Rosenfeld photos on every inch of wall space, tucked in drawers, archived in files, boxes, shelves, and video disc—only then can you really understand the magnitude of this family's work. They capture the fluidity, the elegance, the light, the soaring grace of life on the water and, as I have found, also life on land.

In his posthumously published book, *A Point of View*, that relates Stanley's photographic imagination to the images he created, Stanley Rosenfeld writes, "Occasionally the eye catches a situation that does not seem to be part of any developing action—an element that perhaps was not observed at the time of making the photograph" (Rosenfeld, S., 2006). Perhaps that is how he would see *On Land and On Sea*—something not planned, perhaps not even imagined, but nonetheless something that tells a story. Stanley also has written, "Each photograph is not just an instant out of the stream of time. It is the accumulation of a lifetime's experience afloat, reflected in the action of the passing instant" (Rosenfeld, S. 2006). In these images of women included here, each caught in an instant, perhaps we can imagine some of the streams of women's lives—working, caring, playing, and competing.

When Stanley signed Richard and my personal copy of *A Century under Sail*, he wrote, "So you can chart the course our family has traveled—and fill in some missing images." As I culled through thousands of images to find those for this book, I couldn't help but be in

awe at all this family has seen and created. I publish this book as a tribute to their artistic genius and in the hope that I have indeed filled in some missing images.

There is no way I could have completed this book without the extraordinary support from the staff at the Rosenfeld Collection. They have welcomed this project with great enthusiasm and given me unprecedented access to the images and information in the Collection. Mary Anne Stets, Curator of Photography, has been unwavering in her support of this project and I am enormously grateful to her not only for allowing me to do research in the Collection, but also for her sincere care for this family and their work. Victoria Sharps has given me countless hours of her time, helped me find, interpret, and handle the images; she keeps track of all manner of information and details and works tirelessly to preserve this treasured collection. Louisa Watrous, Peggy Tate Smith, and Andy German also embraced the idea of the book from the beginning and have, each in their own way, provided help and encouragement along the way. And, Clare Cunningham, the book's designer, has brought elegance to this project. I thank her enormously for her talent and hard work. I sincerely thank Dusty Friedman, my friend and editor on other projects, who graciously read and proofed every word.

I also sincerely thank the many volunteers who spend countless hours working in the Rosenfeld Collection to catalog, preserve, and compile the images. They do so out of the goodness of their hearts and, without them, none of this would be possible.

One of my few regrets in life is that I never got to meet Morris and Esther. I felt Esther's spirit when I first walked through the gardens of Morris and Esther's long-held home on City Island. Still blooming well into the twenty-first century are the hydrangeas and other flowers Esther had planted. I did get to know and love Stanley—and, briefly, Ruth—who no matter how busy as a mother and career woman in her own right (Ruth taught at Fieldston School in the Bronx) and with such an active life assisting Stanley also produced two extraordinary sons, Richard and Jonathan. I hope this book honors them all.

For various details of the family history, I thank: Adelaide Rosenfeld Bialek (David Rosenfeld's daughter), Elizabeth Evans and Dorothy Frapwell (Eleanor Rosenfeld Frapwell's daughters), David and Peggy Rosenfeld (David Rosenfeld's son and daughter-in-law),

and Jonathan Rosenfeld (Stanley's youngest son). The details they all provided were important, but more important was their enthusiasm and support for this project. Thank you to Heather Hanley, Stanley's second wife, who has cheered me on for years and has been a fervent champion for Stanley and his work.

ACKNOWLEDGMENTS

And to my circle of friends—some on land, some on sea: Thank you for being so supportive while I was working on this and for being so excited about the outcome. I thank Rich and Claudia Fischer, Valerie Hans, Elizabeth Higginbotham, Rob and MJ Peirce, Art Ross, Randall and Joanne Stokes, Howard Taylor, and Maxine and Alan Baca Zinn. Your friendship sustains me! I also thank Phoebe Josephine Altenhofen (of *Voyager*), Harris Cram (of Hesperus), Sam and Claire Choate (of *Kolonahe*), and Clara Petry (of Odyssey) for helping me understand why kids love boats—and for sharing some fun. I also appreciate the support of the Provost's Office and the Dean's Office of the College of Arts and Sciences at the University of Delaware for providing funds that helped support the research for this project.

Most especially, I thank Richard Rosenfeld. He has read every word of this book (sometimes having to listen to me read it out loud), helped with formulating the ideas for every chapter, and provided loads of information about the family and the photographs. He has told me numerous stories of his family's work, shared details of maneuvering *Foto* while his father was yelling for him to "get closer" or "turn to port," talked about the experience of working with his father, grandfather, and uncles, accompanied me to the Collection, and has been a fervent supporter in every imaginable way. Best of all, he taught me how to sail. He keeps me on course and I love him for it. Many say that working on a book is a labor of love, but in this case that is literally true. This book is a tribute to the Rosenfeld family, an expression of love for Richard and for his family, and my own learned love of sailing and being near, in, and on the water.

Margaret Andersen Rosenfeld
Elkton and Oxford, Maryland

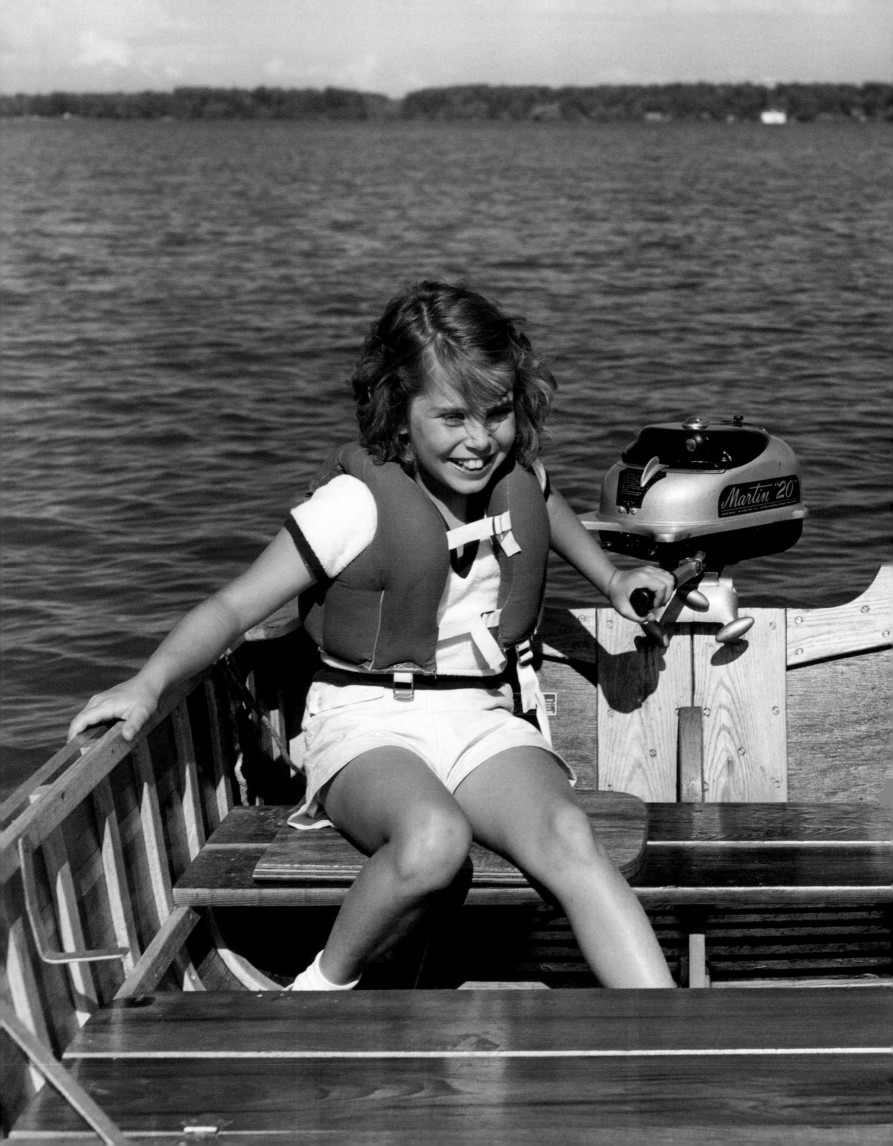

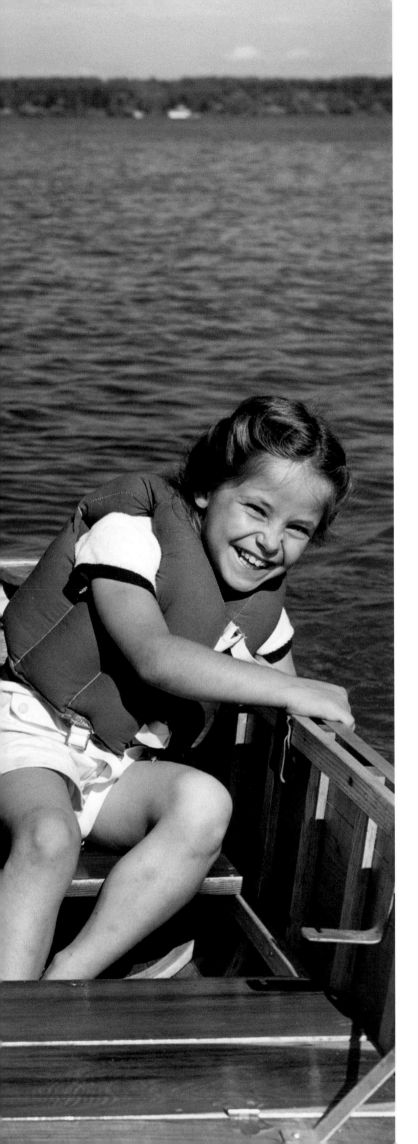

Chapter One

LEARNING
THE ROPES

"If we want to teach our children self-reliance…

we should take them down to

a river a lake or a bay and let them

learn to row a little boat."

—Richard Bode, *First You Have to Row a Little Boat*

rom an early age, children are drawn to water. Whether to feed ducks, swim in a river, float in a boat, or just splash around, children seem to sense the allure of water. And should they be lucky enough to be on boats, they are also captivated by the thrill of moving through water, catching the wind, or just bobbing in the rocking motion of their watercraft. Kids draw pictures of boats in school, imagine themselves in exciting ocean-going adventures, and simply love to splash and frolic in water with friends.

If you ask young children what they love about water and boats, they'll likely tell you that it's just plain fun! But they'll also say how peaceful it is to be near water—perhaps even the youngest of us find respite from the pace of modern life by being near water. A young girl I know, age seven, told me that what she loves most about being on her sailboat is that it's so soothing—the rocking and the cozy space make it a peaceful place. But she also loves sailing, whether in a large sailboat or a small sailing pram. "Because you get to hear the wind," and—in the words of another young friend, "When it tips, it's like being on a rollercoaster—it's really fun!"

Perhaps this is best expressed by Tania Abie, an 18-year-old who sailed alone around the world in 1987. Not certain of her course in

PREVIOUS SPREAD:
YOUNG GIRLS RUNNING AN OUTBOARD MOTOR, CA. 1960
Though likely being used as models, these young girls look like they are enjoying their outboard ride. (NN.1984.187.27847)

TWO GIRLS BAITING A FISHING LINE, 1956
Also taken for Evinrude Motor Company, these girls look like they are enjoying putting a minnow on a fishing line. (1984.187.152020F)

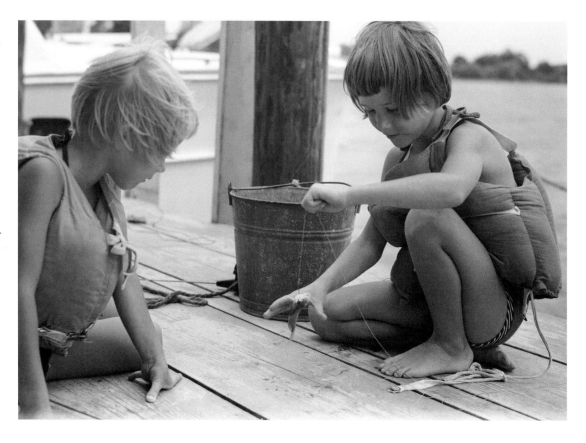

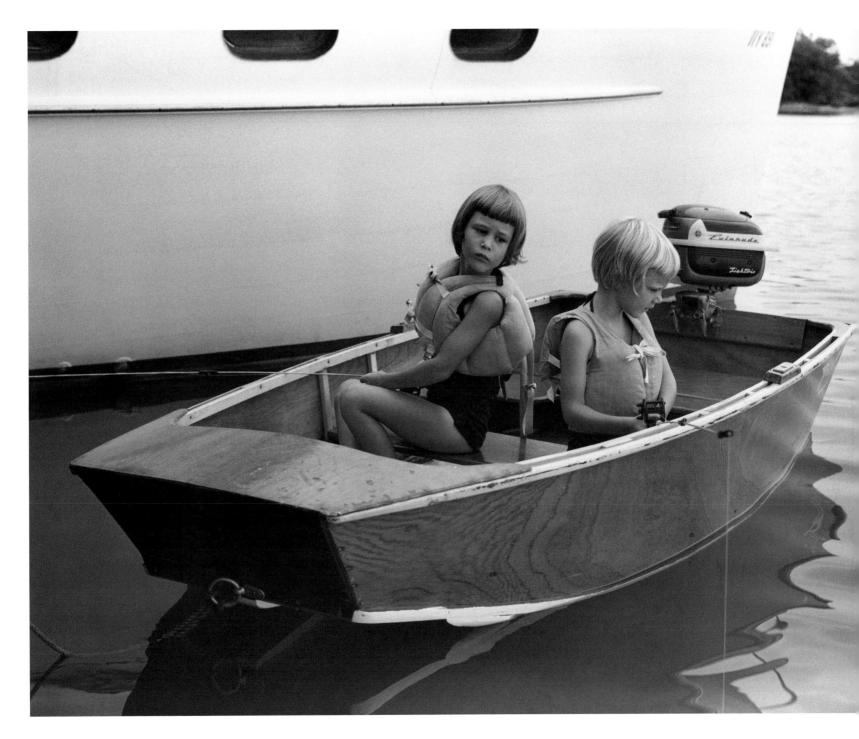

THE PRAM, 1956
These young girls in a pram are models for an advertisement for a "Lightening" Evinrude motor. (152016F)

life and drifting after finishing high school, she changed when her father made her a bargain: He would buy her a boat if she would sail it around the world, single-handed, and write about it when she returned. She did so, and wrote her book about the experience, *Maiden Voyage.* Tania Abie writes, "Sailing was special. Thoughts became clearer and simpler at sea, uncluttered by the pressures of responsibilities and familiar habits. It was easy to be happy" (Abie 1989:20).

The general stereotype of young girls is that they are docile, less

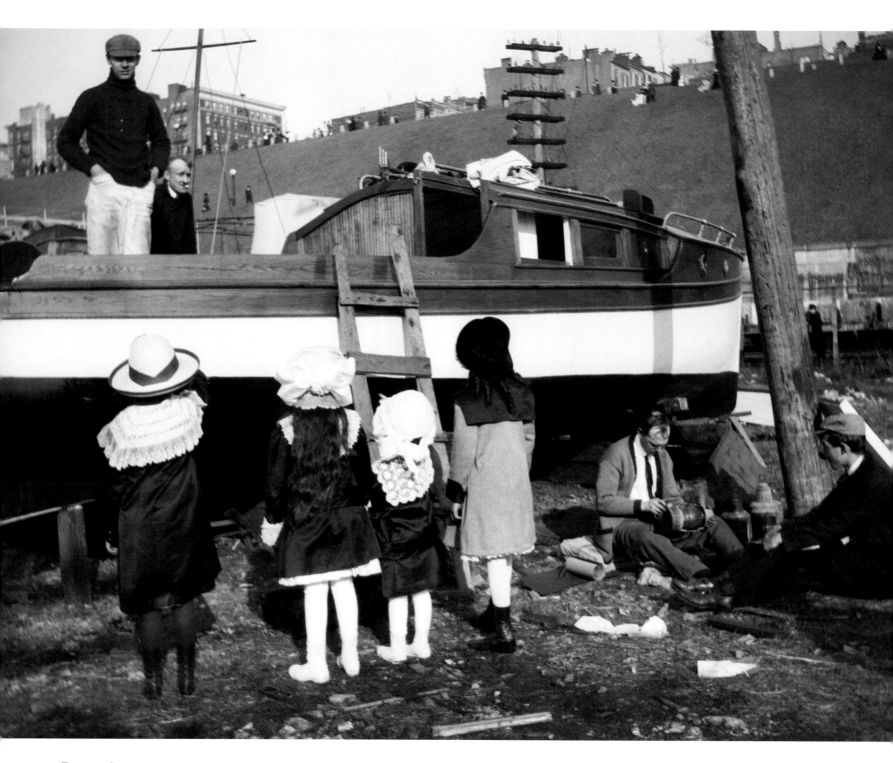

FITTING OUT, ca. 1924

*Dressed in their Sunday best, young girls
watch a cruiser being fitted out in the yard
as the boat is being prepared for spring
launching. (1984.187.14292F)*

adventurous than boys, and seldom action-oriented. Girls who love the things that boys do are labeled tomboys and are encouraged to grow out of that—as if it were a dangerous phase, a divergent path to becoming a true woman. But when you watch young girls near the water or on boats, you can see their enthusiasm for adventure and exploration. Whether they explore the aft end of a mast or they are about to capsize a small sailing craft, young girls reveal their curiosity and love of action when on boats. Why do we then try to discourage them from seeking adventure, letting them succumb to the social forces that more narrowly circumscribe women's roles?

Ellen MacArthur, the youngest person and only the second woman to complete the Vendée Globe race—a nonstop, solo sailboat race around the world (in 1998)—writes that throughout her childhood she read about boats, designed sailboats, and dreamed of sailing. When she got her first boat, purchased from saving her school lunch money, she spent summers working on it and then attended sailing school. Isabelle Autissier—renowned for her extraordinary sailing skills—learned to sail alone because she was shunned by men who sailed and she was not invited to join sailing crews. She and Catharine Chabaud were the first women to participate in the Vendée Globe (in 1996). Autissier, a French marine biologist, had to drop out of the race when her 60-foot boat was dismasted by a rogue wave in the Southern Ocean, notorious for its strong storms and high seas. Left adrift, she was dramatically rescued by the Australian Navy four days later. Catherine Chabaud was the first woman to circle the world alone, non-stop. Though not in a race and preceding the Vendée Globe, Kay Cottee from Australia was the first woman to sail non-stop and single-handedly around the world in 189 days—from Sydney to Sydney.

The first woman ever to cross an ocean single-handed was Anne Davison who left Great Britain on May 19, 1952 and arrived in Miami on August 13, 1953 (on a 23-foot sloop, *Felicity Ann*). Sharon Sites was the first woman to solo-sail the Pacific Ocean in 1965 (on a 25-foot sloop, *Sea Harp*) from San Pedro, California to Hawaii in 29 days. Wendy Hinds of Great Britain was the first woman to complete the extraordinarily rigorous Whitbread Round the World Race (now called the Volvo Ocean Race), doing so on a 71-foot boat, *Second Life*. The Whitbread is a 27,000 mile long race, considered the "Mount Everest of ocean racing" (www.volvooceanrace.org). Nine other women crewed on various boats in the first 1973 Whitbread race, though Hinds was the only woman to finish every leg of the race. But two women, Paquita Carlin from Mexico and Yvonne Van der Byl from Great Britain, crewed some of the legs on the 1973 winning yacht, *Sayula II*. In 1989 an all-woman crew entered the Whitbread race for the first time in history. By 2002, 108 women had sailed in the Whitbread/Volvo Ocean Race. And, in 1995 Dawn Riley captained the first all women's crew in the America's Cup, onboard *America True*.

When Ellen MacArthur finished the Vendée Globe race in 1998, she set the second fastest record for solo-sailing around the world. Most young girls are not as singularly focused as Ellen MacArthur nor perhaps as likely to set world records as these women have done, but what might young girls do and how might they flourish were we to let them run their own course?

The photographs in this section show some of the thrills young girls find in hanging around boats. Some of these young girls are models (taken as part of the Rosenfelds' commercial work at boat shows, launches, and in other venues), but the images still capture the marvel that young people find in boats and on water. Other images capture the thrill-seeking that young girls can find in sailing; and in still others, you will see the calm that young people speak of about the water. As always, the Rosenfelds' eye captures the spirit of childhood, such as fishing from a small pram, gazing into the dark hole of a dorade during the Newport to Bermuda race, or the curious inquiry of a young girl staring into the base of the mast of the 12-meter yacht, *Neferiti*, being launched in Marblehead, Massachusetts.

It makes you think about why we so often suppress the spirit and spark of adventure from young girls who would otherwise grow up to be intrepid, valiant, and courageous—attributes that, oddly enough, name some of the world's most well-known yachts, yachts that ironically as typically are referred to in feminine terms. Knowing about the women who defy gender stereotypes—like the women who have sailed the high seas—opens new horizons not only for such heroines, but also for young girls who can then chart new courses for their lives.

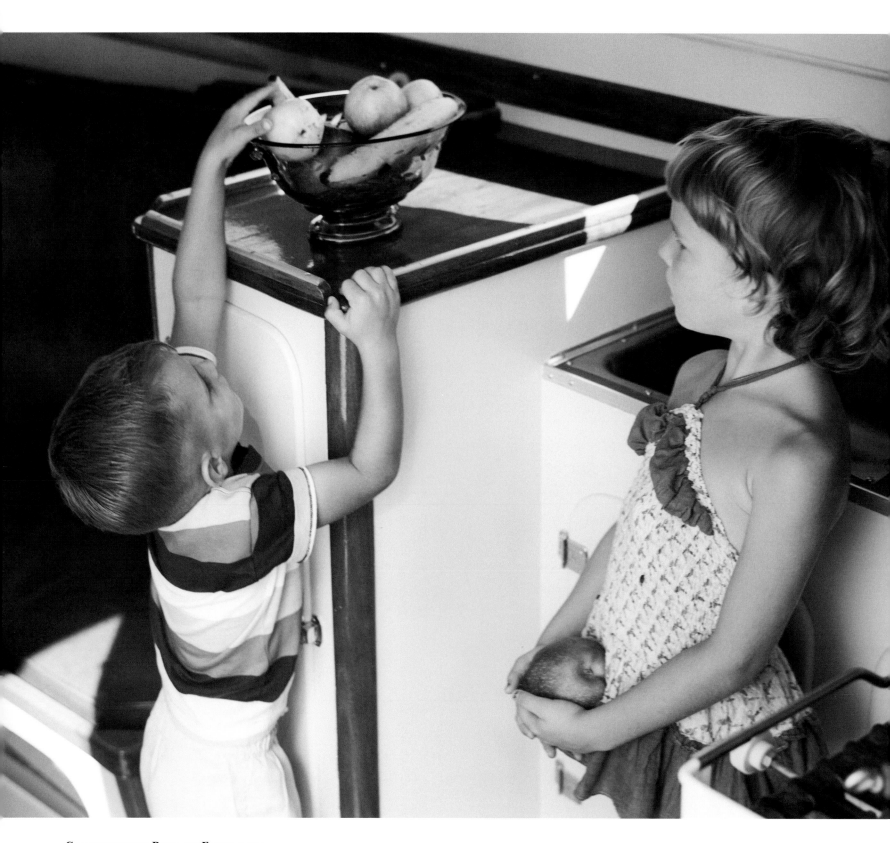

CHILDREN WITH BOWL OF FRUIT, 1954
*Some of the Rosenfeld photos were made for
advertising campaigns, such as this image for
the Williams Advertising Agency taken in
1954. (1984.187.143923F)*

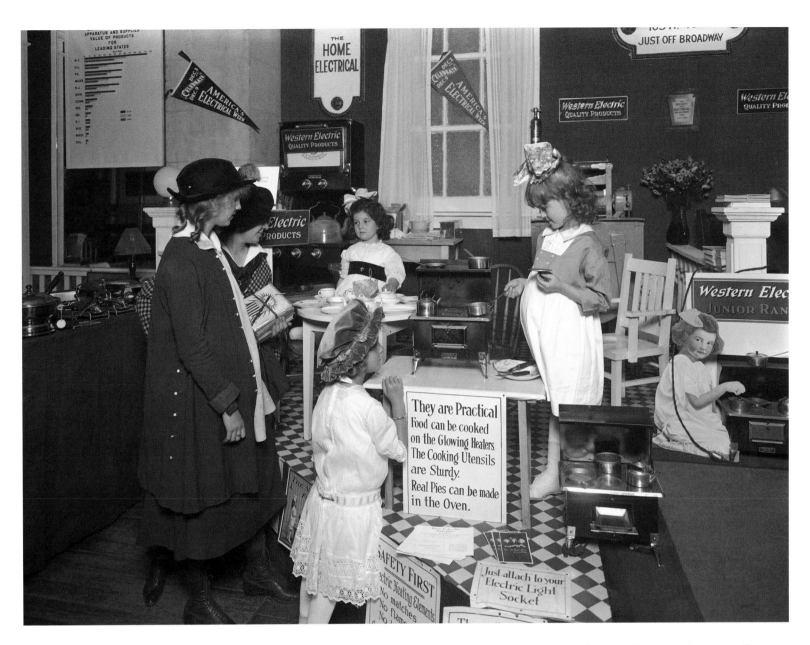

COOKING TOYS FOR GIRLS, 1916

Promoting the use of electricity in the early twentieth century often relied on the gender roles deemed appropriate for girls and women at the time. Taken at an Electrical Exposition in New York City, this photo displays products of the Western Electric Company. (1984.187.4890)

MAST OF *NEFERTITI*, 1962
At the launch of the 12-meter yacht, Nefertiti
*in Marblehead, Massachusetts, this young
girl peers into the base of the mast.*
(1984.187.171824.30)

CURIOUS ABOUT A COWL VENTILATOR
*At the start of the Newport to Bermuda Race
in 1968, these young girls are intrigued by
the vent provided by a large dorade on a
sailing yacht. (1984.187.185162.18)*

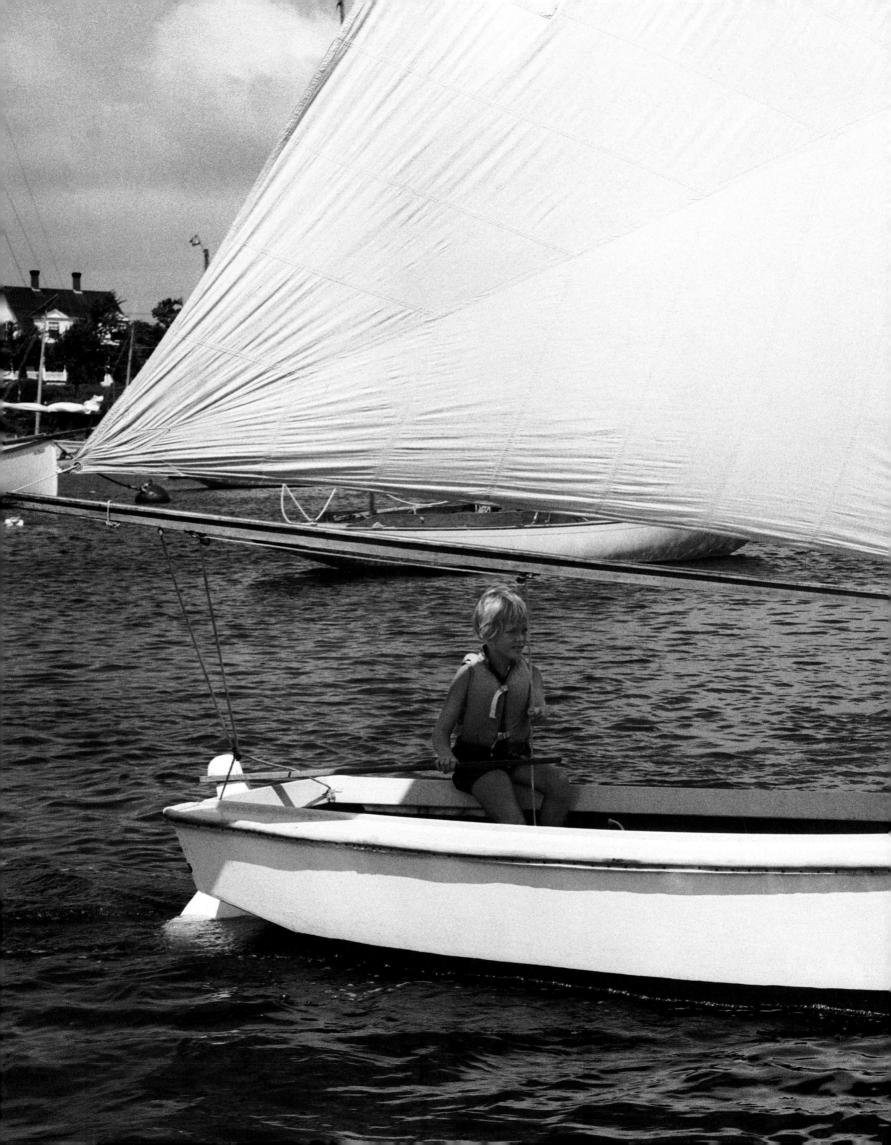

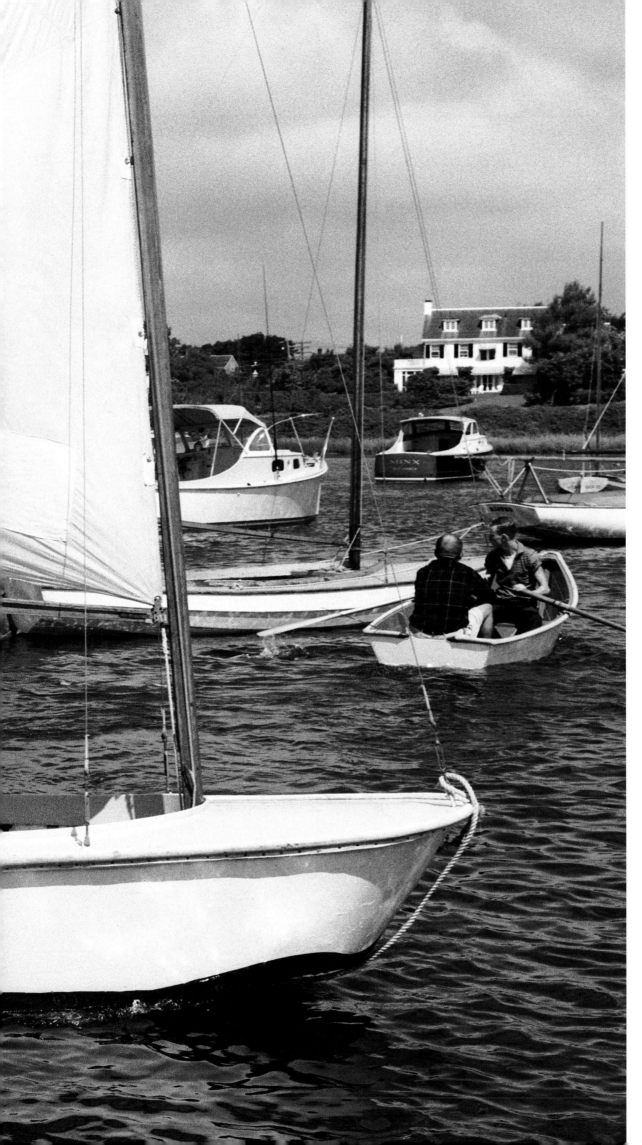

GIRL IN A SMALL SLOOP, 1957
*Learning early to sail, this young girl
happily maneuvers her small sailing
dinghy through a crowded harbor.
(1984.187.156915F)*

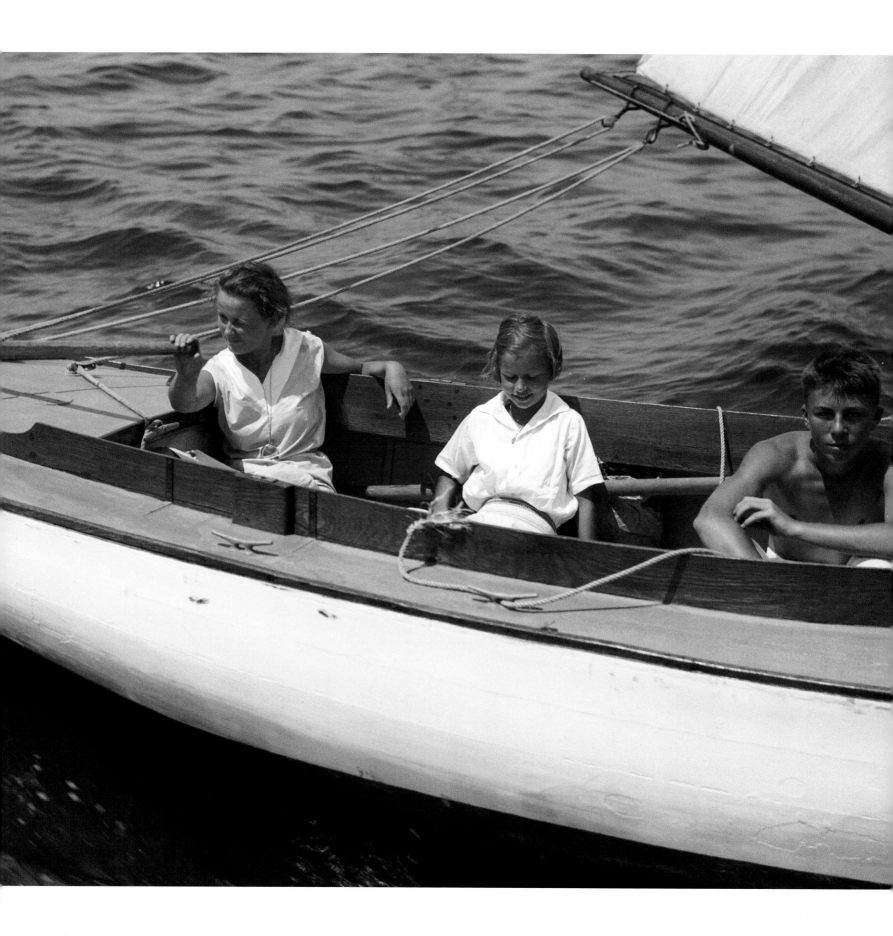

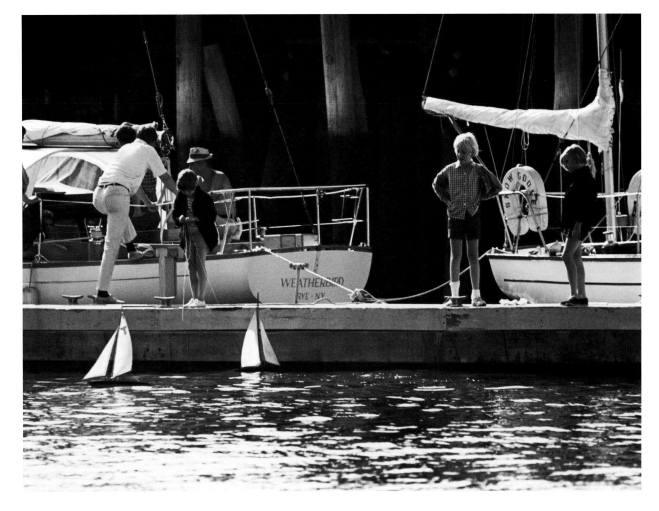

REGATTA SCENES, 1968
Young girls watch toy sailboats from the dock at a sailing regatta. In the background are Weatherbird *(a 38-foot sloop) and the yawl,* Snow Goose. *(1984.187.185284-22)*

BILLY BONES, 1931
A Pirate-Class sloop, Billy Bones #5 *is undersail, a young girl at the tiller, another absorbed in her thoughts, and a young man assisting. (1984.187.47333F)*

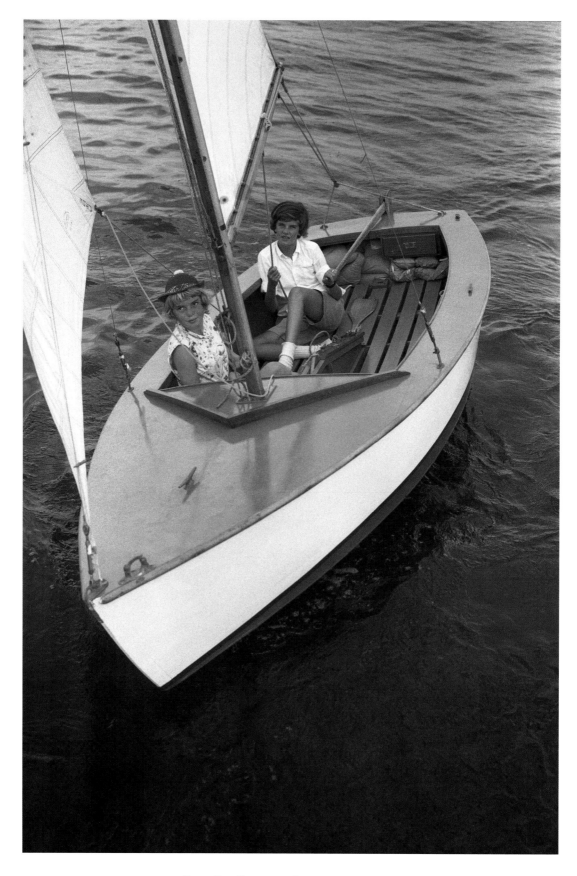

BLUE JAY CLASS, 1956
*Young girls are racing at the American
Yacht Club at Rye, New York in the juniors'
divisions. (1984.187.147676F)*

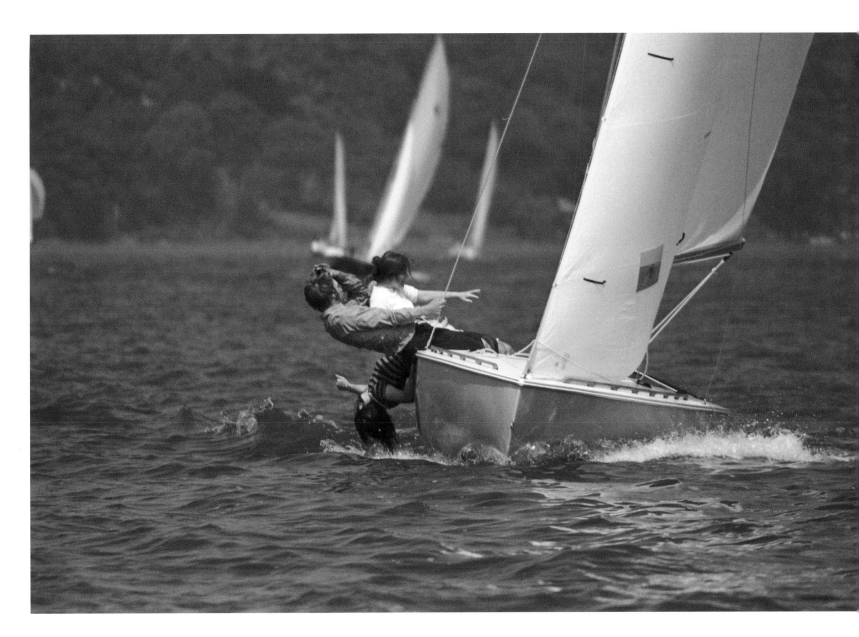

HIKING OUT III, 1973

*Peggy Tate Smith, former staff member of the
Rosenfeld Collection, competes in the North
East American Championships off Noroton
Bay in Darien, Connecticut. With them are
an unknown man and her friend, Susan
Nickerson, who always loved hiking out
until her hair was in the water!
(1984.187.189958.34)*

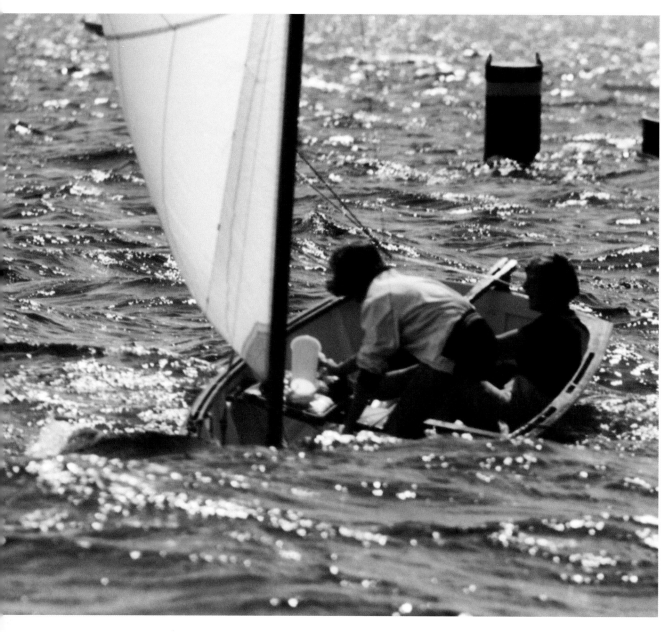

(1984.187.166550.2)

GIRLS BAILING A DINGHY, 1960
Swamped! Taken during Larchmont Race Week, the girls are racing in a Dyer Dhow dinghy. (1984.187.166550.3)

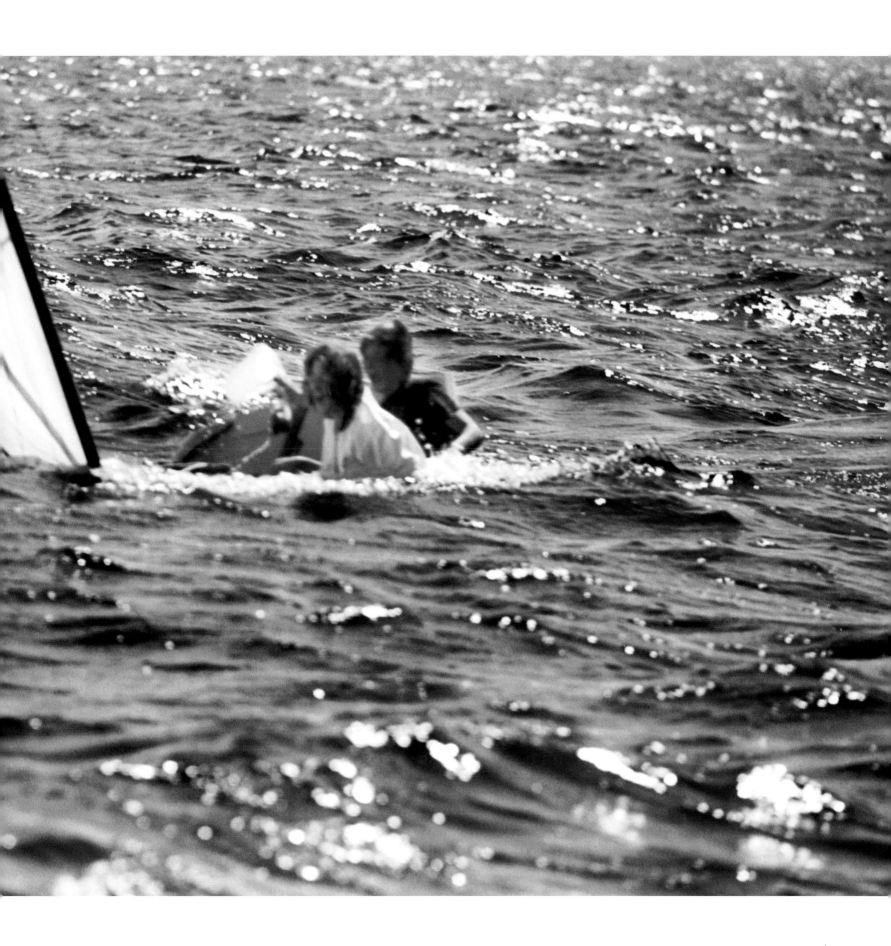

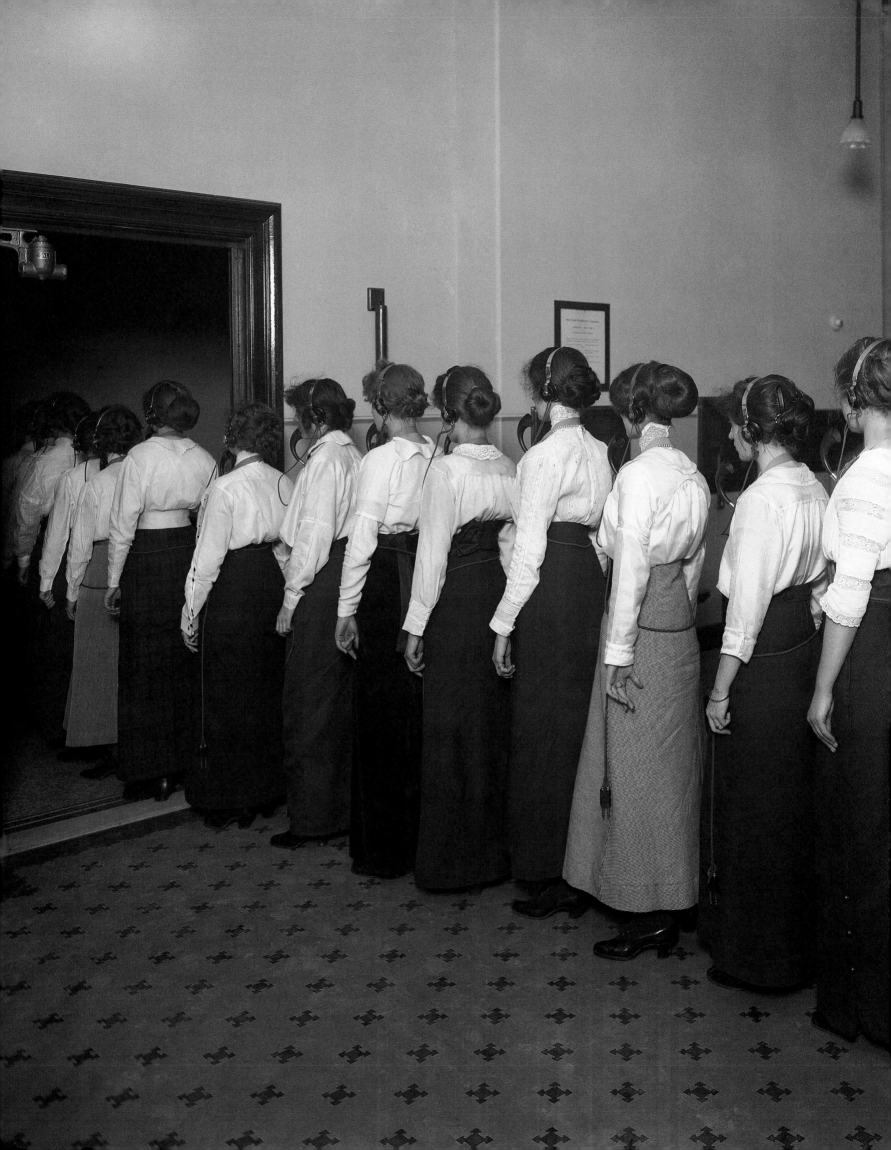

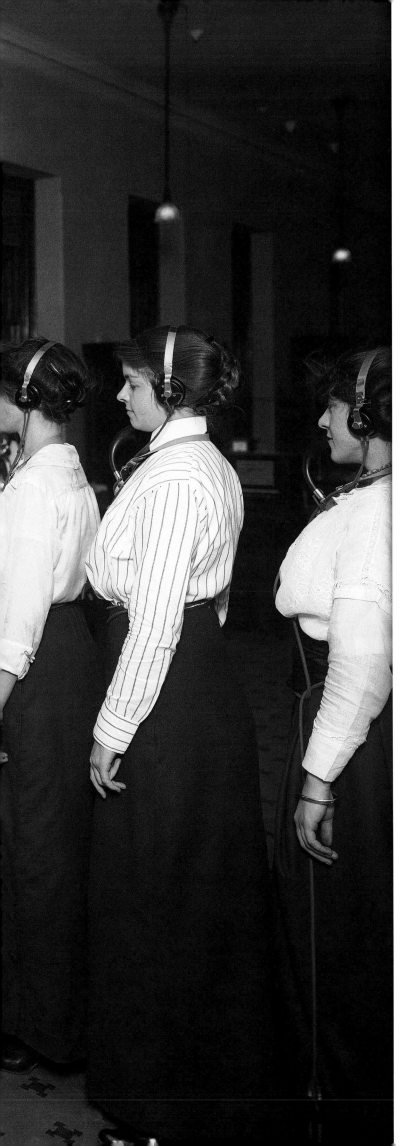

THE DAILY GRIND: WOMEN AND WORK

"Notions of propriety and role served as organizational principles for women's work force participation. … Job experiences for women were defined in terms of values appropriate to future home life: gentility, neatness, morality, cleanliness. …Male jobs, in contrast, encouraged such values as ambition, competition, aggression, and increased income. … Such distinctions confirmed women's place in the home, even while they worked for wages."

—Alice Kessler-Harris, *Out to Work*

31

hen Morris Rosenfeld began his photographic career, New York City was rapidly changing. Immigration, industrialization, new technologies, and population growth were transforming the city's—indeed, the nation's—character. The city was being built; people crowded into tenements in the lower East Side where the Rosenfelds worked; young women were leaving their homes to go to work in factories and in offices. The city was bustling and, on summer nights, steaming. Some families slept on the street at night, not because they were homeless, but because it was hot and little breeze would cool the crowded apartments. Families in the Lower East Side might live five people to a room; tenements were crowded, and there was noise and dirt everywhere. As many as 800 people crammed into an acre on some city blocks (von Drehle 2003).

This was a period of labor activism, the formation of the settlement house movement, the development of the women's suffrage movement, and a time when young, white women could be more independent than in the past. More women were leaving their homes to work for wages, at least until it was judged time for them to marry. The feminist movement was growing strong, not only through the suffrage movement, but also through various labor organizations. Eleanor Roosevelt, then a young society woman herself, was a member

ON THE PREVIOUS PAGES:
FIRE DRILL, 1912
At the Tremont Exchange of the New York Telephone Company, you can see women operators lined up for a fire drill. Their dress was specifically intended to promote a particular image of service-oriented women as the telephone company vied for public approval. (1984.187.1634)

RIGHT:
SLEEPING OUT, ca. 1915
Perhaps these appear to be homeless people, but they are a family sleeping on Monroe Street in Brooklyn, New York due to the extreme heat. Although these people seem to be poor, the practice was common in the summer heat at the time. (ANN.1984.187.4305/RD.1984.187.7719)

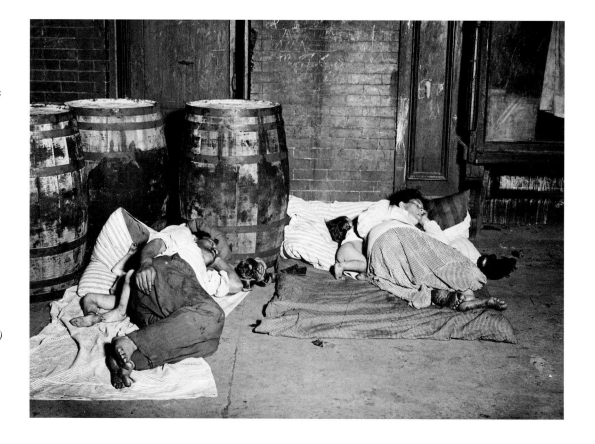

of the Women's Trade Union League, an organization founded in 1903 as an alliance between wage-earning women and middle-class, bourgeois women.

Modernization was changing New York City. Electrical power was lighting up the city and changing how people lived and worked. By the 1920s electrical light and power consumption had increased threefold, changing such basic things as how people washed their clothes and how they communicated with each other. Telephone use was becoming more common, and a new consumer culture was also emerging, with estimates that by 1915, women were doing 80 percent of all consumer purchasing (Norwood 1990). New consumer products were widely available, manufactured in the industries where women were employed. And, window shopping became a new pastime for women. What a time the young Morris Rosenfeld must have witnessed!

An immigrant himself, Morris Rosenfeld started his studio on the Lower East Side in 1910. He and his wife and family lived for a time on 78th Street in Manhattan, then in the Bronx until they moved to City Island in 1926. Rosenfeld and Sons kept the studio on Nassau Street in the Lower East Side until they later moved to 23rd Street, a studio that remained their place of work until his son Stanley closed it in June 1980. They left hundreds of thousands of photographs documenting, not just the maritime life of the time, but also the social, labor, and architectural history of this phase of the nation's development.[1]

What was life like for women in this setting? The dominant ideal defined women's place as in the home—at least for white, middle-class women. The cult of true womanhood, a belief system promulgated in the nineteenth century, idealized woman's role in the family and defined her presence in the home as a moral calling. Carrying into the twentieth century, the cult of true womanhood stereotyped women as pure and graceful, but submissive. Woman's role was to nurture children, subordinate themselves to the family, and soften the otherwise competitive and harsh world associated with men.

Of course, neither immigrant women nor black women could achieve this ideal. Ideal womanhood was reserved for middle-class or bourgeois women, but it shaped the broader cultural framework for understanding women's lives at the time black women, though much more likely employed than white women, were working mostly as

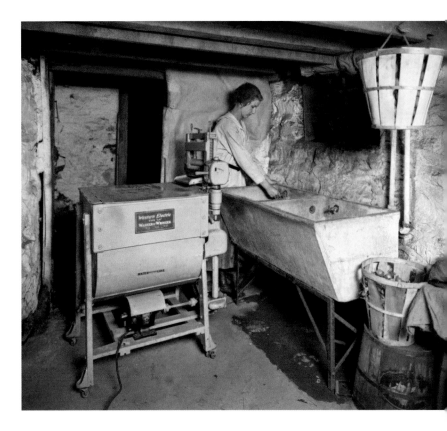

ELECTRIC WASHER AND WRINGER, 1921
Although labor intensive by today's standards, the onset of electricity brought new methods of daily chores into the home, such as this wringer washing machine introduced by Western Electric. Prior to the development of washing machines, laundry was either sent out or could take an entire day to do at home. Electrically powered washing machines could reduce the time to half a day (Kessler Harris 1982, 1984.187.12459)

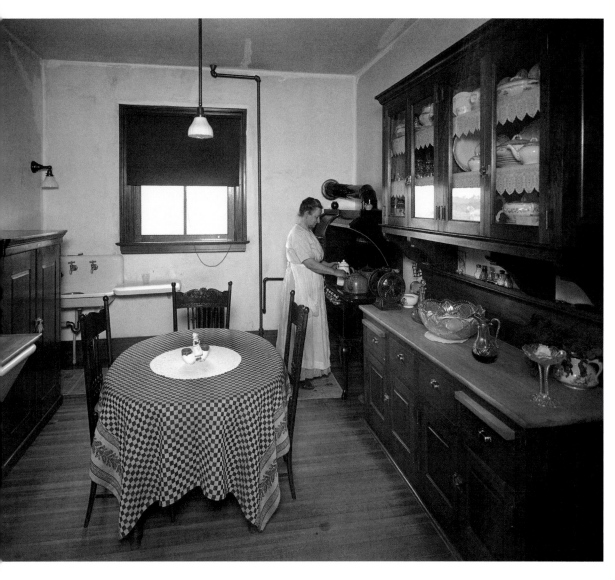

WOMAN IN THE KITCHEN, 1918
Not all families could afford this commodious kitchen, but it set a bourgeois ideal for modern housework. (1984.187.7375)

private domestic workers. Though some were moving into industrial employment, they were excluded from most of the jobs that white women had. In the few cases where black women found industrial work, they were in the worst jobs and subject to frequent layoffs. During the early twentieth century, black women's employment was also being undercut by the same technological developments that were improving life for others. Electric washing machines started to replace the work of laundresses; vacuum cleaners, and other household technologies, and the work of domestic servants. Still, African American women and men flocked to the cities of the North in what is now known as the "Great Migration"—the period between 1910 and 1930 when black Americans left the grinding poverty and agricultural work of the South in search of new industrial jobs. In New York City and other venues, this resulted in the Harlem Renaissance, a period of cultural and artistic expression in the 20s that produced

some of America's finest art, music, and literature.

In the early twentieth century, immigrant families also made up a huge proportion of the urban population. One-third to one-half of families in major cities, New York being no exception, were immigrants. Immigrant women were most often employed in domestic work or factories. The particular form of work they found often depended on their ethnic background—Jewish women worked in the garment industry; Irish, German, and Scandinavian women, in domestic service; Slavic women in canneries, laundries, and other factory settings. Even within industries, nationality patterned women's segregation in various jobs—Russian and Eastern European Jews were largely concentrated in women's garment manufacturing; Italian women, in men's garments (Amott and Matthaei 1996).

Some of the early contract jobs taken by Rosenfeld and Sons were for New York City's growing industrial companies—Western Electric,

The New York Telephone Company, National Vulcanizing and Fiber Company, and other organizations and offices. Western Electric and The New York Telephone Company were employing many of the city's young, unmarried, white women. Stanley Rosenfeld estimated that between 1910 and 1920 Morris' group of eight photographers worked for the American Telephone and Telegraph Company every other day; their photographs appear in some of the histories of Western Electric and AT&T.[2] And, although his first love was always marine photography, Morris had a staff of 14 photographers by the 1920s working on industrial advertising, architectural design, and news. As a result, the Rosenfeld Collection provides a glimpse into part of this phase of New York's history and documents the daily working life of some of New York City's women.

By 1910, half of New York City's single women worked for wages. Many of them worked in the garment industry, but they were employed in other areas, as well. There are precious few photographs of black and immigrant women in the Rosenfeld Collection because of where the Rosenfelds did their work—the industries where labor practices excluded black workers. Explicit policies against hiring blacks, Jews, and immigrants were common. The telephone company—where the Rosenfelds took many of their industrial photographs—was not forced to change its exclusionary employment policy until World War II as the result of the Fair Employment Practices Commission, black labor activism, and the need for more labor (Green 2001).[3]

The telephone company had originally hired boys as operators in the 1870s and 1880s, but found them to be too unruly. They swore, they drank, they shouted, and company management soon found they could both cut wages and have a more congenial voice on the line (Green 2001). In the 1880s, telephone operating became women's work and by 1926, 95 percent of switchboard operators were women.

In the nineteenth century, it was thought that women's work—at least that of white women—would have a negative impact on the family. But with a rapidly expanding economy in the early twentieth century and during World War I, employers needed more workers, and beliefs about women's work started to change. The dominant idea was still that work and family were separate spheres—work, a world for men and home, the world of women. This posed a

dilemma for employers: How could they recruit more women into the expanding labor market while still embracing the belief in idealized womanhood?

The solution lay in how women's work was defined—at least for the white, middle-class women employers they desired. To begin with, women's work was believed to be only temporary. If women were supposed to be stay home with the family, then work was something "respectable" women could do while still single. Although more married women were working, most working women were single, young, and assumed to be working only until marriage. Some companies even set age limits for its women workers, age 17 to 25 in the case of the Bell System. Perceived as not staying in labor force long and not needing to support a family, women could also be paid lower wages than men, who were presumed to be the family breadwinners. Thus, the ideology of men's and women's separate spheres was strengthened even as women were entering the workforce in greater numbers. Not only was this consistent with the ideas of the time, but it also gave employers the flexibility to fire women when they needed to cut labor costs. At the telephone company, for example, married women were hired in the 1920s during the conversion to a dial system; they could then be easily laid off once the installation was complete.

The belief that women's and men's nature was rooted in biology seemed to justify why women were suitable for particular jobs. Women were judged to have exceptional patience, nimble fingers, and a tolerance for monotony. It is then no accident that by the 1920s women were close to half of those working in electrical supply factories (U.S. Department of Commerce 1920)—in jobs that were repetitive, tedious, and without room for individual expression.

Sexist beliefs also inspired a paternalistic attitude toward working women. In the telephone company, women operators were treated like school girls in a grade beyond high school: Home visits were a prerequisite for employment. Women were advised on dress and personal hygiene, and also prohibited by company policy from showing any "uncleanliness of the hair, nervousness, skin diseases, nose, throat, or lung troubles" (McBride 1905; cited in Green 2001). Fashion historians have written, "The outfit of a plain dark skirt (light in summer), a belt, and a crisp white blouse was suitable for working women and college students, for street wear and lunching

in a restaurant, and also for golf, tennis, boating, and other summer sports" (Milbank 1989). The telephone company followed suit, with women wearing long, black skirts and high-collared, long-sleeved white blouses. Management also exercised harsh discipline over such seemingly personal choices, but women resisted when they could. Telephone operators struck in San Francisco in 1907, and they refused to wear the company dress; nonetheless, the company would not relent in its policy.[4]

The carefully cultivated image of telephone operators as "ladies" also reflected and contributed to keeping women of color and working-class women out of this occupation. White women were seen as perfect for customer service, based on the belief that they were genteel, demure, and literate. This image was used to justify keeping non-native and black women out of operator's jobs. Race defined "the lady." Although you might think that gender and race would be irrelevant to sitting at a telephone switchboard, women's place in the telephone company was expressly defined by their gender, race, and social class, not just their training and experience. Being white was thought to be ideal for telephone operators, presumably reflected in their voice. White skin implied certain valued characteristics—judged, of course, in opposition to the presumably undesirable characteristics associated with women of color. This was explicitly promoted by the company. Even in the 1930s a national newspaper for telephone operators contained short stories glorifying the old south and stereotyping black women as mammies. As late as the 1950s, white women operators were known to perform minstrel shows, sometimes in black face.

Employers also preferred hiring middle-class women, presuming that this would forestall the growth of a working class consciousness. The labor movement was associated with the working-class, and employers feared the labor organizing associated with this class.

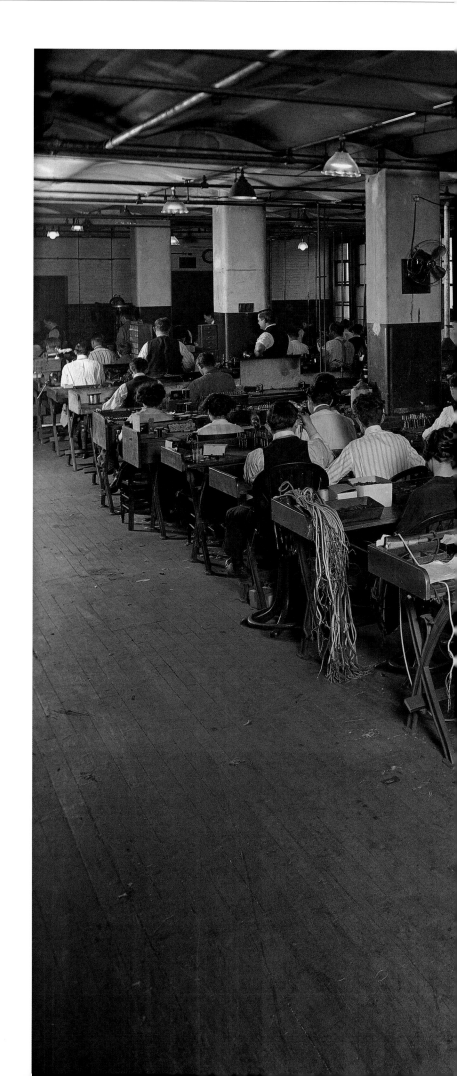

WOMEN MAKING WIRE ATTACHMENTS, 1915
In a large factory room, women at the Western Electric Company in New York make wire attachments for telephones. (1984.187.3718)

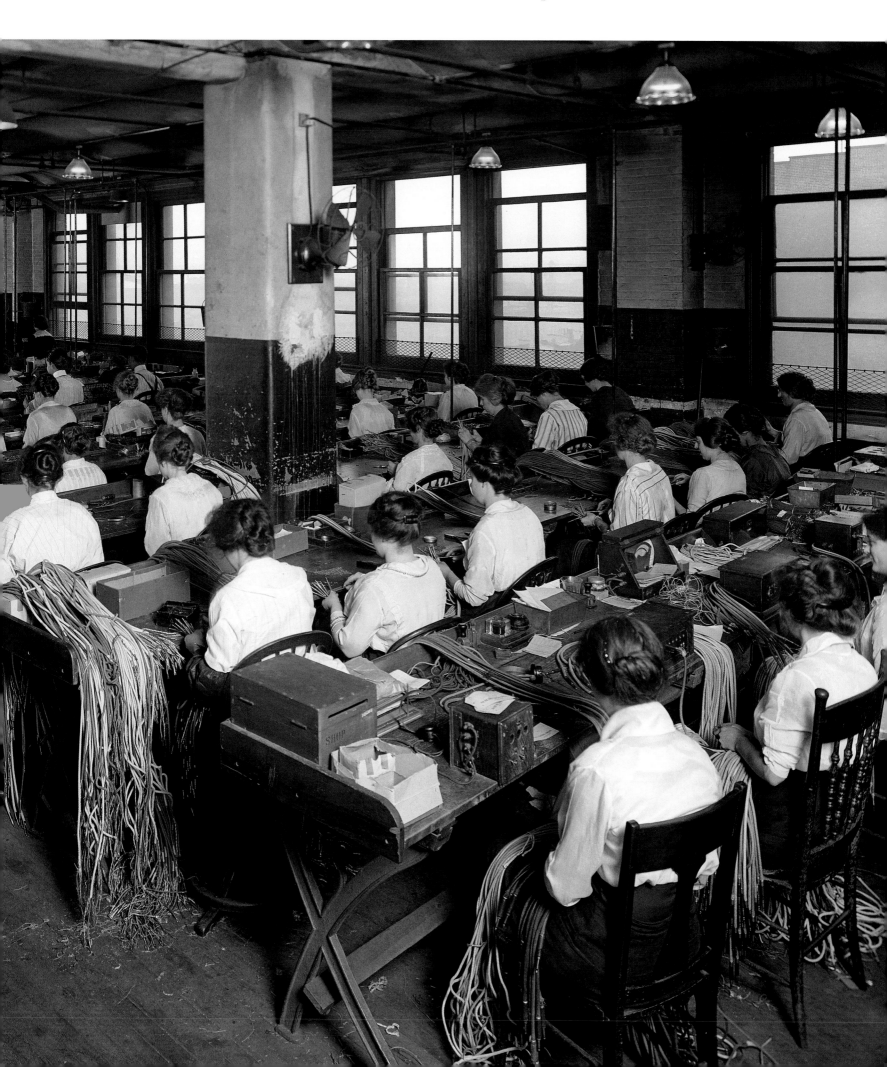

Moreover, women were not expected to desire advancement, since their primary attachment was believed to be the home. Indeed, the doctrine of separate spheres did to some extent work against labor activism—certainly across class lines, since middle-class women's identities were presumably more centrally tied to family, not jobs.

Yet, there is plenty of evidence that women did organize on their own behalf, and, in some cases, were more active in organizing unions than men. Women fought back, organized unions, and protested some of the unfair labor practices. They demanded better wages, better working conditions, and the right to organize. Indeed, in the period immediately following World War I, women's union strength increased, as did men's. Following the war, women's assertiveness increased in numerous industries where they organized, due in part to the confidence they acquired from their experience working during the war. At this time, numerous strikes shut down the phone system in different parts of the country. One of the largest was the New England Telephone and Telegraph Company in 1919. To this day, some of the most significant laws governing women's employment rights have come from legal action inspired by women's activism in the telephone company (Norwood 1990).[5]

The work that the Rosenfelds have documented also included the emergence of modern office work. Like the telephone company, the emergence of the modern office required an expanded supply of workers, and women were deemed perfect for the job. In the early twentieth century, what we now know as "scientific management" became the guiding philosophy for business. Offices moved toward more hierarchical and bureaucratic work. Greater value was placed on precise record keeping, accountability, efficiency, and reliability. By 1930 office work was the most likely working option for urban, white women, and the number of clerical workers grew from 34 percent in 1910 to 49.4 percent in 1930 (U.S. Department of Commerce 1930, 1940). Whereas earlier offices had been small, staffed perhaps by one, two, or three male secretaries, the widespread introduction of the typewriter transformed a once prestigious profession into a field defined as "women's work." With the need for more office workers, women were said to be "naturally dexterous" and nimble—perfect as a cheap supply of clerical labor. The wages and the prestige of secretarial work then declined.

The photographs in this section capture some of this history of women's labor, revealing both the places where women worked, including in the home, and show how gender has segregated women into particular niches of the labor market. The images also capture some of the ironies of women's work in the context of beliefs about true womanhood—doing grubby, dirty work with cables and wires, but wearing black stockings! Embedded in these images of women in their shirtwaists is a social history of women's work and its connection to the gender, race, and class inequalities of the time.

[1]Stanley continued to work until not long before his death in 2002; for more information on the Rosenfeld family, see the Rosenfeld Collection web site: www.rosenfeldcollection.org

[2]See Venus Green. 2001. *Race on the Line: Gender, Labor, and Technology in the Bell System. 1880-1980*, Durham, NC: Duke University Press and Stephen N. Norwood. 1990. *Labor's Flaming Youth: Telephone Operators and Worker Militancy, 1878-1923*. Urbana, IL: University of Illinois Press.

[3]The first black operator in New York was not hired until 1944.

[4]The attire deemed appropriate for working women, shirtwaist dress or blouse and skirt, also sustained the fashion industry—and is now notoriously documented by the Triangle Shirtwaist Factory fire in 1911, where labor conditions were so poor that 146 women died when the fire started and escape routes were blocked. See David von Drehle's book *Triangle* (2003) for a riveting account of this labor disaster.

[5]One of the groundbreaking cases during the second wave of feminism in the late 1960s was *Weeks vs. Southern Bell Telephone and Telegraph Company*. By this decision, employers could no longer categorically exclude women from various jobs based on their presumed physical abilities, unless employers could prove that such things were a "bona fide occupational qualification." Even then, women could not be excluded as a class, as had been the standard practice.

SUPERVISING TELEPHONE OPERATORS, 1918
At this office of the New York Telephone Company on Spring Street in New York City, operators are supervised by two women. (1984.187.7120)

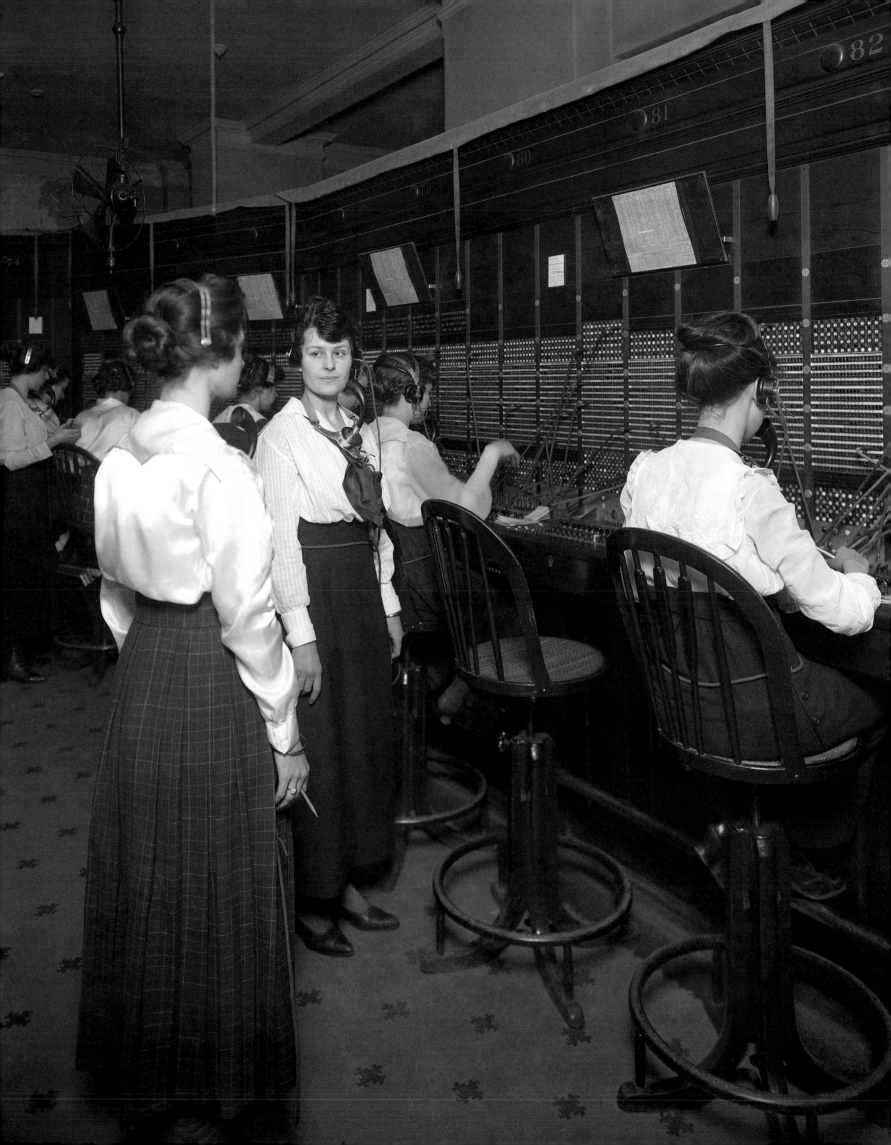

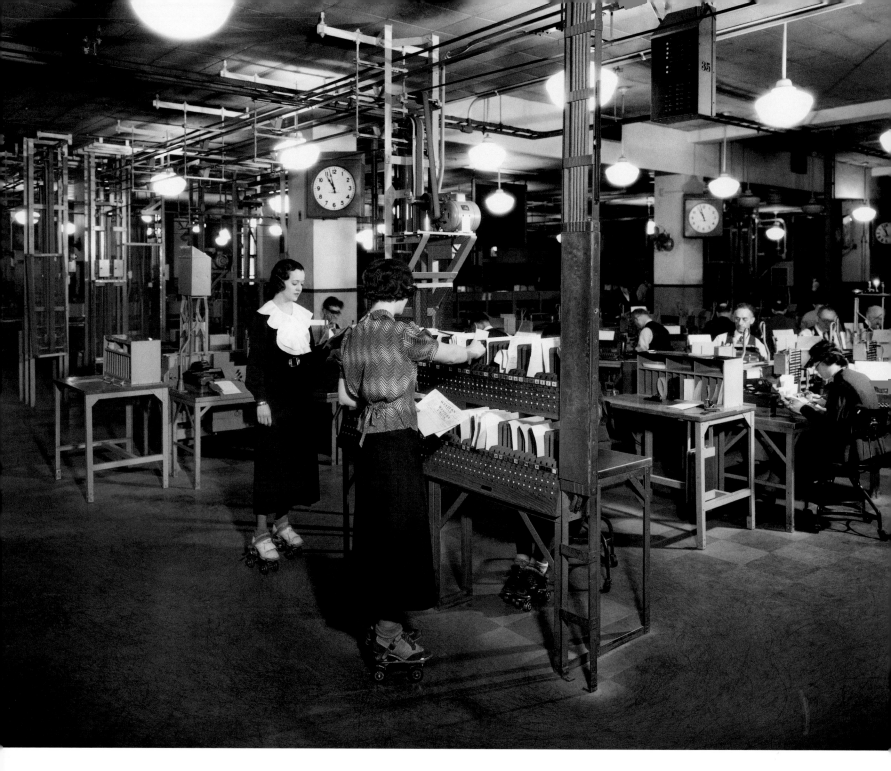

WOMEN ON ROLLER SKATES, 1935
*At the Western Union Office, Traffic
Department, women work at a sorting
station. (1984.187.44891)*

NATIONAL LAUNDRY COMPANY, 1929
Located at 5th Avenue and 141st Street, the National Laundry Company employed African American women as laundresses though they were supervised by white women. (1984.187.34786)

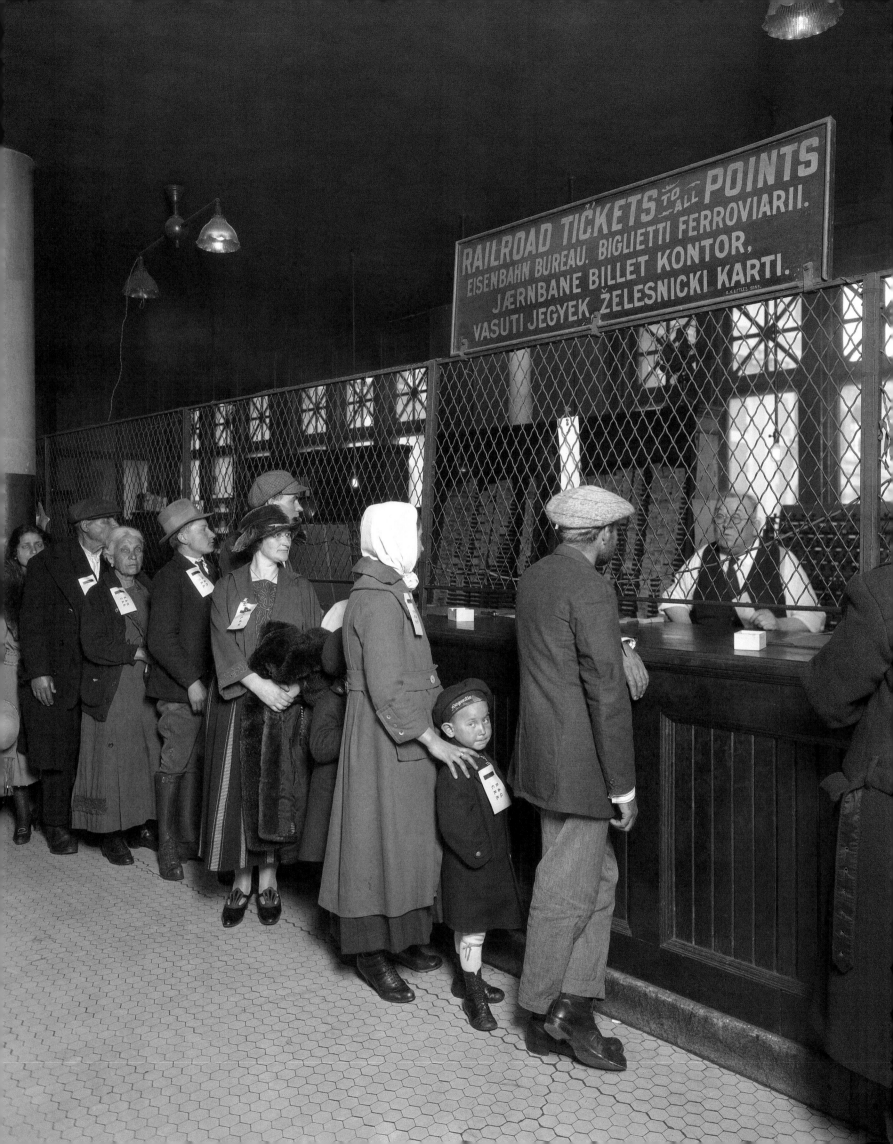

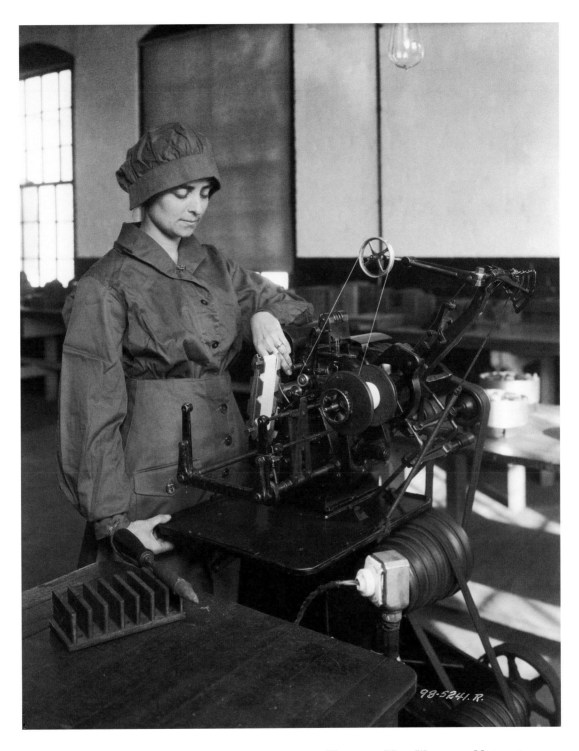

WOMAN AT WIRE-WRAPPING MACHINE, 1920
Wearing protective clothing, this woman operates a machine that wraps wire. (1920 1984.187.10313)

OPPOSITE:

ELLIS ISLAND, 1924
Part of the work commissioned by the American Telephone and Telegraph Company, this photo depicts newly arrived immigrants waiting for railroad tickets at Ellis Island, New York. (1984.187.19680)

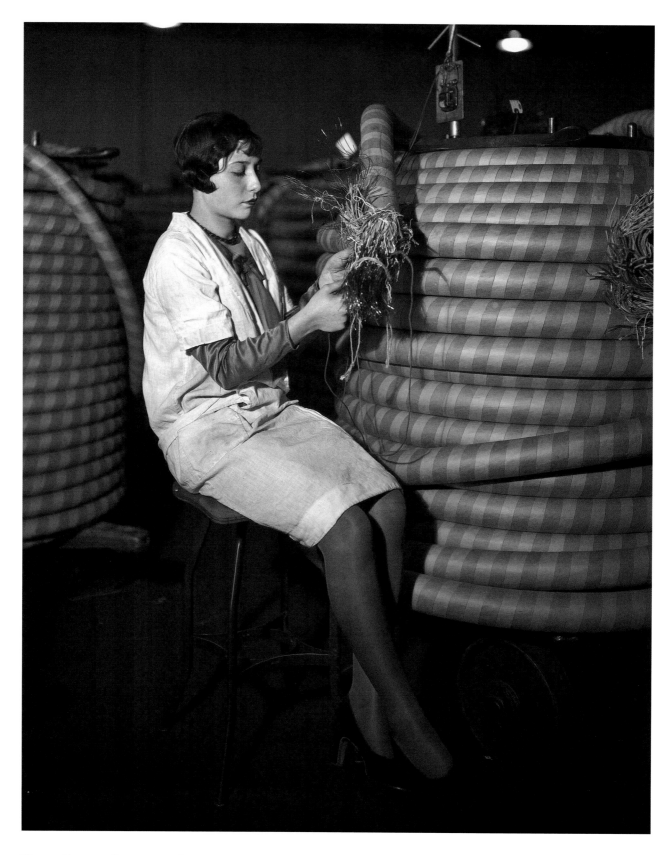

WOMAN SORTING CABLES, 1928

*At the Kearny, New Jersey plant of Western
Electric, this woman sorted cables and worked on
various forms of machinery dressed in stylish
attire. (1984.187.33207)*

44

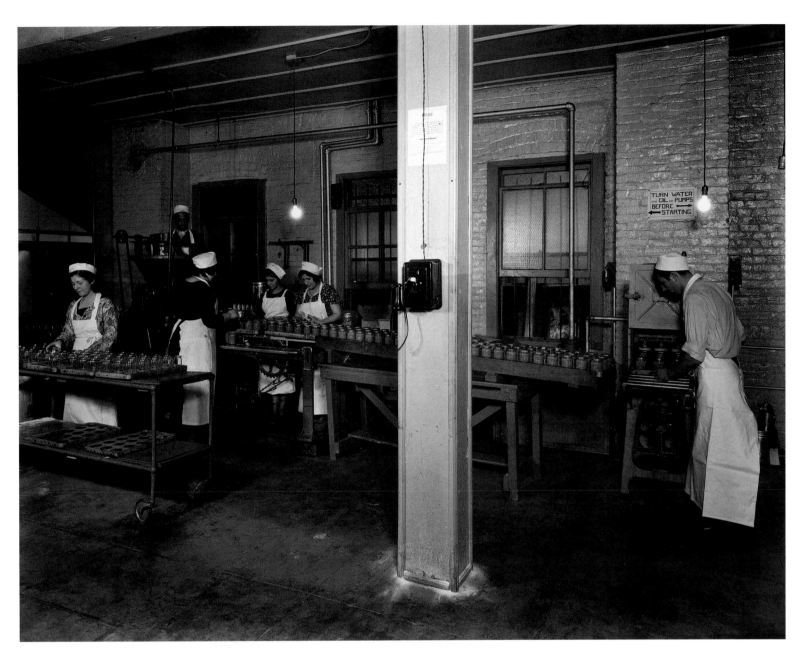

INTERIOR OF GLASS FACTORY, 1931

The advent of assembly lines streamlined the production of goods and, by the early twentieth century, women no longer had to do all the canning, baking and preserving in the home. Household work normally done inside the home could now more easily and cheaply be done outside the home (Kessler-Harris 1982); The growth of industries, such as the canning industry, also required more workers, such as at this glass packing company, Chin and Lee, at 113 Bank Street in New York City. (1984.187.41503)

WOMAN AT CABLE MACHINE, 1929

*Despite the images of ideal womanhood prominent
in the early twentieth century, women often did
the "dirty work" of society. A pretty necklace
completes the ensemble. (1984.187.33856)*

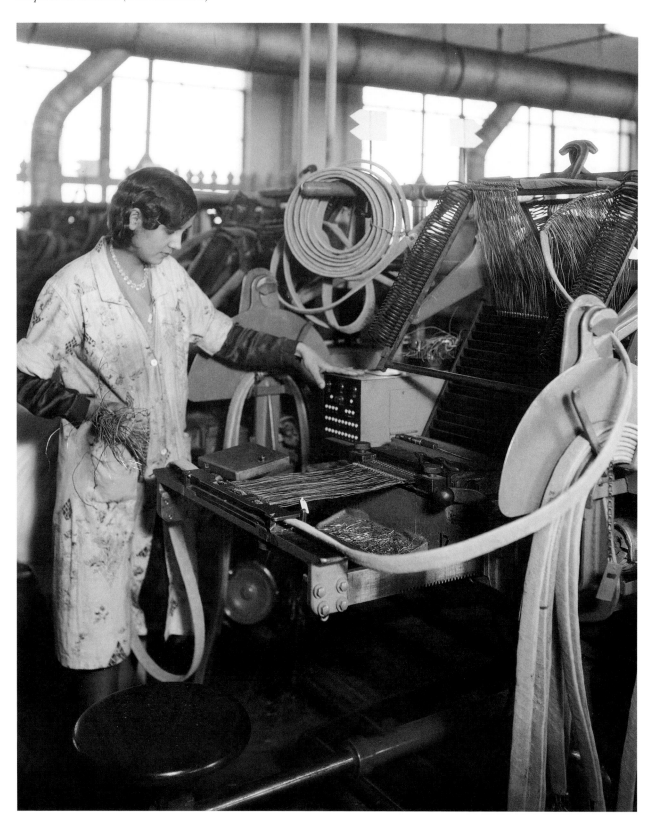

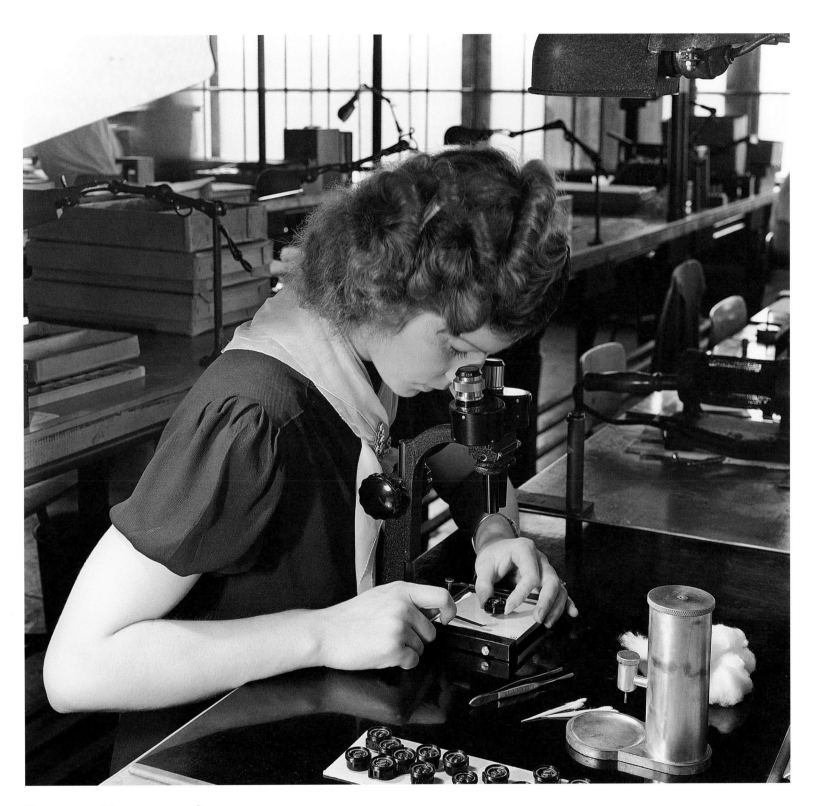

WOMAN AND A MICROSCOPE, 1938

*The belief that women were naturally more
dexterous than men supported the use of
women in particular forms of labor. Here a
woman assembles ortho-technic audiophones
at Western Electric in Kearny, New Jersey,
(1984.187.53807)*

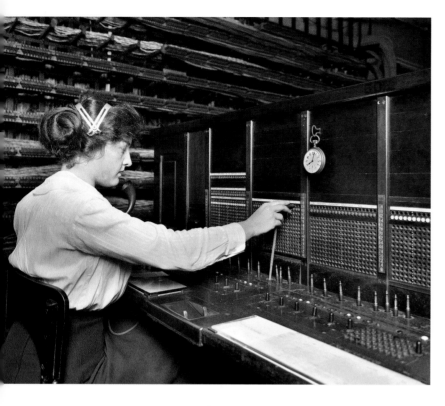

ABOVE:

OPERATOR AT THE SWITCHBOARD, ca. 1912

To sell itself as a service-based company, the tele-phone company promoted an image of women operators as genteel and delicate. (ANN 1984.187.1144)

RIGHT:

MARKETING SCHOOL, 1916

Women were instructed as operators at the newly formed telephone companies, and were specifically instructed not only in using the switchboard, but in appearing "ladylike." (1984.187.4837)

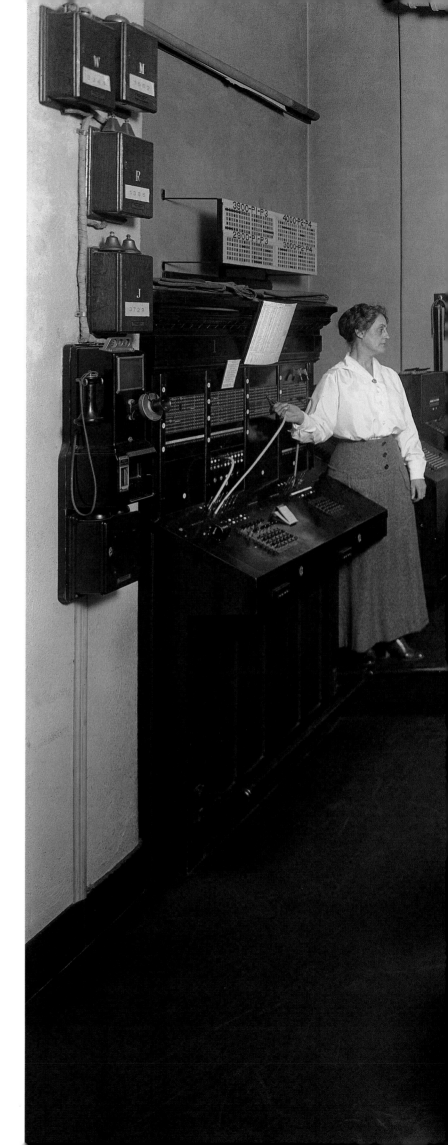

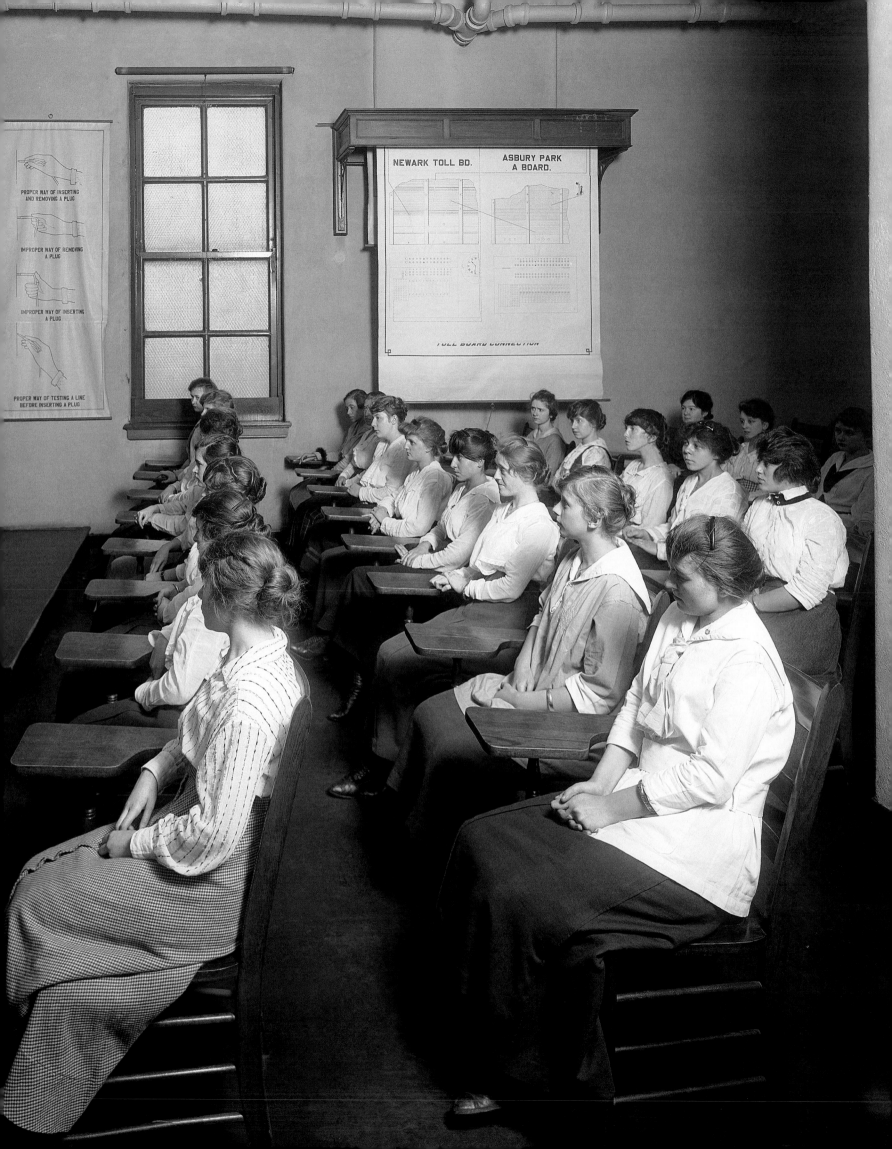

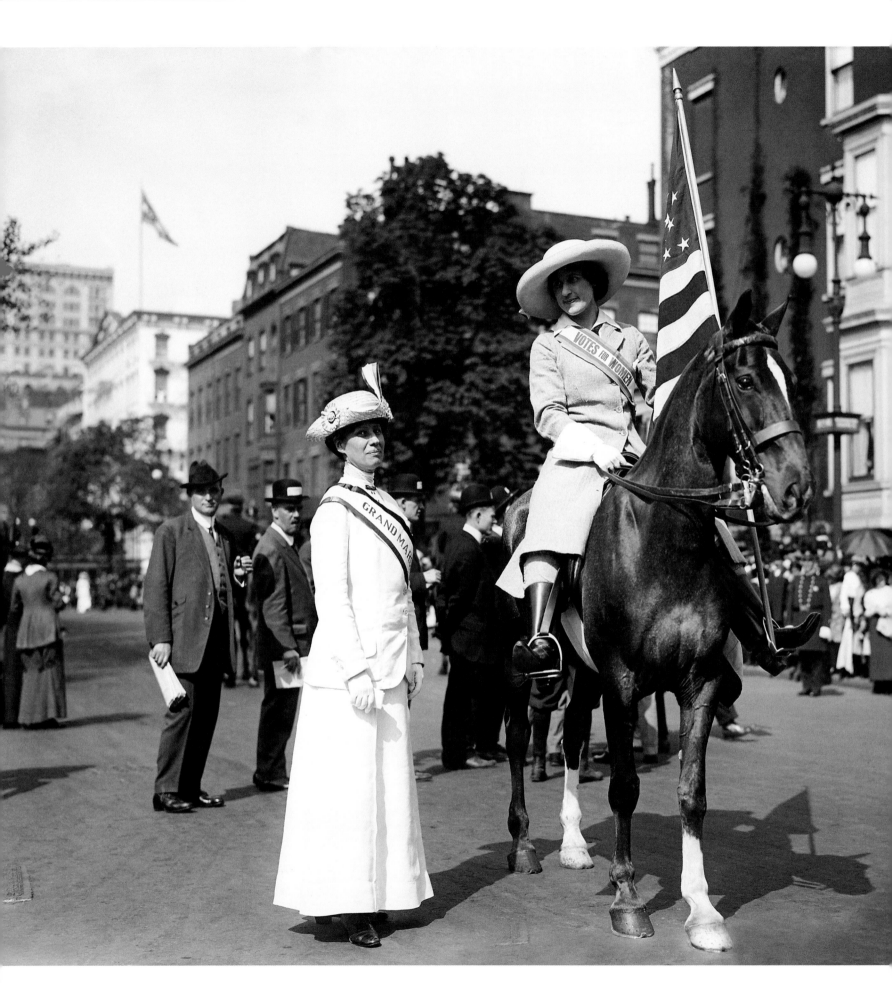

MODERNIZING OFFICE WORK, 1940
The advent of modern office work at the turn of the twentieth century meant that women replaced men as secretaries. This image, common over the course of the twentieth century, was taken at the newly opened headquarters of Elco Cruisers at Port Elco-Miami. Elco (the Electric Launch Company) was founded in 1893 but got its reputation by building motor launches for the British Navy in World War I. During the two World wars, Elco was known for building high quality cabin cruisers.

MISSES GAGE AND MILHOLLAND, 1916
Two women suffragists, one "Miss Gage," and the other, Inez Milholland (Boissevain), wear the characteristic white banners promoting "Votes for Women." Inez Milholland (Boussevain, 1886-1916) attended Vassar College, where she was suspended for organizing a woman's suffrage meeting. Suffering from anemia, she died young (at age 30) after collapsing during a speech in Los Angeles. Miss Gage's identity is unknown, though she could have been a descendant of the nineteenth century feminist, Matilda Joslyn Gage (1826-1898).
(ANN.1984.187.6818)

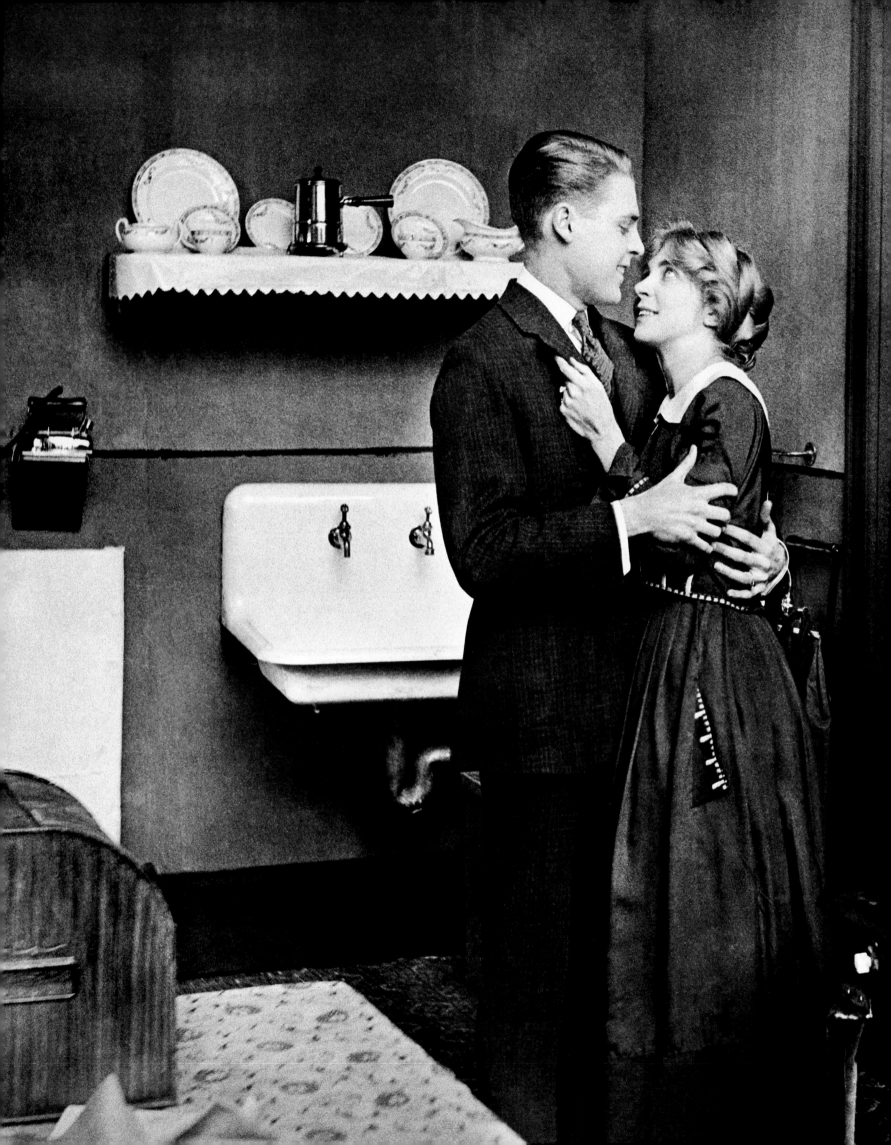

Chapter Three

LIFELINES: WOMEN AND THE WORK OF CARING

"Women's classic part in war is to send her men away with a smile and then wait."

—Henry P. Davison, *The American Red Cross in the Great War*

53

PREVIOUS SPREAD:

PREVIOUS SPREAD:

IN LOVE, 1916

Depicting the social ideal of married love as well as the modern convenience of electric stoves, this image comes from a glass plate negative copied from a moving picture story. (1984.187.1882S)

BELOW:

SEMINOLE NATIVE AMERICANS, 1921

Morris Rosenfeld and his family spent several winters in Miami where he set up a darkroom and continued his work. Included in the Collection are photographs of Seminole Indians, such as this one where women are tending both the baby and the canoe. Other photographs in the Collection, seemingly of Seminoles, were posed by other people, not Indians. (1984.187.504M)

he Progressive Era was an age of social reform. Dating from approximately 1880 through 1920, this was a time with a strong humanitarian ethic, coupled with a belief in progress and reform. Progressives, such as Susan B. Anthony, advocated for the expansion of democracy and the rights of citizenship. Optimism abounded and the public generally believed that change and modernization was afoot. This characterization of the Progressive Era overlooks, however, the harsh conditions in which many people lived at the time. African Americans had been newly freed from slavery and were not included in the vision for expanded democracy. Many immigrant groups lived in crowded slums. It was a time of great changes: great wealth and optimism, a mood of optimism, but also the time of many many problems now

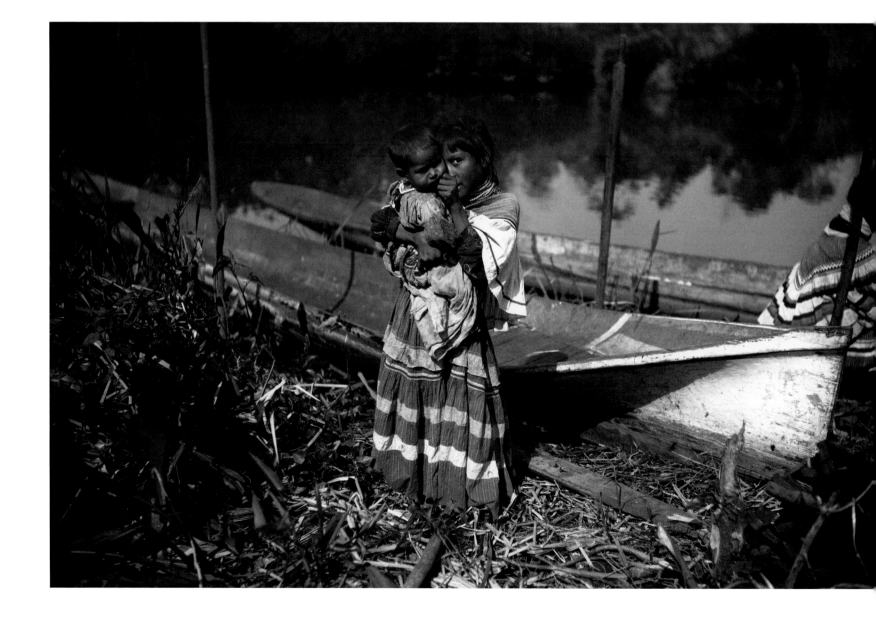

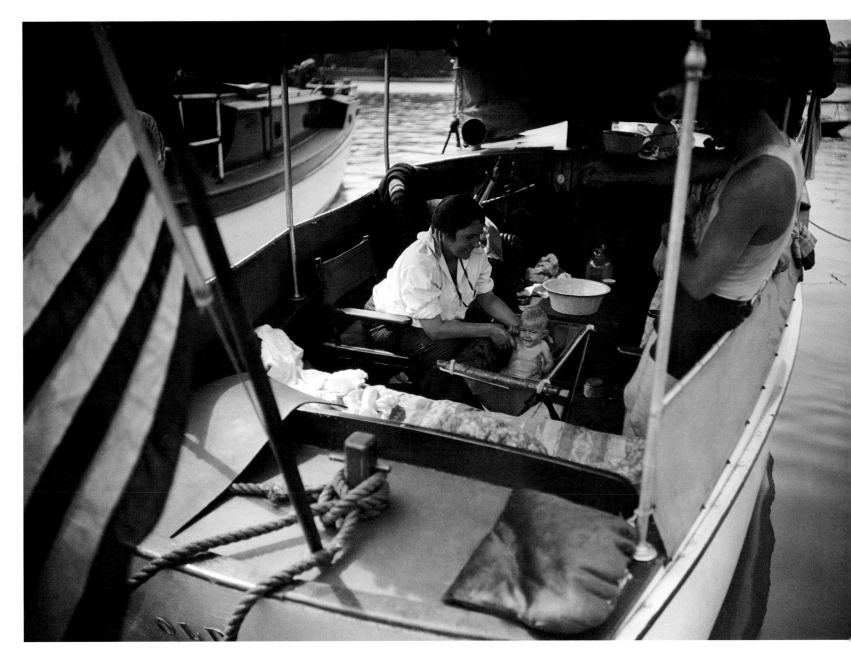

THE BABY BATH, 1921
Even during the Detroit Races at the Detroit Yacht Club, women's care work continues as the baby gets a bath. (1984.187.7056F)

associated with urbanization—poverty, overcrowding, and new health and social needs for those with limited resources.

In some ways, New York City would have been one of the epicenters of such change. New buildings were changing the city's landscape and new immigrant groups were transforming the city's face. As Morris Rosenfeld was establishing his business near the end of the Progressive Era, around him would have been all of the contradictions characteristic of this time: a belief in upward mobility, but also more visible poverty; faith in the evolving logic of science, but remaining vestiges of old, and new racial and ethnic prejudices. The wealthy sported their exquisite yachts, while others struggled to meet basic needs—food, shelter, and health. Morris Rosenfeld must have

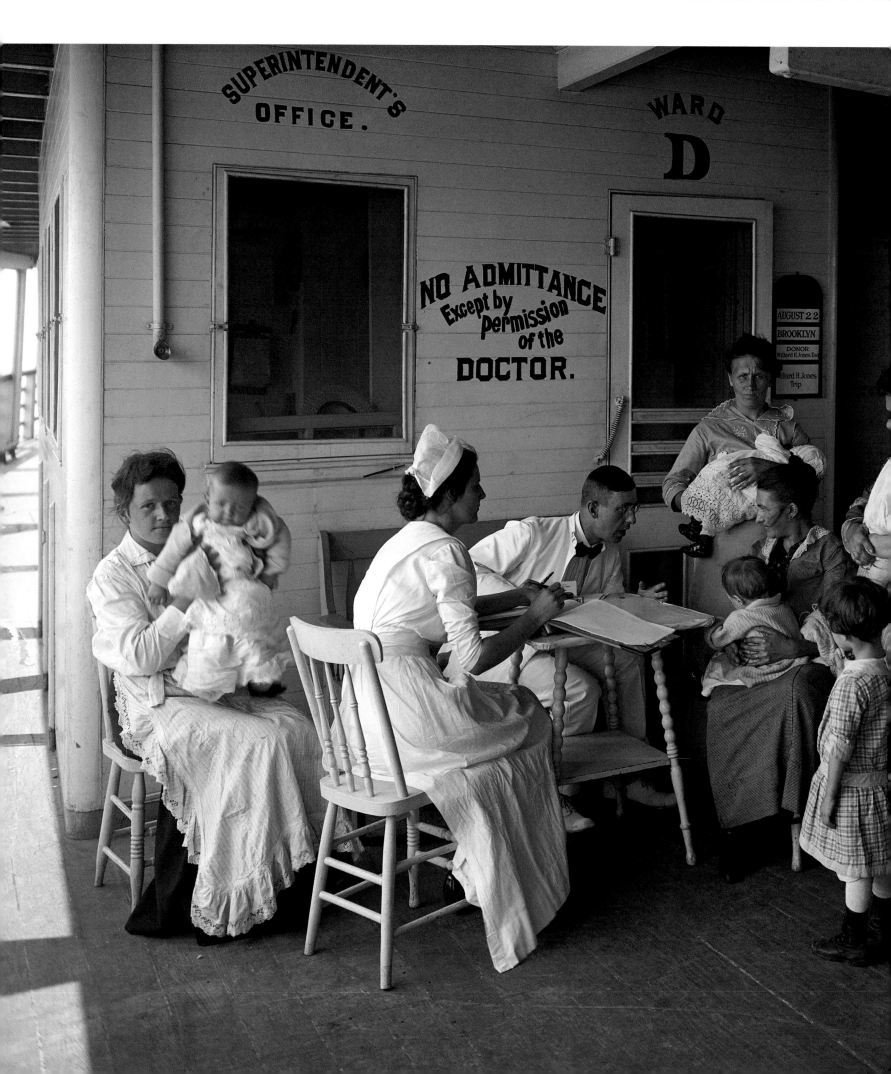

observed these different social realities in his excursions throughout New York City. As a Jewish immigrant himself, Morris sat on the edges of both worlds—photographing the most elegant yachts of the time, but also seeing the work of philanthropy, where most of the workers were women.

During the Progressive Era, among the more prosperous classes there was a belief that society was moving in the direction of expanded opportunity. The growth of scientific enterprise and technological innovation at the time also meant that people put more faith in expertise. New professions were emerging and machinery was quickening the pace of life. Photography was changing too. The development of dry-plate photography, faster shutter speeds, and new films enabled photographers to experiment with new techniques and new visions of their subjects. Some photographers of the early twentieth century, like Dorothea Lang, Jacob Reis, and Walker Evans, used the photographic medium to document social problems. Combining his artistic eye with commercial interests, Morris Rosenfeld had his eye on different subjects in and around New York. Combining his commercial work with an artistic eye that has been compared to the work of Alfred Steiglitz, Margaret Bourke-White, Paul Strand, and others (German 2005), Morris Rosenfeld's work captures much about early twentieth century life. While fascinated with the grace and movement of boats, Morris Rosenfeld documented various forms of life in the city of New York, including the work of progressive organizations.

Based on the belief in social reform, philanthropic and charitable organizations were growing at the turn of the twentieth century, even while the forces of industrialization and modernization that generated wealth for some also spawned new social ills. The turn of the century was marked by the founding of new philanthropic trusts, more charity organizations, and numerous reform associations.

For women, this was a time of growing opportunities. Education for women was growing, and many of the professions now identified

THE *HELEN C. JULLIARD*, 1914
Sponsored by St. John's Guild, the Helen C. Julliard *floating hospital provided health services to New York City's needy. (ANN 1987.184.6729)*

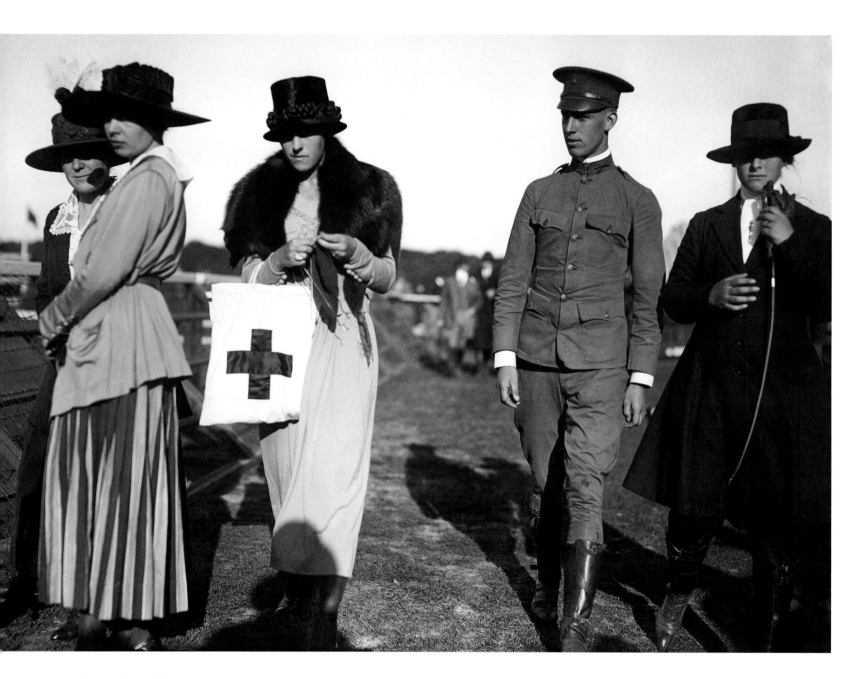

as "women's work" were developing, establishing new professional practices, and requiring more training to professionalize the work. Home economics, for example, was developing with an emphasis on "scientific housewifery." Social work and nursing, too, were becoming new domains for women's careers. Columbia University offered the first course in social work in 1889 and opened the School of Social Work in 1909. This was a time when the new social sciences— sociology, psychology, economics–were establishing their roots in American higher education. Teaching was also emerging as a primary career choice for educated women—a career followed by many of the women in the next generation of the Rosenfeld family.[1]

The characteristics associated with progressive reform were

ABOVE:
HORSE SHOW, 1917
The Red Cross during World War I was visible on many fronts, including at this horse show. (ANN.1984.187.6789)

OPPOSITE:
SEWING FOR THE WAR EFFORT, 1917
Also printed from a glass plate negative, this image depicts a sewing room, probably in a commercial venue where Morris Rosenfeld had a contract. Here women are sewing bandages and banners for World War I. (ANN.1984.187.6763)

harmonious with the definition of women's maternal role. The women's club movement, which originated in the early nineteenth century, extended well into the early twentieth century. By 1920 the General Federation of Women's Clubs had nearly a million members. Women were actively engaged in and leading progressive organizations dedicated to such projects as community outreach; improving the social environment; founding hospitals, schools, and clinics; and, in general, working to serve the poor. Historians have noted, however, that most of the charitable work focused on European immigrants, since many of these organizations had the mission of Americanizing immigrants, consistent with the assimilationist thrust of the time, at least for whites. Black Americans were typically ignored by these charitable organizations, even when organizations promoted racial tolerance.

For women it was a time to express their voices and be more visible in public roles. Important women's organizations were formed,

including the Women's Bureau of the Department of Labor (established in 1920), and existing organizations like the Young Women's Christian Association (YWCA) expanded their role, advocating for various social causes, workers' rights, and child safety.

One of the best known reform efforts was the settlement house movement. The settlement house movement brought middle-class women into the urban slums where they would live and work with poor residents. By 1913, there were over 400 settlement houses in 32 different states, the most famous of which was Hull House in Chicago, founded by Jane Addams. But there was also the Henry Street Settlement in New York City, founded by Lillian Wald in 1895 and still in operation today. Women held prominent positions of leadership in the settlement house movement, with over half of the prominent houses led by women—a rather extraordinary feat for the time (Koerin 2003).

By World War I, women were identified as responsible for the

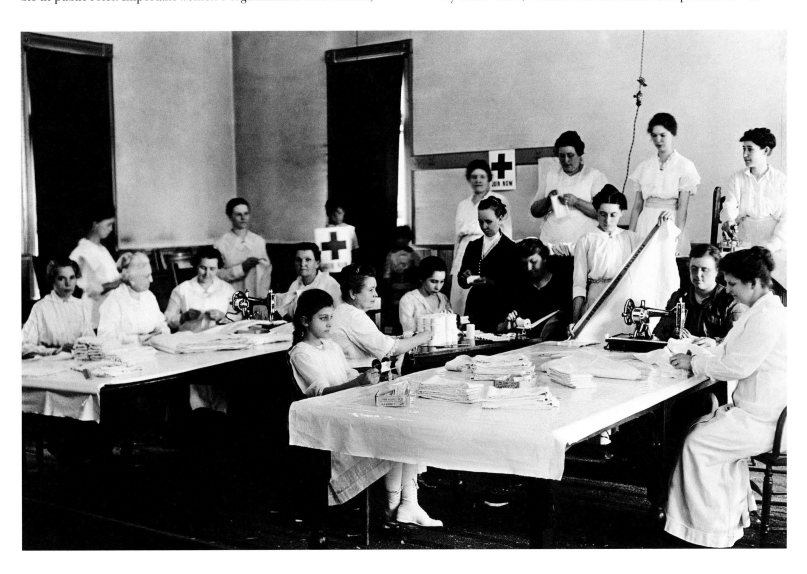

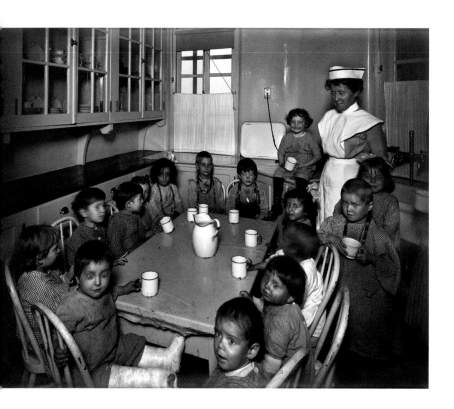

ST. JOHN'S GUILD SEASIDE HOSPITAL, 1920
*The care work of women here provided nutri-
tion for the hungry children at the table.*
(ANN.1984.184.6721)

nation's welfare. Care work, whether in the form of housework, child care, nursing, teaching, or social work dovetailed well with women's perceived nurturing spirit—a spirit women were said to have by nature. While this stereotype of women is, on one hand, quite sexist, many have also pointed out that such a belief made women's role in civic and political life possible (Kessler-Harris 1982).

Evidence of these times is captured in some of the Rosenfeld photographs—not only of women in the home and other nurturing roles—but especially those of the American Red Cross and the New York Floating Hospital. Like other reform organizations of the time, the American Red Cross and the Floating Hospital were established by those who believed that the more fortunate should use their time and resources on behalf of the needy. Benevolence and charity were hallmarks of the age, even though the spirit of these reforms was rarely extended to those most in need—African Americans.

The American Red Cross was founded in 1881 for the purpose of providing humanitarian volunteer aid to the sick and wounded in times of war and international relief in times of famine and disaster. The origins of the American Red Cross can be traced to the Civil War and the relief work that was then taken up by citizen volunteers. First working as a Civil War nurse, Clara Barton—founder of the American Red Cross—campaigned for the establishment of this national organization. She framed her campaign—taken directly to presidents—in the context of the Geneva Treaty, signed in 1864 in the aftermath of the bloody Crimean War. Part of the Geneva Conventions, the articles of the Geneva Treaty for the first time provided a neutral zone during war for ambulances and hospitals. The treaty also established that civilians treating and aiding the wounded would be safe from harm. Thus, the familiar red cross was adopted as a symbol of safety and aid.

When Clara Barton assumed the presidency of the American Red Cross in 1881, she was 60 years old. She served until 1904 (when she was 82), relinquishing control to Mabel T. Boardman. Under Barton's late nineteenth century leadership, the American Red Cross had been informal and with rather loose methods of management and organization. The introduction of scientific management as the prevailing business philosophy of the new twentieth century brought pressure to make the Red Cross a more professional and scientifi-cally-managed organization. The Red Cross had, until this time, been

able to play only a limited role in various recovery efforts. For example, following the devastating Galveston Hurricane of 1900—one of the nation's largest ever natural disasters—the Red Cross had been able to have only a small part in the $2,500,000 relief effort.[2] With the U.S. entry into World War I in 1917, the American National Red Cross grew in stature. In 1911 President Taft proclaimed that the Red Cross was the only volunteer society authorized to render aid in time of war.

St. John's Guild had been established in 1866 by the parishioners of St. John's Chapel on Varick Street in New York City. Its purpose was to aid the city's poor and to alleviate the squalor of their living conditions. In 1864, the Guild chartered a barge to be used to take children on seafaring expeditions, with the thought that giving the poor children fresh air, sunshine, and good food would improve their health—health otherwise compromised by the filthy conditions of their city life. The idea of such a floating hospital was first intended to serve the newsboys of *The New York Times*—who were seen as in desperate need of good health care.

The idea took hold and in 1875, St. John's Guild commissioned the boatbuilders Lawrence and Foulks to build a ship that would accommodate 2,500 sick children and their mothers. Named for its underwriter, Emma Abbott, an internationally acclaimed opera star, the *Emma Abbott* made three weekly trips along New York's harbors. By the summer of 1881, the *Emma Abbott* transported children in need of recuperation to the Seaside Day Nursery in Staten Island. By 1897 the Floating Hospital—as it came to be known—and Seaside Hospital on Staten Island also began treating convalescent adults, as well as children.

Over its twenty-seven year career, the *Emma Abbott* is estimated to have served nearly one million patients. It was replaced in 1902 by a more modern ship, the *Helen C. Julliard*. Although St. John's Guild

disbanded in 1980, the Floating Hospital continued to operate as an independent corporation, although since September 11, 2001, it no longer does so on the ship. Its contemporary programs include a free health clinic, preventative medicine, social services, and entertainment—all provided by volunteers for children, families, and senior citizens. Recently, the Floating Hospital's mission has been expanded to focus on child abuse, substance abuse, AIDS, developmentally disabled children, and poor children in the city schools.[3]

Care work, a term now used to refer to all forms of labor that sustain and nurture human life, remains associated with work done by women. Often not even considered work and among some of the lowest-paid occupations, care work nonetheless continues to be the major way that humanitarian work is done. The early photographs of care work taken by Morris Rosenfeld and Sons reveal how much this work has been associated with the work of women.

[1]Esther Hirsch Rosenfeld, Morris's wife, worked as a homemaker; before she married, she worked in the garment industry. In the next generation, Ruth Landesman Rosenfeld (Stanley's wife) received an M.A. and B.A. from Barnard College and worked as a seventh grade teacher at the Fieldston School in the Bronx. Dorothy Stevenson Day Rosenfeld (William's wife) was a career administrator in the public schools of Port Chester, New York. Adelaide Rodstrom Rosenfeld (David's wife) received a B.A. from Barnard College and taught mathematics at Wadleigh and Walton High Schools in New York City in the 30s. Eleanor Rosenfeld Frapwell, Morris's only daughter, was a full-time homemaker, but worked in the office of Rosenfeld and Sons from time to time. The next generation of Rosenfeld women also includes very accomplished, professional, career-oriented women.

[2]The hurricane resulted in the waters of Galveston Bay rolling over the city of Galveston. Five to six thousand of the city's 38,000 residents were drowned or otherwise killed. This extraordinary disaster has been chronicled in the book, *Isaac's Storm* by Erik Larson (1999).

[3]See the web sites of the Floating Hospital (www.thefloatinghospital.org) and the Museum of the City of New York (www.mcny.org) for more information.

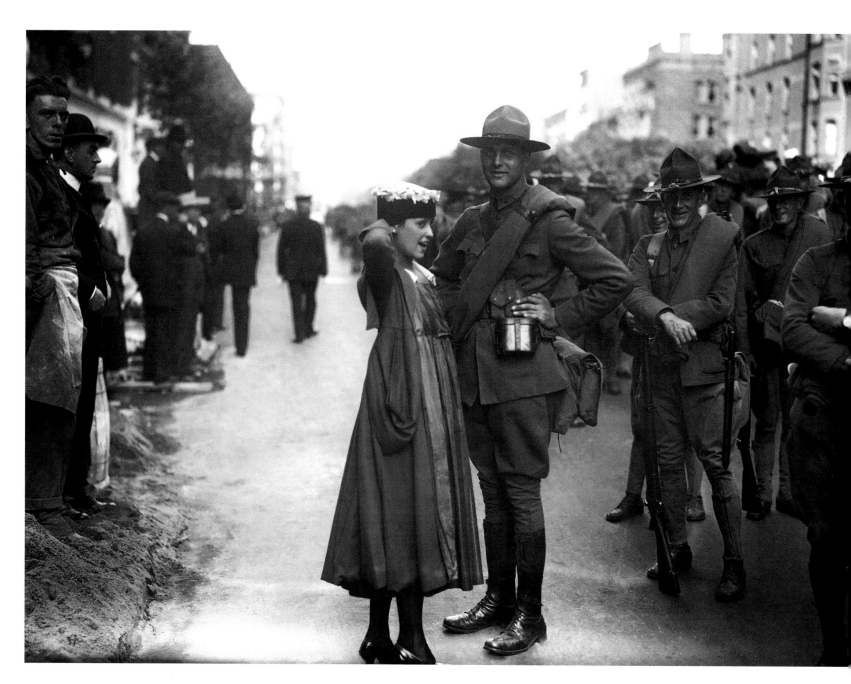

WORLD WAR I SOLDIERS AT EASE, 1917
*A young girl waits with soldiers for the start
of a parade. (1917 ANN 1987.184.6805)*

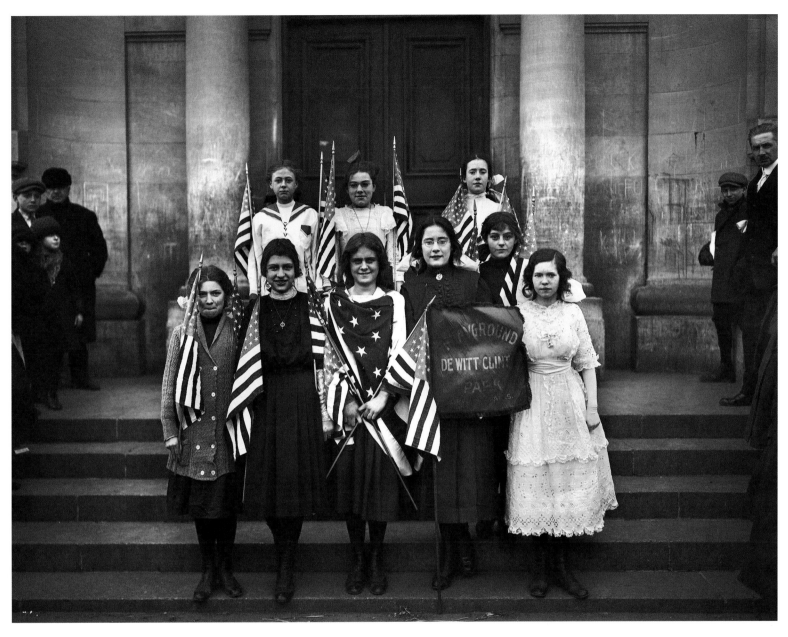

DeWitt Clinton Park School, 1917
In Hell's Kitchen, New York City, young girls show their patriotic support for the war during a school ceremony. (ANN 1987.184.6649)

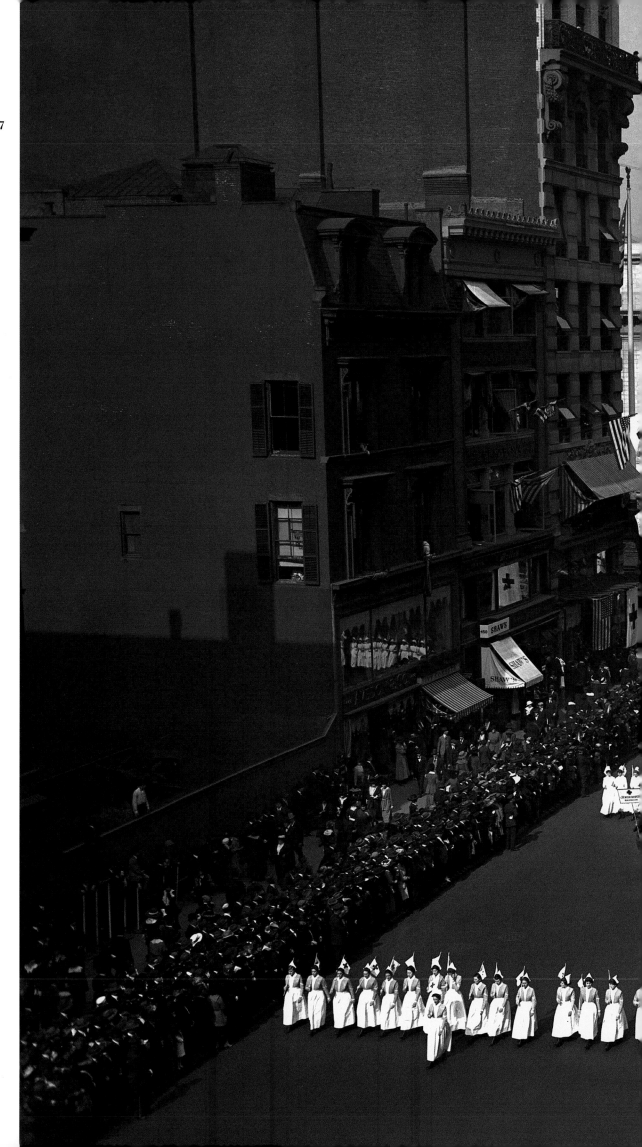

AMERICAN RED CROSS PARADE, 1917
*Broadway in New York City is the scene
for a patriotic parade with American
Red Cross women workers.
(ANN1984.187.6764)*

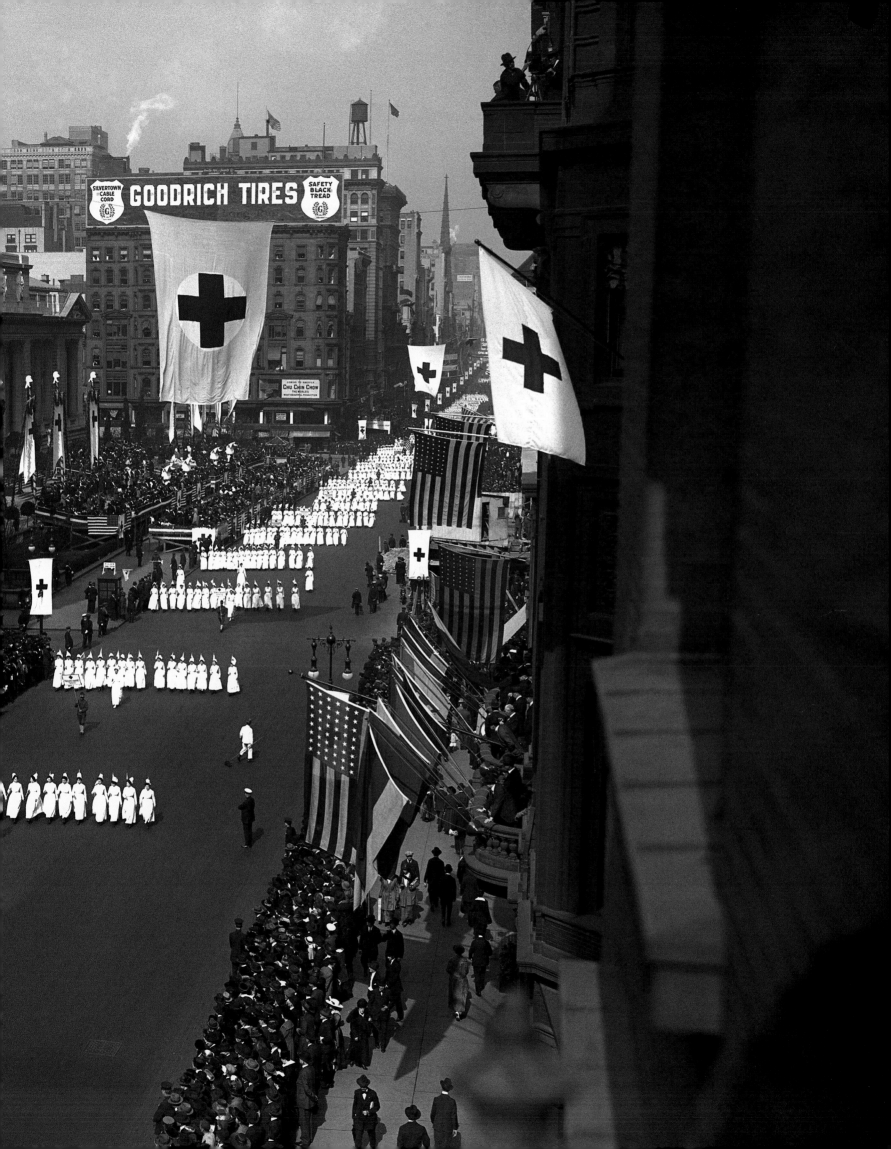

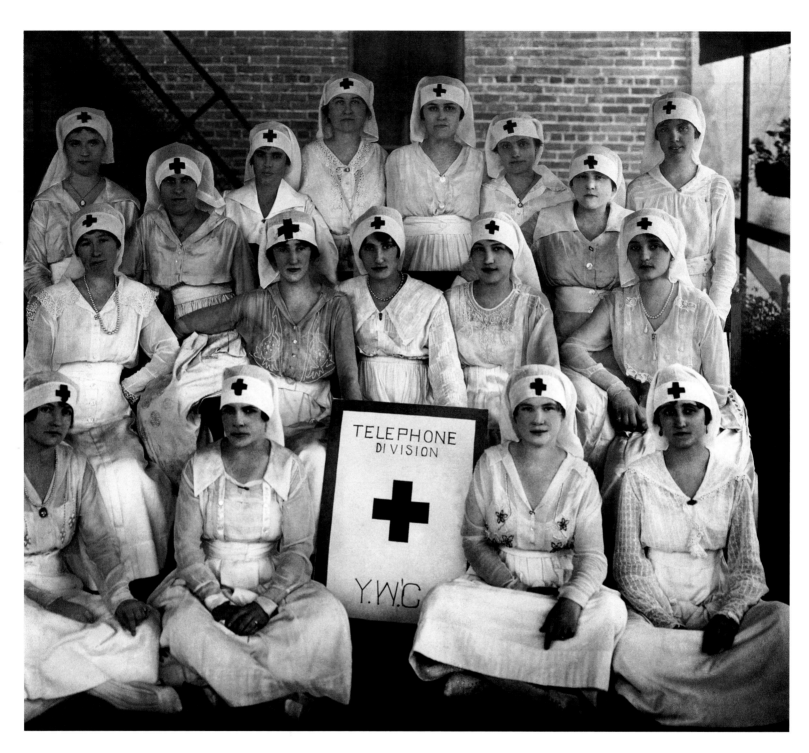

**TELEPHONE OPERATORS FOR THE
RED CROSS, 1921**
*Posed for a formal photograph, these telephone
operators are also Red Cross volunteers.
(1987.184.12716)*

TELEPHONE OPERATORS IN U.S. UNIFORM, 1917
Posing for a formal picture, these women were telephone operators also serving as war volunteers.
(ANN 1984.187.6757)

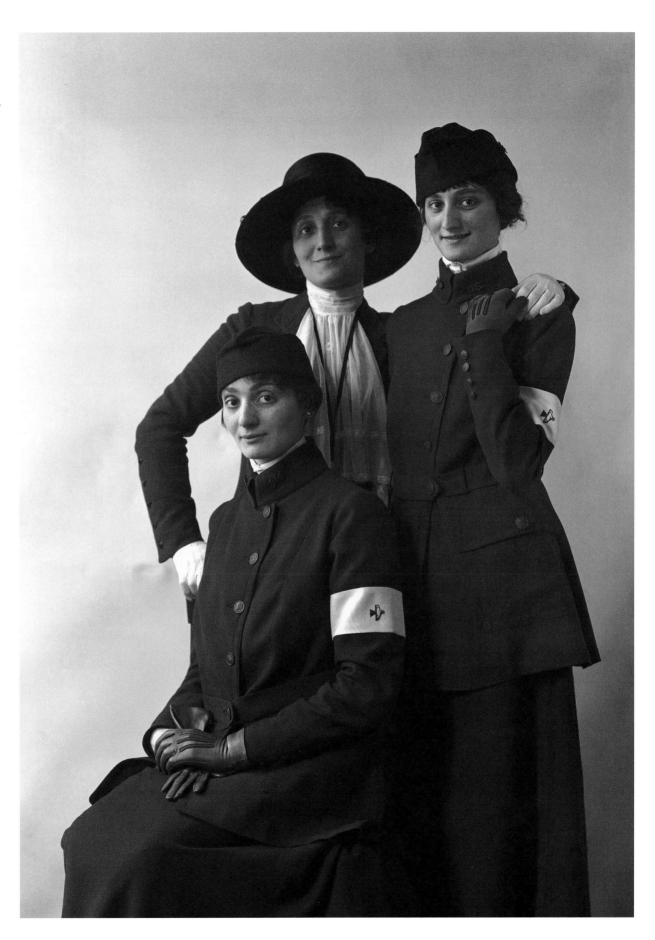

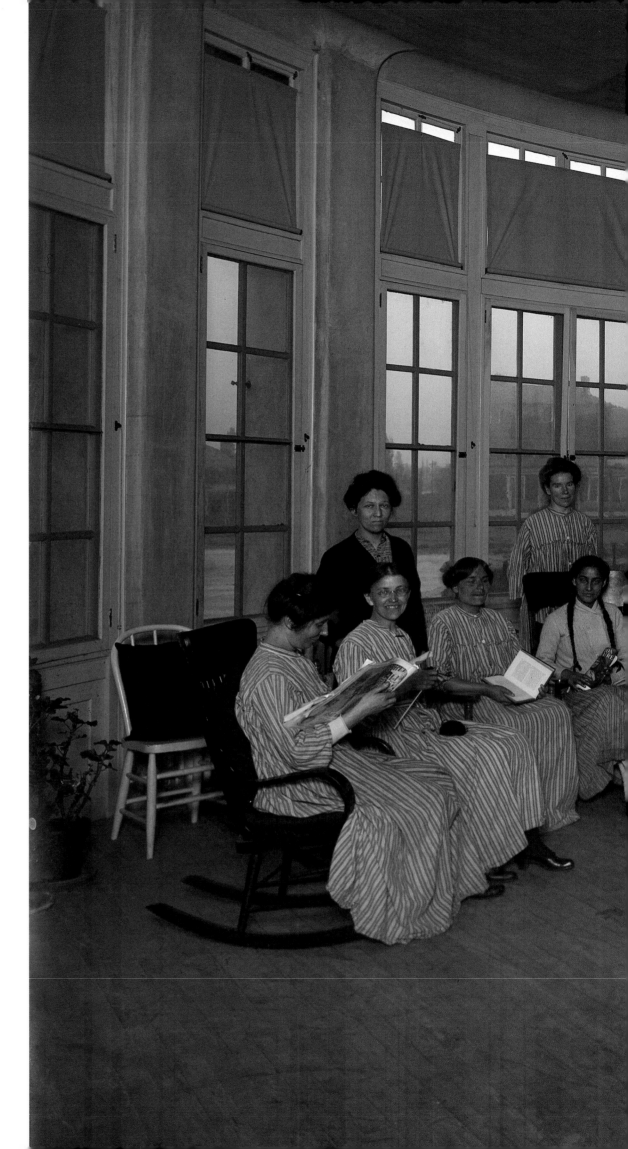

WOMEN AND INFANTS WARD, 1920
Assembled are some of the workers in the
floating hospital. (ANN 1987.184.6714)

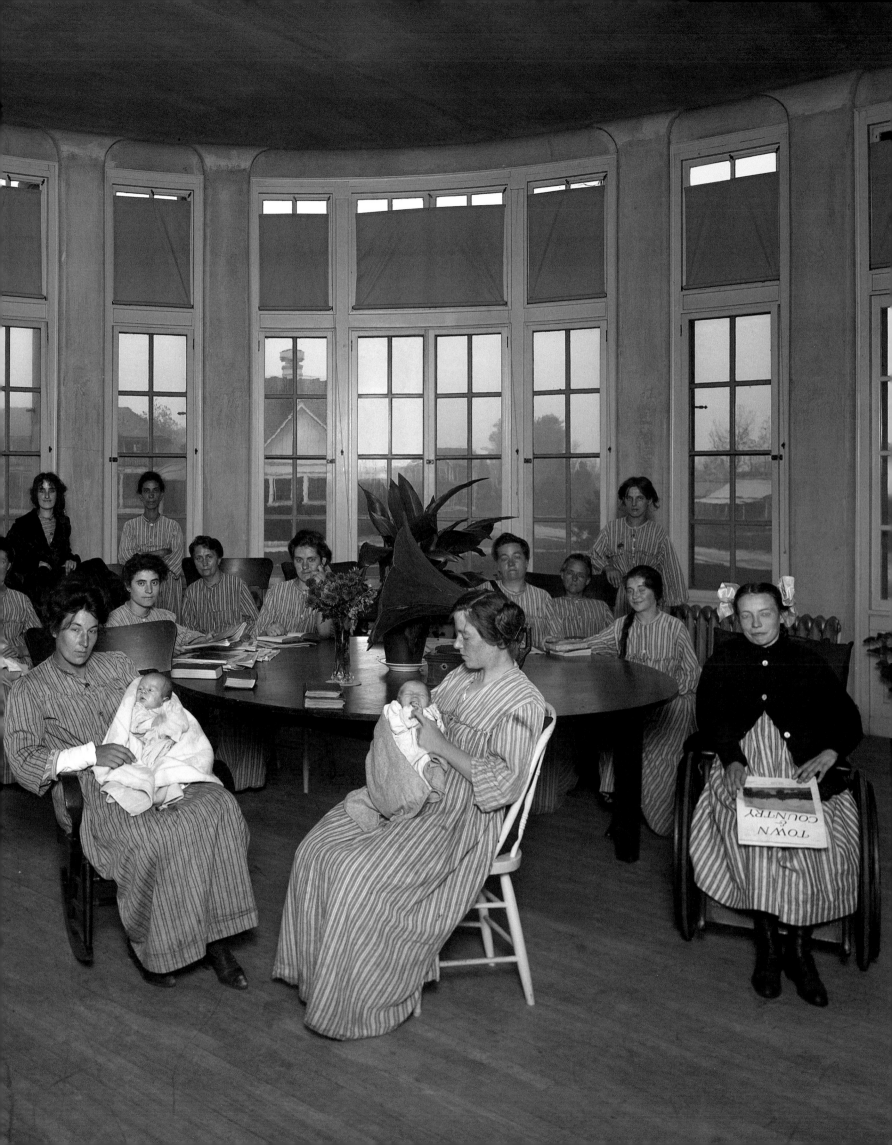

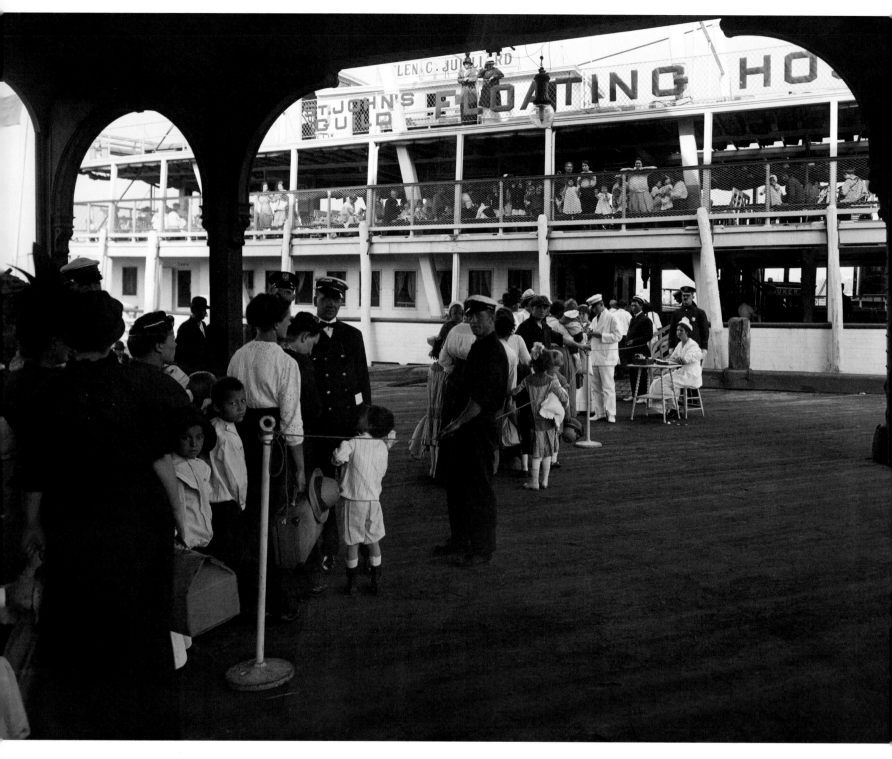

St. John's Guild Floating Hospital, 1914

Docked beside a wooden pier, the floating hospital receives its patients. (ANN 1987.184.6739)

WAITING ROOM: *THE HELEN C. JULLIARD,*
1914
*For many, the floating hospitals of the early
twentieth century were the only form of
available health care.*
(ANN 1987.184.6736)

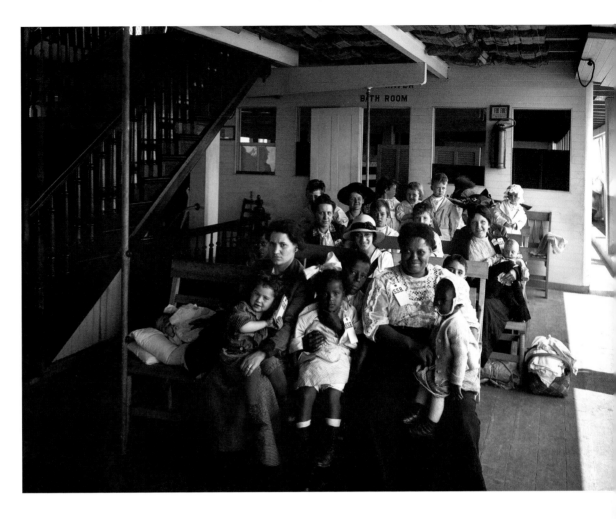

ST. JOHN'S GUILD SEASIDE HOSPITAL:
IN LINE FOR MILK
*It is estimated that the Floating Hospital,
Emma Abbott served nearly one million
patients in its twenty-seven year career.*
(ANN 1987.184.6722)

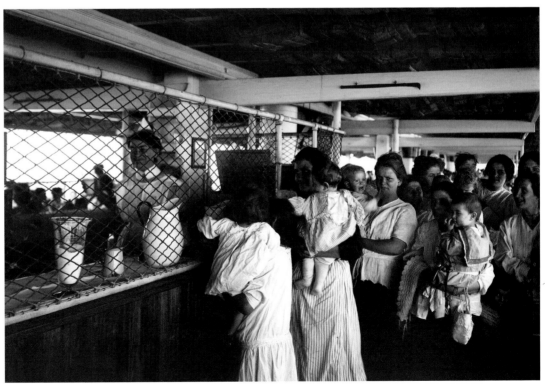

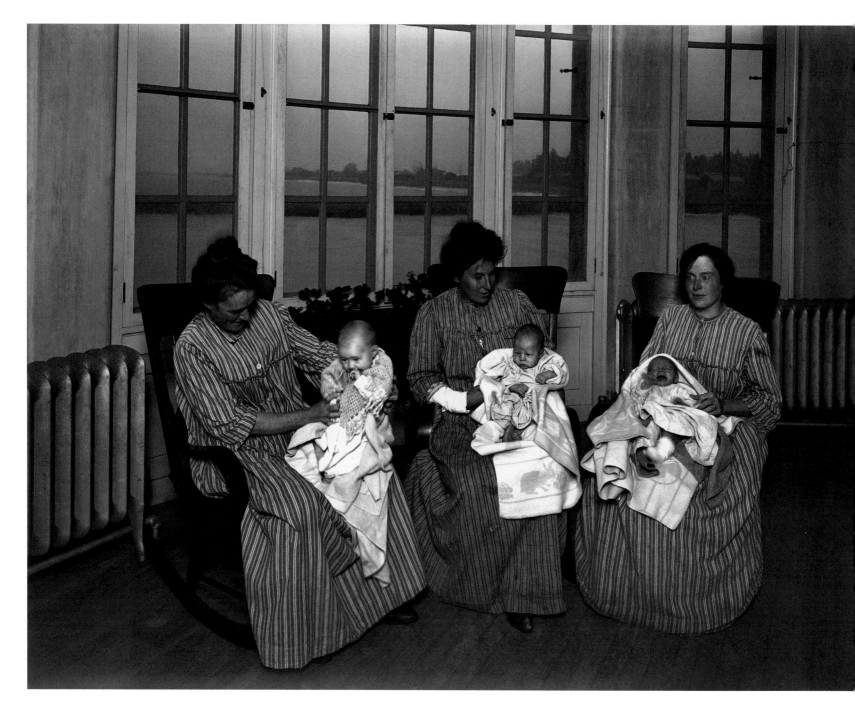

WOMEN WITH BABIES, 1920

These women with babies are working at the St.
John's Seaside Hospital, Staten Island, New York.
(ANN 1987.184.6717)

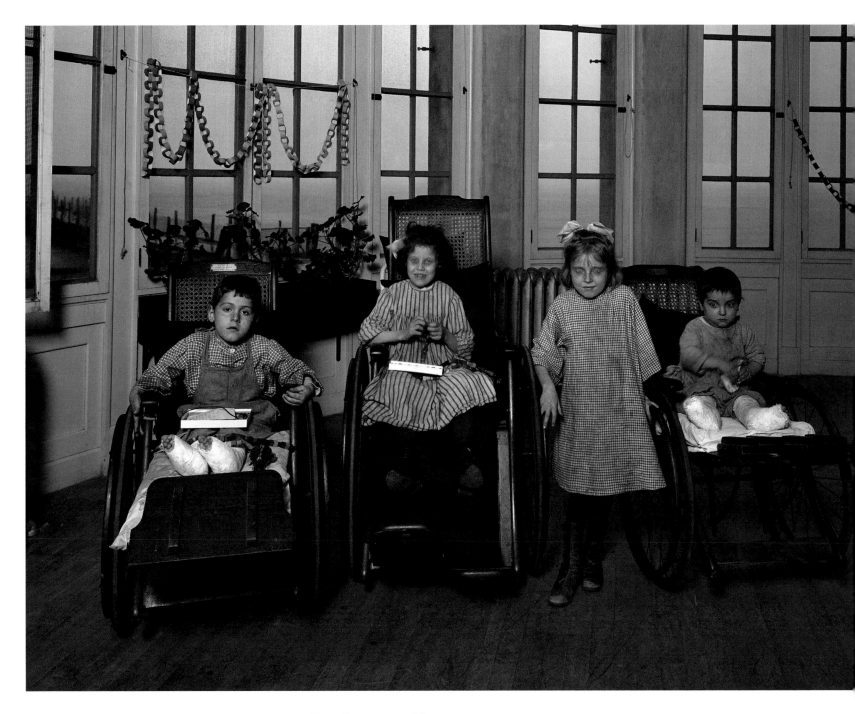

FOUR CHILDREN IN WHEELCHAIRS, 1920

Also served by the St. John's Guild Seaside Hospital, these children are beneficiaries of philanthropic work. (ANN 1987.184.6718)

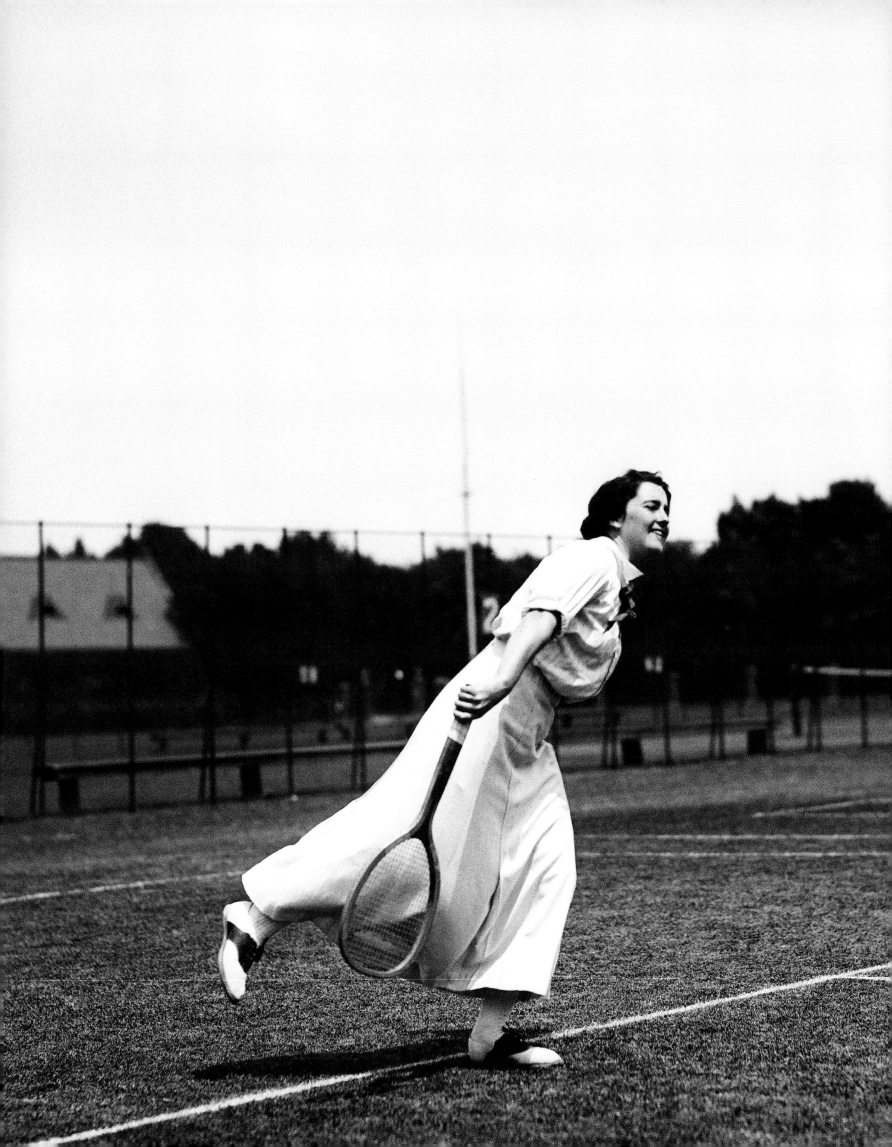

ROSENFELD COLLECTION
MYSTIC SEAPORT.

Chapter Four

SPIRIT, SPORT AND SPECTATORS

"The story of women in sports is a personal
story because nothing is more personal
than a woman's bone, sinew, sweat and desire,
and a political story because nothing is more
powerful than a woman's struggle to be free."

—Mariah Burton Nelson (Stanford basketball star),
quoted in Lissa Smith, *Nike is a Goddess*

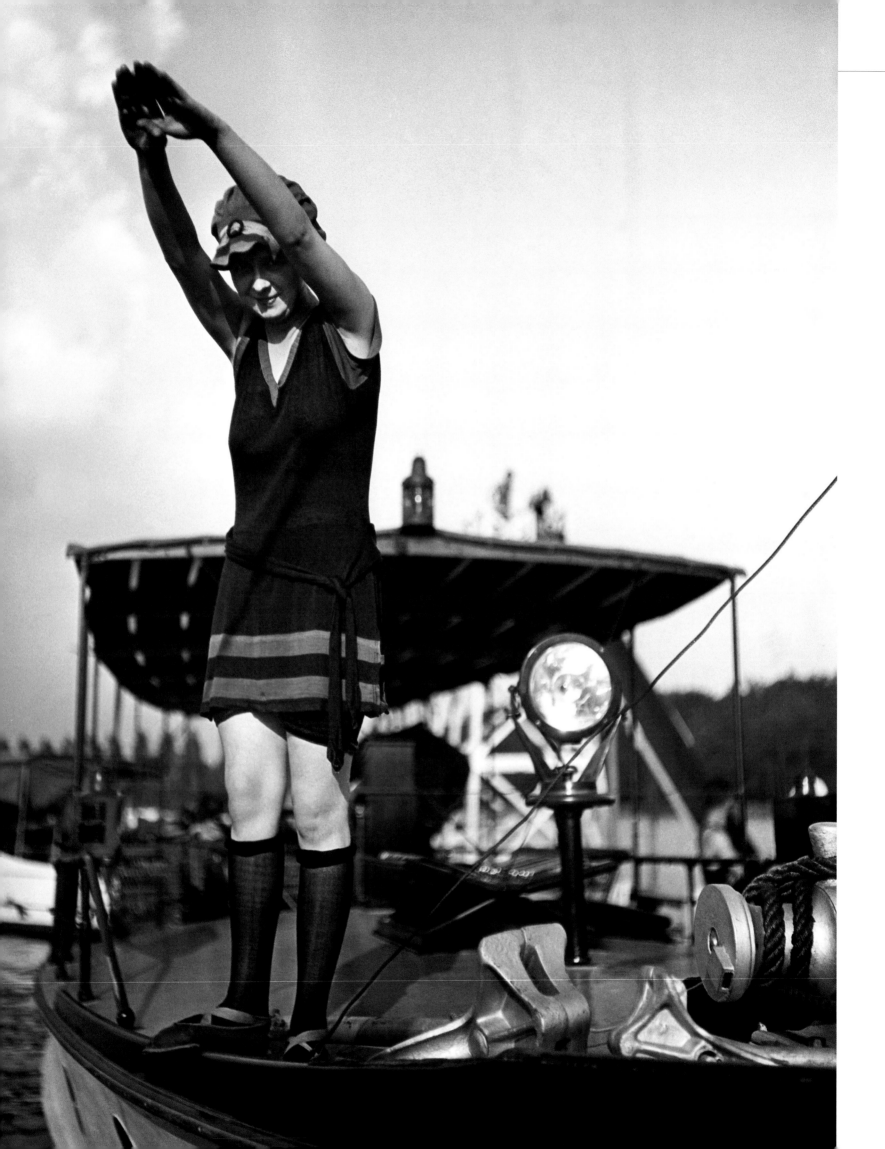

PREVIOUS SPREAD:
**LADIES TENNIS CHAMPION: MARY
BROWNE, 1917**

*In addition to her top status as a tennis
champion, Mary Kendall Browne was also
an amateur golfer. She was inducted into
the International Tennis Hall of Fame in
1957. (ANN 1984.187.6568)*

OPPOSITE: BATHING GIRLS, 1921

*Taken at the Detroit Races in 1921 this
photograph is from a 5x7 nitrate negative.
(1984.187.7128F)*

BELOW: DOG SHOW, 1920

*Mrs. Theron R. Strong poses with her dog
at the Southampton Dog Show in New
York. (1984.187.4417F)*

ast. Action. Speed. Competition. Sweat. Muscle. Motion:
the words associated with sports. Delicate. Passive. Patient.
Calm. Soft. Embracing. Proper: Words that described ideal
womanhood in the nineteenth century, but surely not
words associated with sports and athletics. But by the turn
of the twentieth century, Victorian ideals of true womanhood ebbed
while images of the "new woman"—glamorous, but active—emerged.
As Morris Rosenfeld photographed women at various sporting
events, yacht races, and other social venues, he would have seen
women who were on the cusp between strict Victorian ideals and
ideas about the "modern" woman. Athleticism partially defined the
modern woman, at least within the limits of what was judged as
proper. The photographs he took reflect the spirit of an evolving
new century.

During the early twentieth century, a national sporting culture

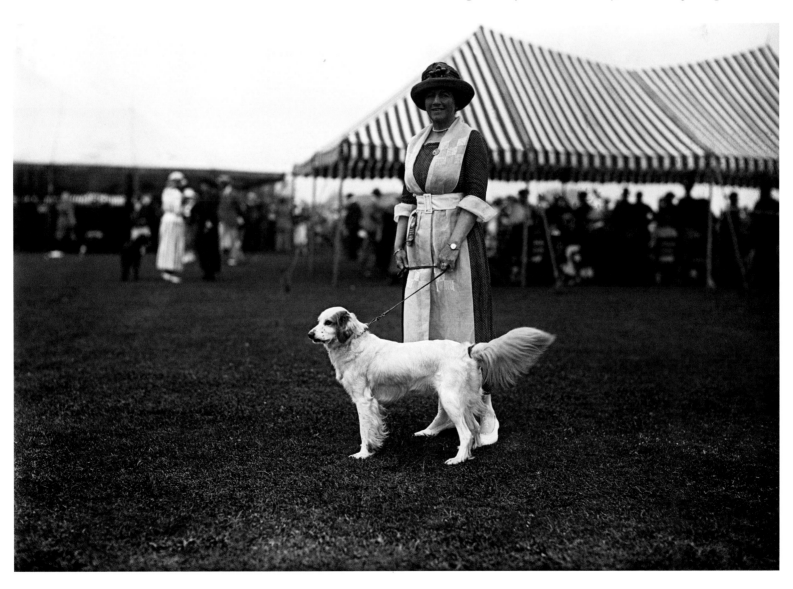

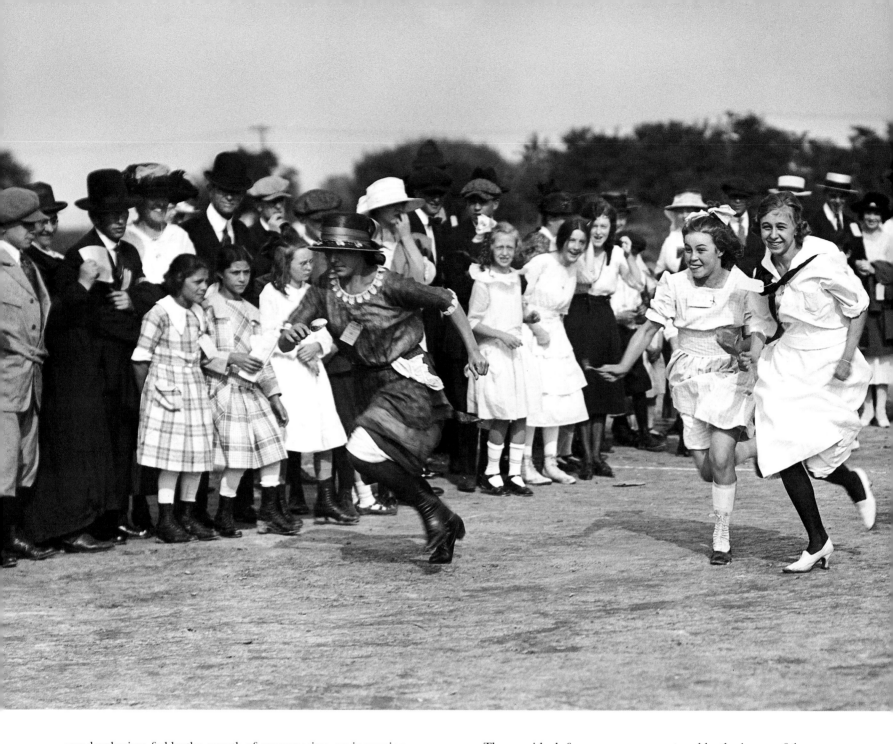

was developing, fed by the growth of consumerism, an increasing distinction between work and leisure time, the growth of national media, and changes in what was perceived as "manly" and "feminine." Women were demanding the right to vote, entering formerly all-male professions, and becoming more educated. To many, the woman athlete represented both the promises and dangers of the new modernism. The promise was in the abandonment of old-fashioned ideas; the danger lay in fears that women would become like men and that women's sexuality would be unleashed—an image best symbolized by the flappers of the Jazz Age in the 20s. Many women were shedding the restrictive clothing of prior generations, even appearing in public in slacks, bloomers, and free-flowing clothing (Cahn 1994).

The new ideals for women were captured by the image of the Gibson Girl, born in the late nineteenth century. Drawn by Charles Dana Gibson, the Gibson Girl, as she came to be called, was widely circulated and enthusiastically received, Gibson's drawings of the Gibson Girl appeared frequently in popular magazines such as *Harper's* and *Collier's*. The Gibson Girl represented a new spirit for the twentieth century. Tall and slim, brave and strong, yet still glamorous and feminine, the Gibson Girl meant that women could be more active than nineteenth century ideals had allowed. She was a sports enthusiast, vigorous and energetic, glowing with a zest for a modern, active life. Frequently portrayed on a bicycle, she also played golf and tennis. The Gibson Girl was valorized for her bravery, skills, strength, and overall good health. Of course, she was also

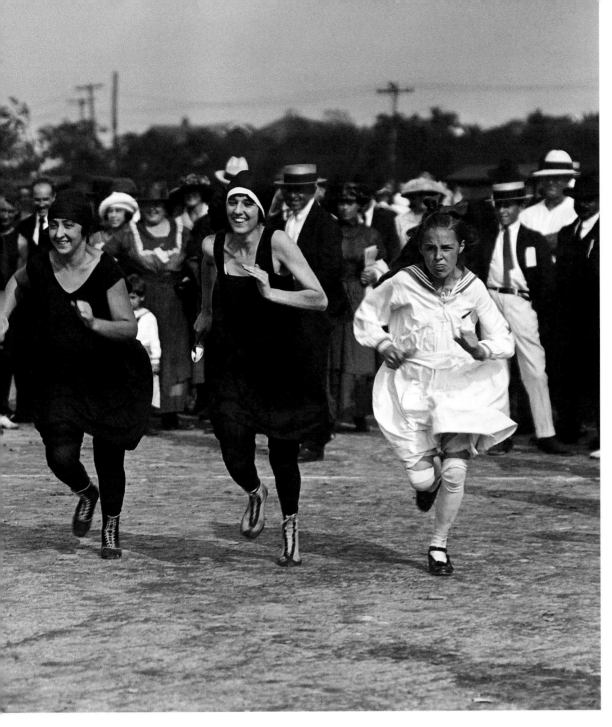

rich, thus she was found in country clubs and resorts, on tennis courts and in croquet matches. Her strength was in her play, in contrast to the strength of working class and black women at the time which was exerted in their work (Guttmann 1991).

As women's roles were changing more generally at the beginning of a new century, women's activities as sportswomen were also evolving. In the preceding Victorian period, middle-class women had been beseeched not to deplete their energy on athletic pursuits. Athletic endeavors—indeed many endeavors—were deemed by experts to be hazardous to women's reproductive organs. Thus, Thomas Emmet, prominent gynecologist in the late nineteenth century, implored young girls "to pass the year before puberty and some two years afterwards free from all exciting influences." Girls' minds,

he said, should be "occupied with a moderate amount of study, with frequent intervals of a few moments each, passed when possible in the recumbent position, until her system became accustomed to the new order of life" (Emmet 1879; cited in Rosenberg 1982). Likewise, when the bicycle craze of the late 1880s and 1890s erupted, Miss T.R. Coombs asked, "How can we admire a girl, however beautiful she may be, whose face is as red as a lobster, and streaming with perspiration, whose hair is hanging in a mop about her ears, whose hairpins are strewn along the race-course, and whose general appearance is dusty, untidy, and unwomanly?" (cited in Guttman 1991)

But now, at the dawn of a new era, women were bursting forth, representing everything that was believed to be progressive and new. Elite women played in summer resorts and country clubs where

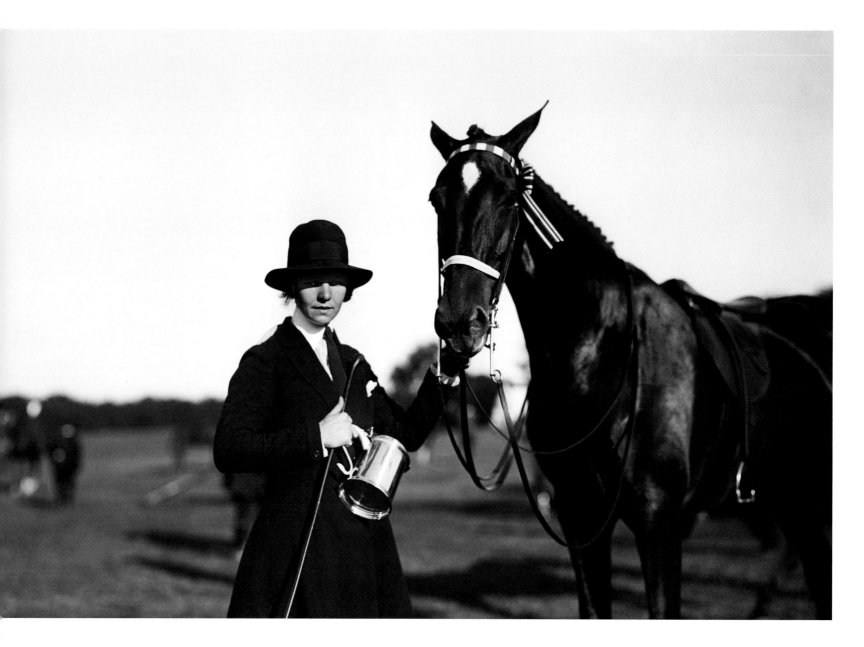

HORSE SHOW, 1917

A young woman (winner of a silver cup) and her horse. The photo was produced from a 5x7 glass plate photographed at Piping Rock, Long Island Sound, New York. (ANN. 1984.187.6860)

croquet and tennis were popular. The tennis courts of resorts like those in Newport, Rhode Island became places where new icons representing women's beauty were created. Ava Willing Astor, daughter of Caroline Astor, actually appeared in the Newport Casino in bloomers, astonishing and scandalizing her mother—an arbiter of refined taste and style.

Books published on sports at the time included lavish photographs of wealthy, well-dressed women playing golf and tennis. Of course, some of the most popular sports—golf, croquet, and tennis—required costly lessons, equipment, and lots of land. Sports for the leisure class were to be refined and graceful, in sharp contrast to the perceived vulgarity of working class activities, believed by the rich to be raucous and rowdy. For the leisure class, some of the appeal of

sports was in their exclusivity, but sports were also a way that elites solidified their social ties.

The growing popularity of sports among all social classes also defined the "new man." As capitalism grew and middle-class and elite men were less likely to do manual labor, how could such men still show their virility? The answer lay in athletics. The new man was to be fit, competitive, and vigorous, an ideal perhaps best embodied by Teddy Roosevelt. Indeed, sports fused with masculinity. But if sports defined the man, what were women athletes? Would athletic competition emasculate women? This dilemma was resolved by asserting women's right to participate in sports, but only in moderation and with the belief that there were still inherent differences between women and men, mainly based on women's presumed biological imperative to be mothers.

On the brink of modernism, change was coming, but women were not completely unfettered. Women were not admitted to the athletic clubs that had become common for middle-class men, so they formed their own athletic clubs. In various ways, women persisted in their quest for sports. Charlotte Perkins Gilman, noted feminist of the early twentieth century, argued that developing a fine physique was important for women. She was proud of her own athletic ability and encouraged her teen daughter to play basketball, a rarity since it is a contact sport. Popular as sports were becoming for women, contact sports were generally discouraged.

Well into the twentieth century, there was considerable controversy over the advisability of women's sports. Women's colleges, established in the post-Civil War period, required calisthenics of women. Although athletic competition was part of the curriculum, only intramural, not intercollegiate, competition was practiced. The first intercollegiate game between women's teams—a basketball game—was played in 1896 between Stanford and the University of California, Berkeley, but men were barred as spectators!

As physical education for women grew in the colleges, women physical educators promoted athletic activity for the same reasons they promoted academic study for women: to achieve educated motherhood. Women were not to be overly competitive or serious about athletic achievement. Rather, women's sports remained nestled in the popular doctrine of separate spheres whereby women's place was defined as in the private world of the home,

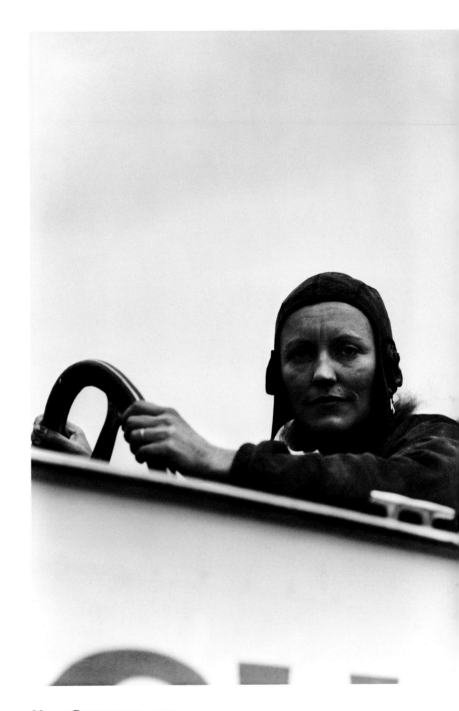

MAUDE RUTHERFORD, 1937
Famed as a speedboat racer, Maude Rutherford is seen here in the cockpit of her racer Miss Palm Beach *at the President's Cup Race in Washington, D.C. in 1937. (1984.187. 84334F)*

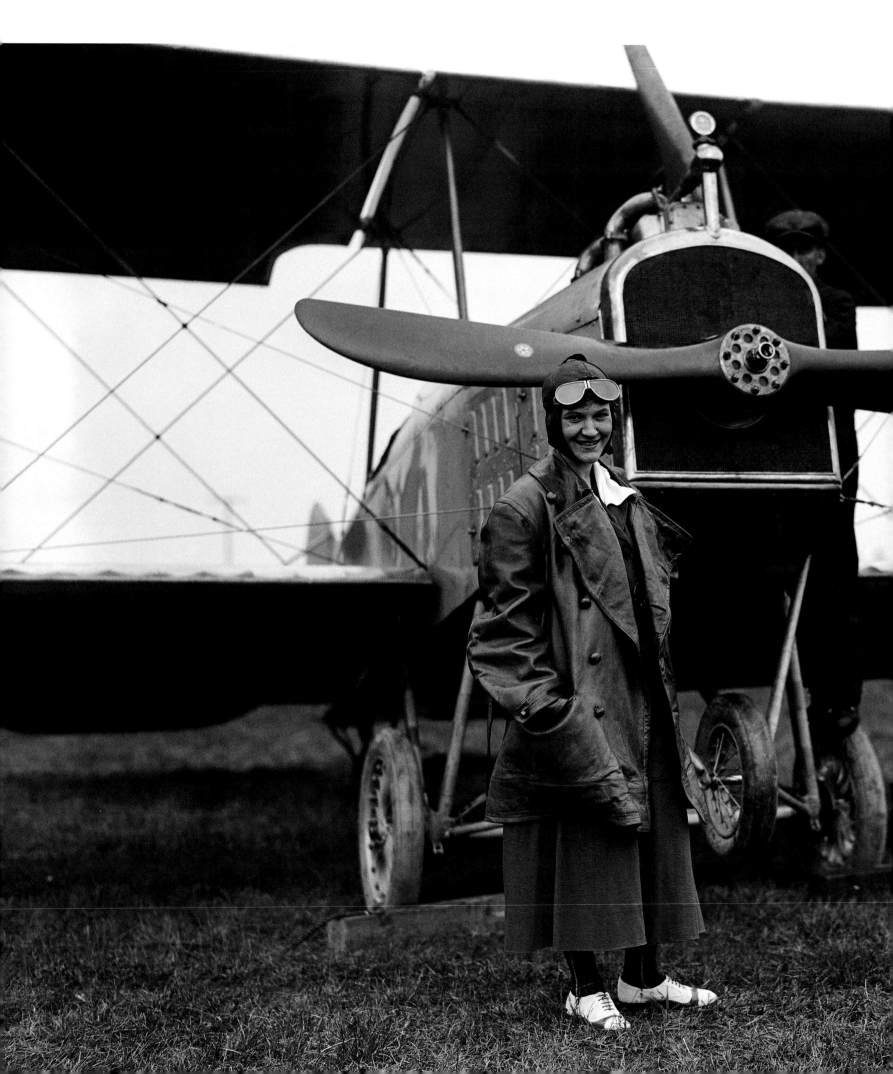

men's in the public world of work. College-level courses in domestic science and home economics flourished. Although women were expected to be fit, their fitness was seen as part of the refined culture they were expected to uphold. As one historian of women's sports has commented about sports in the women's colleges, "Fun and games were followed by tea and cookies" (Guttman 1991).

The same arguments that were used to exclude women from education were used to exclude women from sports. Like the feminist movement, the movement for women's sports had its advocates and detractors, but by the late 1920s, even many advocates for women's sports had firmly adopted the separate spheres doctrine. Some saw the inclusion of women in sports as necessary for the United States to be comparable to other nations. Thus, sports for women was also linked to national pride. But, the backlash in the 1920s was strong. Even the Women's Committee of the American Physical Education Association argued against excessive competition because of the "lamentable failure to safeguard the physical and even moral well-bring of the girls of the country on their athletic contests" (Guttman 1991). Critics worried that female modesty was offended by the "abbreviated costumes" of athletic contests, and some thought that girls would lose their composure during the intensity of sports. Thus, even if women were educated, they were also to be demure. Writing in a magazine for educators, Frederick Rogers said, "Intense forms of physical and psychic conflicts…tend to destroy girls' physical and psychic charm and adaptability for motherhood (Rogers 1919; cited in Guttman 1991). By the 1920s and 30s, the pendulum had swung back to restricting women's collegiate competition solely to intramural sports.

Of course, most girls at the time did not attend college. For them recreational activities were in the dance halls, agricultural fields, or simply the physical exertion of motherhood. Some industrial leagues sponsored bowling and softball for women, as was the common practice of men's teams being sponsored by companies, not the privately-owned sports teams now common. Thus, the *Philadelphia Tribune* organized the first basketball team for black women in the 1930s, a

AVIATRESS AND BIPLANE, 1917
This is an image of a biplane, powered by a Dusenberg engine. This photograph is from a glass plate negative. (1984.187.1030F)

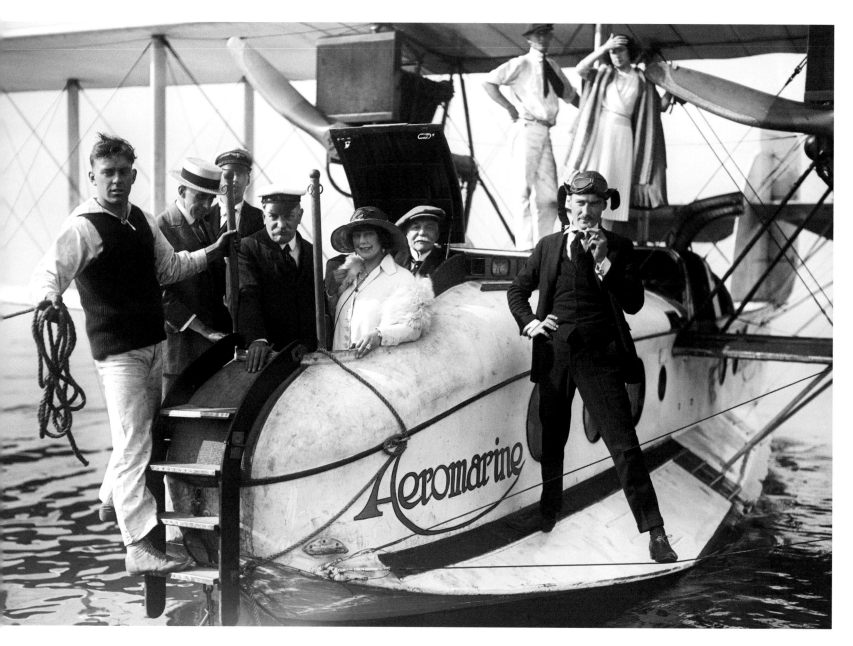

THE *HIGHBALL EXPRESS*, 1920

Designed by Inglis Uppercu, the Aeromarine seaplane ran between New York City and Key West in the winters of the early 1920s. It became known as the Highball Express *because it transported wealthy passengers to Cuba during Prohibition. It is shown here after the end of the International Cup Race in Keyport, New Jersey on July 29, 1920. (1984.187. 4263FA)*

OPPOSITE: MISS MARY BROWNE, 1917

Mary Kendall Browne (1891-1971) was a tennis champion, who won the U.S. Open three times and was ranked as the number one lawn tennis player in the United States in 1913 and 1914. (ANN. 1984.187.6827)

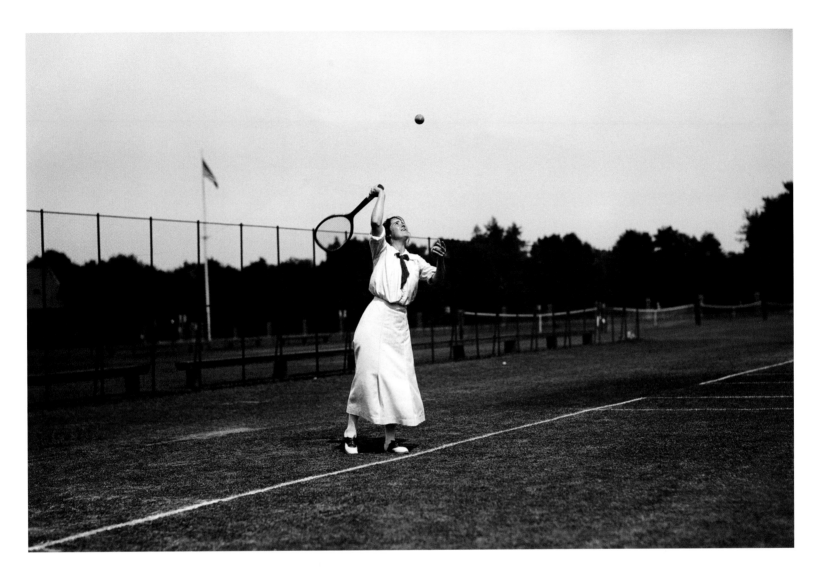

team that included Ora Washington, star of the all-black Tennis Association and winner of seven consecutive singles titles from 1929 to 1935.

The Rosenfeld photos capture some of the spirit of this fascinating period in women's sports. Shown here is Mary K. Browne, three-time lawn tennis champion and fervent competitor. Browne wrote advice to her followers, instructing them on the connection between fashion and physical fitness. Noting that the fashion of the period was straight lines, loose-fitting garments, slim figures, and "boyish" designs, she advocated exercise to achieve this look. She wrote, "The slim girl is twice the girl her grandmother was, and half the weight. Keeping fit to-day is more than a necessity to athletic prowess; it is a duty all who seek success in anything must observe" (M. K. Browne 1926; cited in Cahn 1994). One of Browne's competitors was Suzanne Lenglen, described as only second to Helen Wills as a darling of the American public. Lenglen, too, advised the public on

the importance of exercise and fitness, linking it to the fashion statements she was known for. Lenglen wore her patented bandeau—a silk cloth woven into a head wrap—and silk skirts and gowns that revealed her figure in the sunlight. She wrote numerous articles on tennis techniques and training methods, but also instructed the public on fashion and makeup (Cahn 1994).

On land, on sea, and even in the air, women have played in all kinds of sports. Whether as champions, as spectators, or just for fun, women have enjoyed the thrill of athletic competition. Even at a time when women's roles were more restricted than in today's world, women have lobbed balls, raced speed boats, flown planes, and dashed for the finish line. These photographs capture some of the history of women's activity as sportswomen, spectators, and simply having spirited fun. They also show how earlier generations of women played on their own terms, founding a new age that laid the path for women who now benefit from these early pioneers.

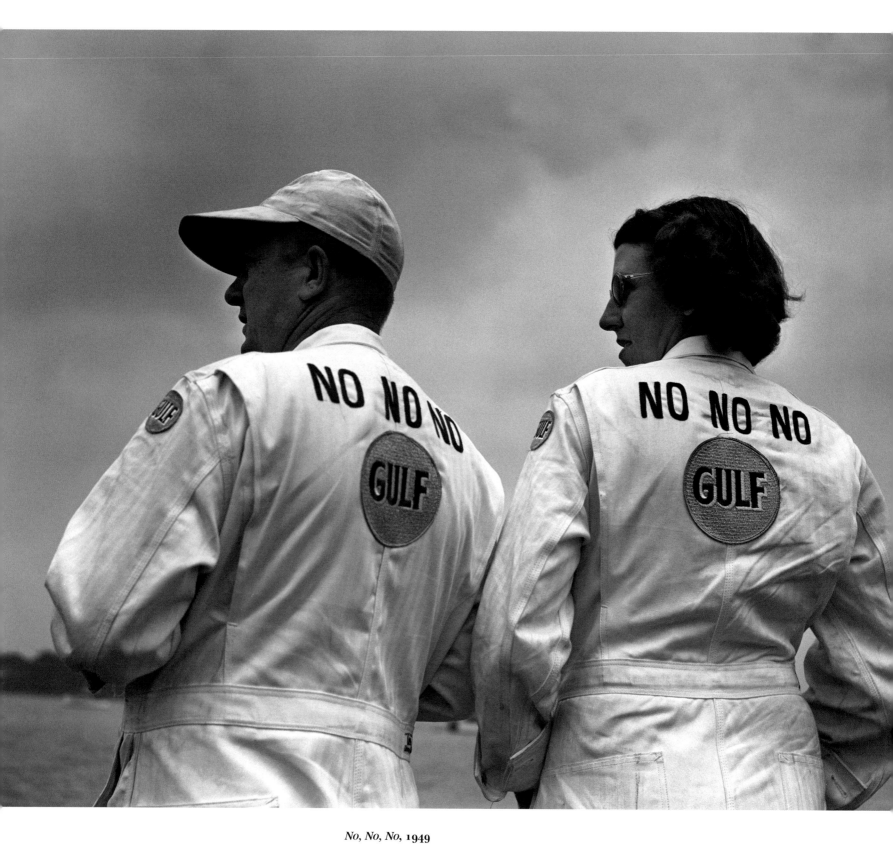

No, No, No, 1949
At the Red Bank Regatta on August 13, 1949
a woman and man display the name of the
sponsor for the speedboat, No, No, No, on
their coveralls. (1984.187.124626F)

EVELYN BARTELL AND MECHANIC, 1938
*Evelyn Bartell is shown following the Albany
to New York City Race on May 15, 1938. She
placed third in the inboard runabout class of
speedboats. (1984.187.87128F)*

TULIPS AT THE FLOWER SHOW, 1954
Commissioned by Oristano Associates, this image was taken at the New York Flower Show. (1984.187.140128F)

FLOWER SHOW, 1953
Taken at the New York Flower Show on March 8, 1953, these two models encourage appreciation of the landscaped stone garden walk. (1984.187.135242F)

Mrs. Sutphen Fishing, 1936

*Seated on the transom of a cruiser, Mrs.
Preston L. Sutphen is silhouetted looking
into the late evening sun. Her husband
was the Vice President and General
Manager of the Electric Boat Company
(Elco) from 1944-1949 and he was a
builder of PT boats, famed during World
War II. (1984.187.77385F)*

Margaret Gavin, 1917

*Margaret Gavin was the Women's Eastern
Amateur Champion golfer in 1916. Born in
England, she is shown here at the Englewood
Golf Club in Englewood, New Jersey.
(ANN. 1984.187.5714)*

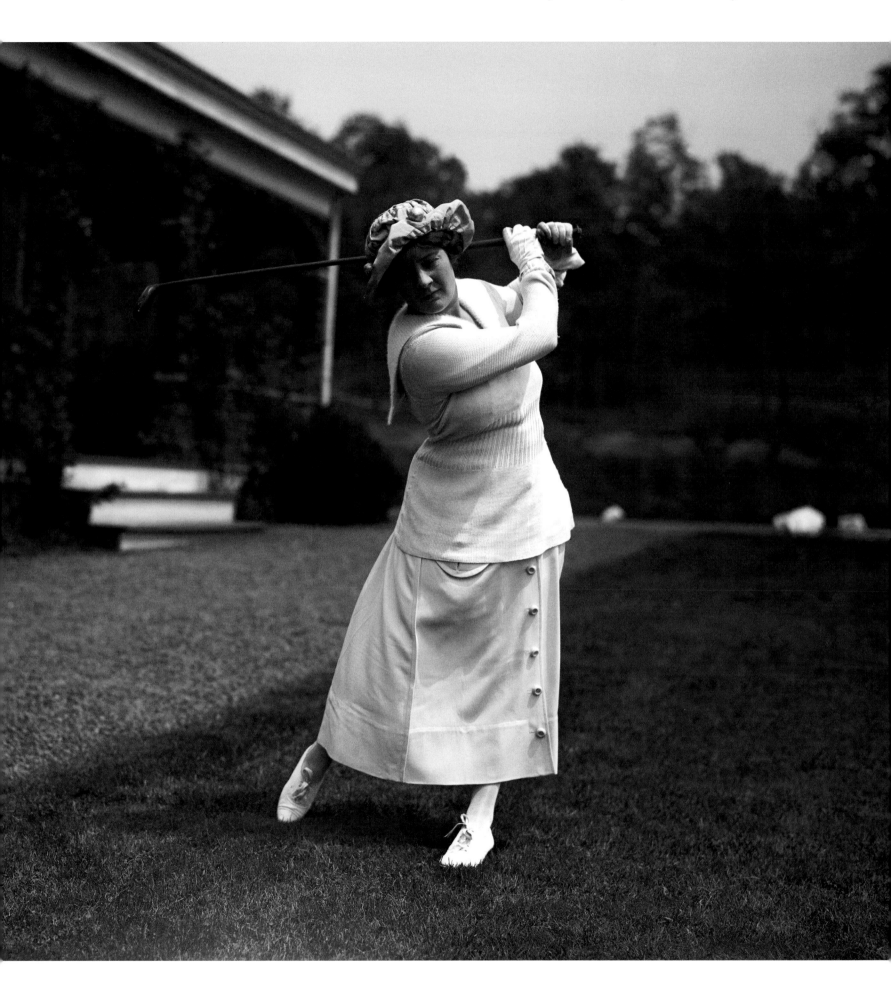

LADIES DAY AT THE YACHT CLUB, 1911
*Taken at Larchmont Yacht Club using a
glass plate negative, the photo shows women
in their finery. Numerous vessels are shown,
including* Kestrel, *a 107-foot screw steamer.
(1984.187.506-S)*

93

94

AMERICAN SHIPPER, 1926
Morris Rosenfeld and Sons shot many photo-
graphs of yacht interiors. Shown here are five
women on the steamer American Shipper
on March 11, 1926. (1984.187.24712)

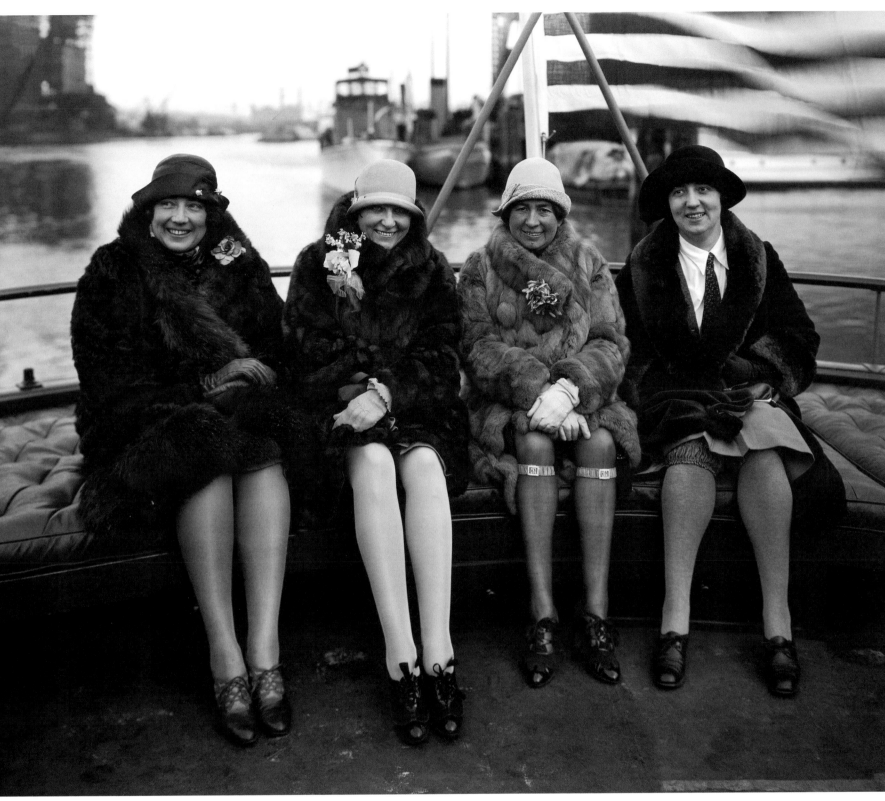

SEA LEGS, 1925
Onboard the yacht Shadow K, *these women are showing off their "sea legs," as the note-taker wrote in the Rosenfeld files.*
(1984.187.23939A)

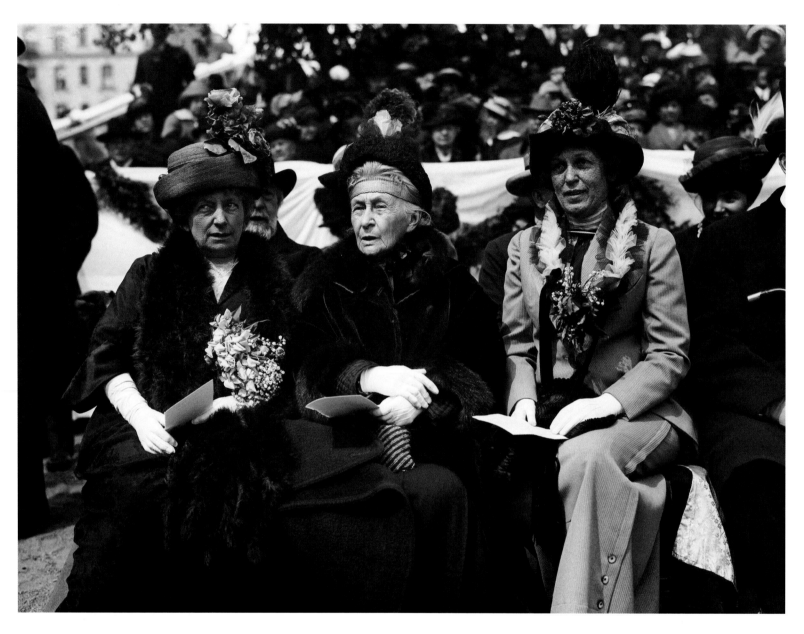

ON THE VIEWING STAND, 1917
Seated during a dedication in memory of
Carl Schurz, a political figure, according to
notes in the original file, "Marianne Schurz
(daughter of Carl Schurz), Miss Juessen
(sister), and Miss Juessen (niece)."
(ANN. 1984.187.6727)

OPPOSITE: *JANEY III*: **LAUNCHING, 1925**
Mrs. Walter O. Briggs launches Janey III—
a 118-foot motor yacht built by Consolidated
Shipbuilding of Morris Heights, New Jersey.
She was married to the Walter Briggs who
owned the Detroit Tigers. (1984.187.21325)

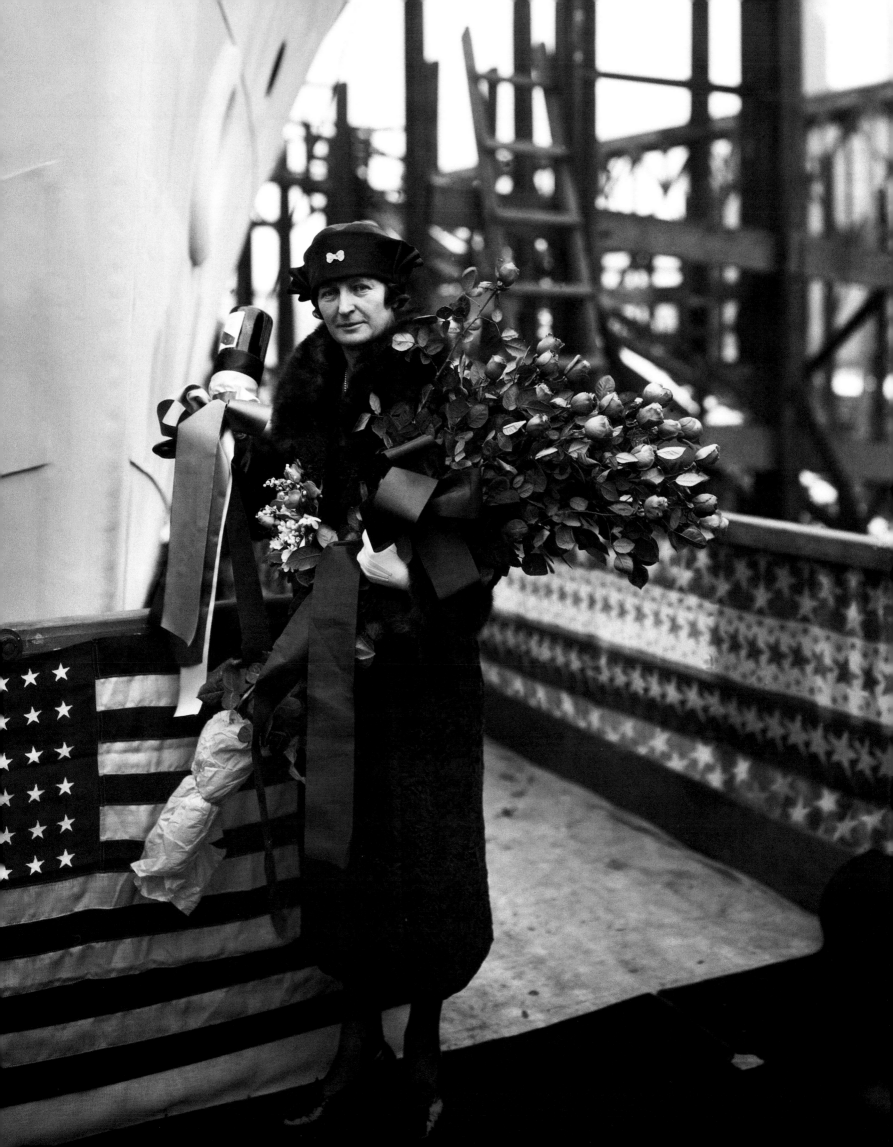

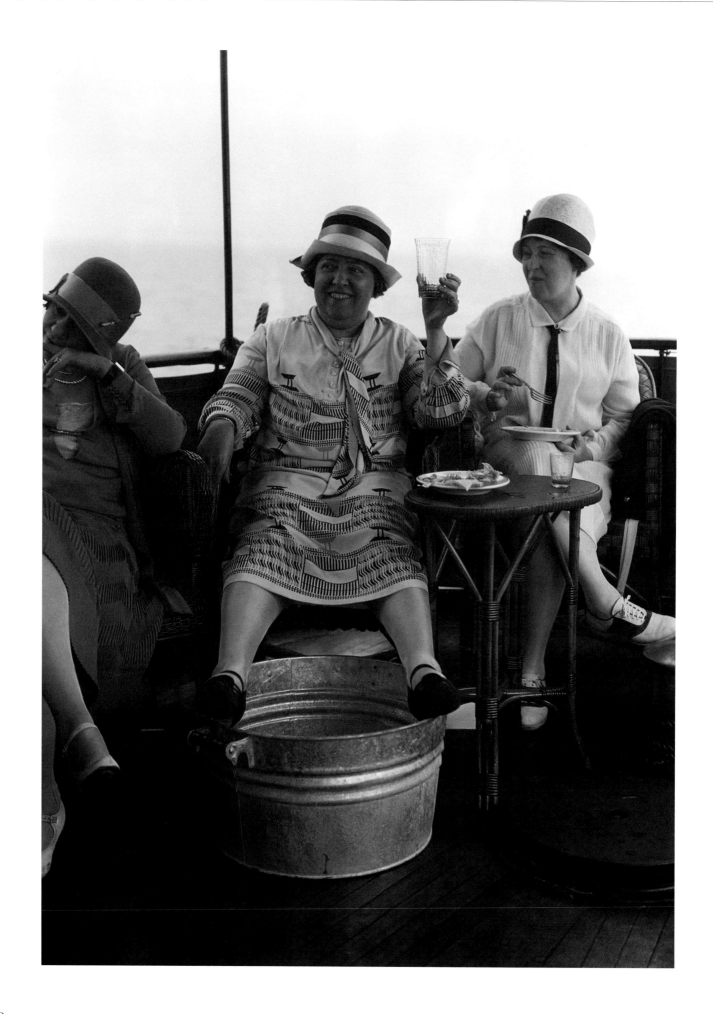

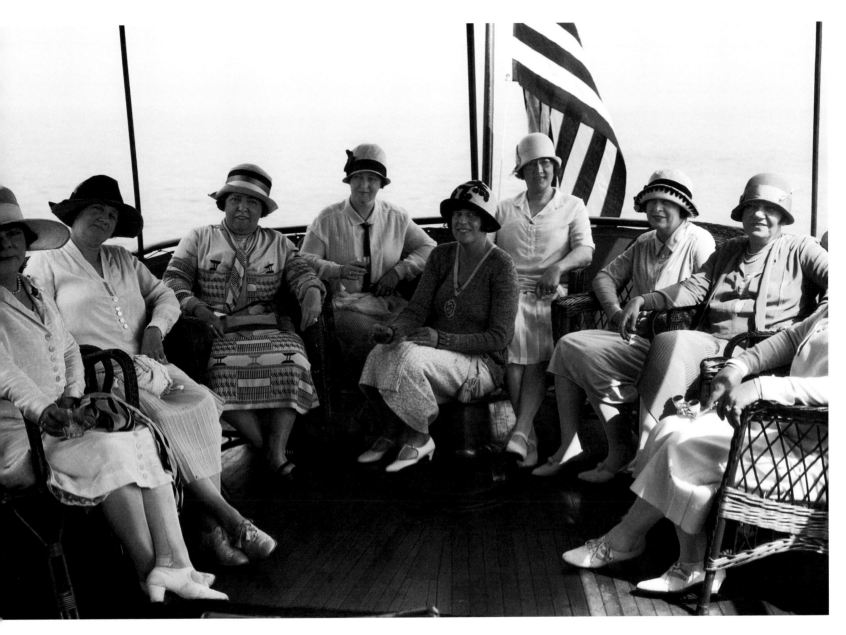

LADIES ON THE AFTERDECK, 1926
During Block Island Race Week (July 10, 1926), these women are enjoying themselves on an unidentified motor yacht. (1984.187.19357F)

OPPOSITE: ***QUEEN OF SHEBA*, 1926**
Block Island Race Week, July 10, 1926: Nothing like soaking your feet! The title comes from original notes written by the photographer. (1984.187.19360F)

WATER SKIPPER, 1958

Prelude to contemporary jet skis, the "water skipper" had a flat-bottomed hull and a handle and control bar with which to direct the craft and its speed. Propelled by a Mercury outboard, this image was taken for an advertisement. (RD.1984.187.5381)

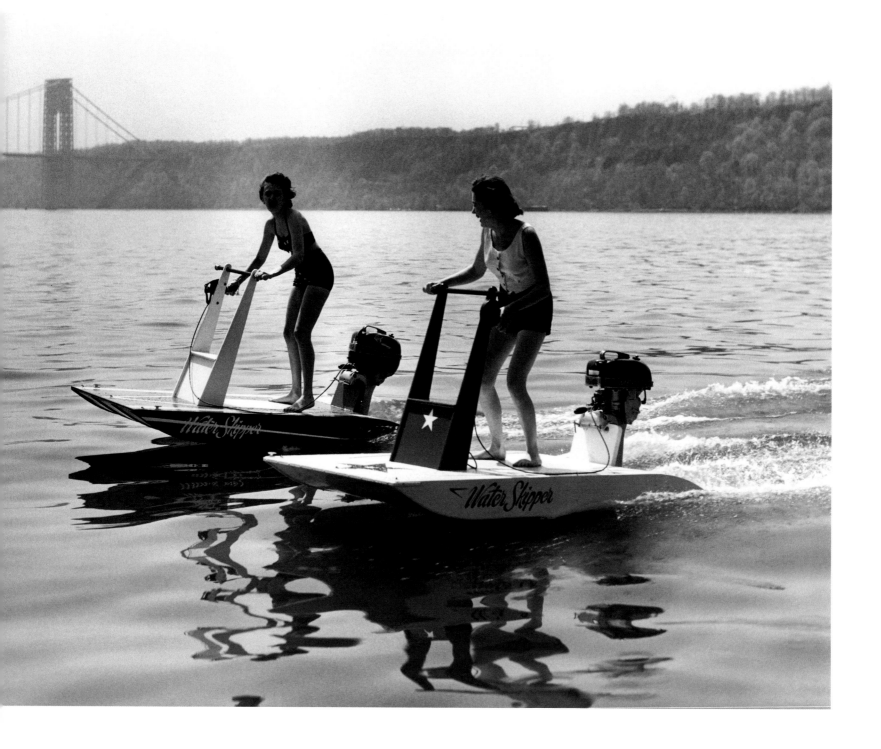

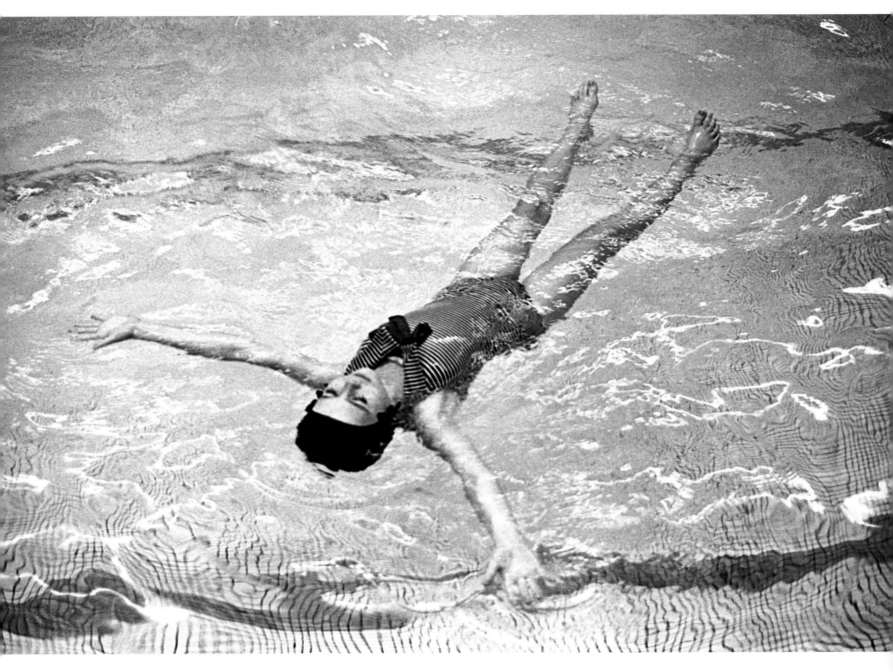

FLOATING SWIMMER, 1963

This serene image was taken as an advertisement for a swimsuit flotation device designed for children. (1984.187.173860.28)

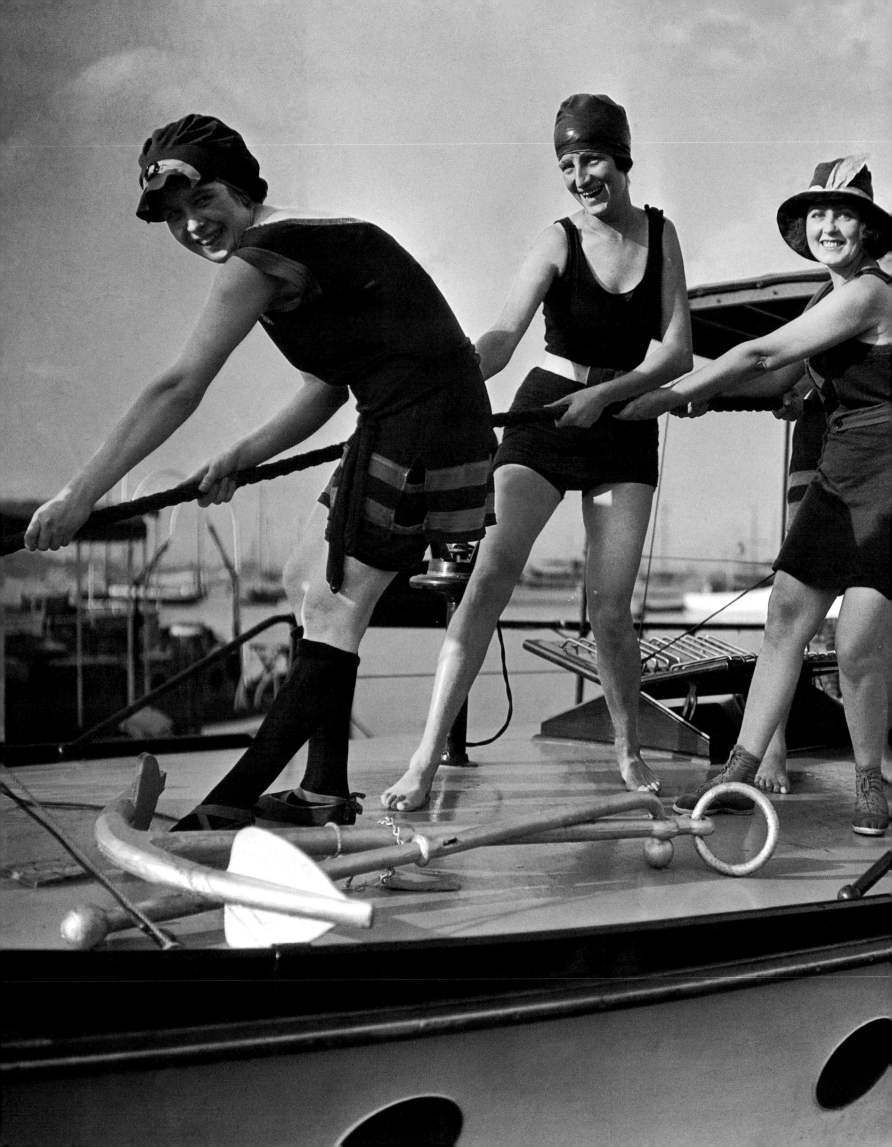

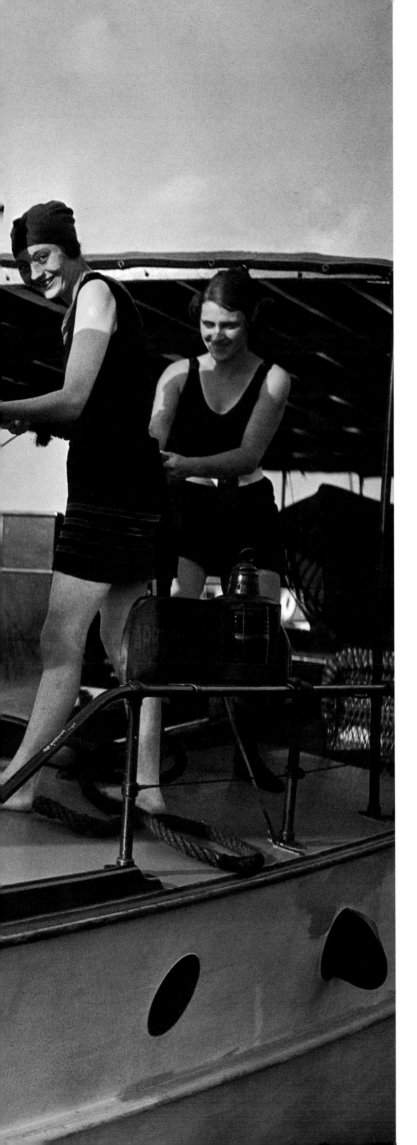

Chapter Five

DISPLAYING WOMANHOOD

"Every yacht, I discovered, has its best photographic

angle—like every woman's face. And the first

approach in taking pictures of a yacht, as in

taking pictures of a woman's face, is to study the

subject and find out what that angle is."

—Morris Rosenfeld, *Sail-Ho!*

103

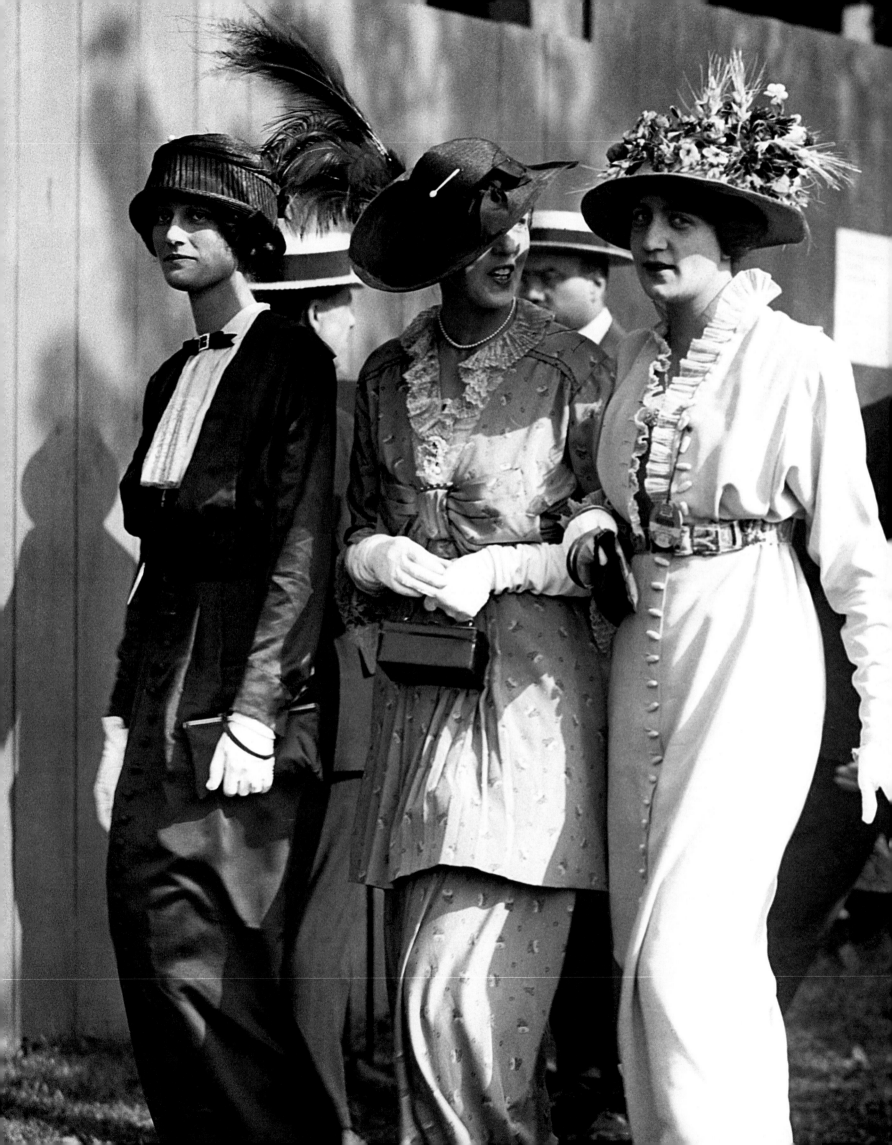

Located throughout the Rosenfeld Collection are numerous photographs of women in various striking and engaging poses. Sometimes the women are photographed as models at boat shows. Other times, they are dressed in finery and furs, perhaps christening a new ship or celebrating a yacht race. Sometimes, they are just beautiful women who caught the Rosenfelds' eye. Dressed in lavish clothing—or sometimes in a simple bathing suit—the women often display the look of a privileged class; other times, they also show the evolving styles of the twentieth century. Sometimes they look, in retrospect, a little goofy. But, these photographs also illustrate how women have been presented in commercial photography over the years, as well as how women sometimes present themselves.

When you see a woman in a photograph, is she the subject of the image or is she an object, used to enhance the composition and draw your attention to the other subject matter? Both are found in this collection. Either way, the Rosenfeld photographs reveal much about changes in women's style over the twentieth century and how representations of women are used in commercial photography.

When Morris Rosenfeld was establishing his business in the early twentieth century, the nation was emerging from World War I —a time when, as we have seen, women's lives were being radically altered. With their growing role in the public world, women were donning new styles. Shorter hair, looser fitting clothing, less adornment—these were the styles of the times. In the period after World War I, styles became clearly more practical and utilitarian. As women entered new occupations during the war, they had learned to wear less restrictive and more comfortable clothing, perhaps not how we would see it now, but certainly more carefree in comparison to what had gone before.

Changes had begun even in the previous century. The Rational Dress Society was an organization founded in London in 1881. Among other things, this group advocated that women should wear no more than seven pounds of underwear—an innovation because women, at least those in the elite classes, were estimated to have worn an average of fourteen pounds of underwear around the time of the Civil War! In 1914, the first bra was patented by Mary Phelps Jacobs—a New York socialite who wanted something other than her

ON THE PREVIOUS PAGES:
BATHING BEAUTIES ON BOARD, 1921
Photographed at the Detroit Yacht Club, these young girls pose on the cruiser Arbutus II.
(1984.187.7133F)

LEFT: THREE WOMEN AT THE POLO MATCHES, 1916
Likely used as a society news shot, these three women were photographed at the polo matches in Newport, Rhode Island.
(NN.1984.187.12)

ABOVE: MODEL WITH ROSES AT THE FLOWER SHOW, 1954
(1984.187.1400141F)

OPPOSITE: PORTRAIT WITH LARGE HAT, 1916
Probably taken at a social gathering of the very well-off, this portrait of Katherine Duer MacKay (1880-1930) shows the elite fashion style of the times. Herself the daughter of a New York high society family, she was married in 1898 to Clarence Hungerford Mackay (1874-1938), a wealthy businessman, sportsman, investor, and patron of the arts. The couple were divorced in 1914.
(ANN.1984.187.6530)

corset to wear under her sheer evening dress. Forsaking the whaleback bones that held her traditional corset, she (or, some suggest, her maid) designed a bra made of pink ribbon and silk handkerchiefs, and sold the brassiere patent to Warner Brothers Corset Company for $1500. Warner Brothers reaped over fifteen million dollars in profits on the new brassiere in the thirty years that followed (Bellas 2005; fashion-era.com). With the U.S. War Industries Board banning all corsets in 1917, because of the metal they used, over 28,000 pounds of metal were saved and the corset faded into history.

In the post-World War I period women also became more practical. They wore less jewelry and had shorter hair. And, the philanthropic work of middle-class women brought women of different classes together. As a result, styles tended to merge across the classes, although clearly the elites continued to dominate and define the fashion industry. But clothing was becoming mass-produced and was more likely to be "ready-to-wear."

Worn with a long, gored skirt, the shirtwaist blouse, made notorious in the Triangle Factory fire of 1911, became the dress of working women. Although we would now find the style constraining, the shirtwaist dress was based on the design of men's shirts. It fueled the growth of the textile and garment industry, and its manufacture was also central to the then vibrant labor movement.

In 1918, a movement was founded to create a National Standard Dress. The design never succeeded, but the idea was for the dress to be fully utilitarian, able to be worn to work, to parties, and to sleep. With metal buckles, it had no hooks or eyes. Clearly, the idea was a flop! But, women's skirts were generally getting shorter—calf-length, not to the floor. And, some have claimed that colors became more somber, reflecting the national grief of the post-war period (fashion-era.com).

The more masculine style of women's clothing in the post-war period was consistent with the other changes happening in women's lives. Dresses took on some of the features of men's clothing, but maintained a feminine look, lest women be judged as looking too manly. Styles had straight lines, broad shoulders, and less of a waistline. Even the "flapper"–symbol of the "Roaring Twenties"—had masculine features: short hair, flat-chest, narrow hips, but still represented the sexual freedom associated with the modern age.

Perhaps nowhere are the style changes for women more obvious than in the design of bathing suits over the twentieth century. As silly as they look now, bathing suits in the post-World War I period were made of wool jersey, were sleeveless, and were often worn with knee socks. They hugged the body, revealing women's limbs, a look consistent with the aesthetics of athleticism at the time. The bathing caps that appeared also were appropriate for the new bobbed hairstyles. In the 1930s, bathing suits evolved into two-piece garments, although they were considered scandalous, associated only with "floozies" and strippers. The two-piece construction of bathing suits in the 30s introduced the possibility for bare midriffs and higher cut legs. "Bathing beauties" like Esther Williams and Dorothy Lamour made the new suits seem glamorous—the wardrobe of the stars.

In the 1940s and 1950s, bathing suits became more corset-like, aided by the earlier invention of Lycra. Along with the rubber girdle, the introduction of elastic thread and "stretch panels" changed, not

OPPOSITE: WOMAN IN A ROAMER CAR, 1920

With a view of Grant's Tomb (in Manhattan) in the background, this actress shows off the new Roamer car, originally built in Streator, Illinois. The Roamer was considered a highly luxurious automobile. (1984.187.10864A)

ABOVE: MODELS ON ELCO CRUISER, 1924

Part of the commercial work the Rosenfelds did, this humorous photograph was shot in the Port Elco Showroom in New York. (1984.187.21045)

just bathing suits, but women's underwear. Flatter stomachs, body-hugging fabrics, and lines revealing the contours of women's bodies became the norm.

Fashion trends are established by the well-to-do, not by the masses. But the mass production that accompanied the expansion of market capitalism and, thus, increased consumerism meant that styles established by the fashion industry for elites trickled down to everyone else. There is also a fashion cycle, whereby new styles also circulate up. Styles of the street become the couture of the rich, though they are then made unaffordable by the average person.

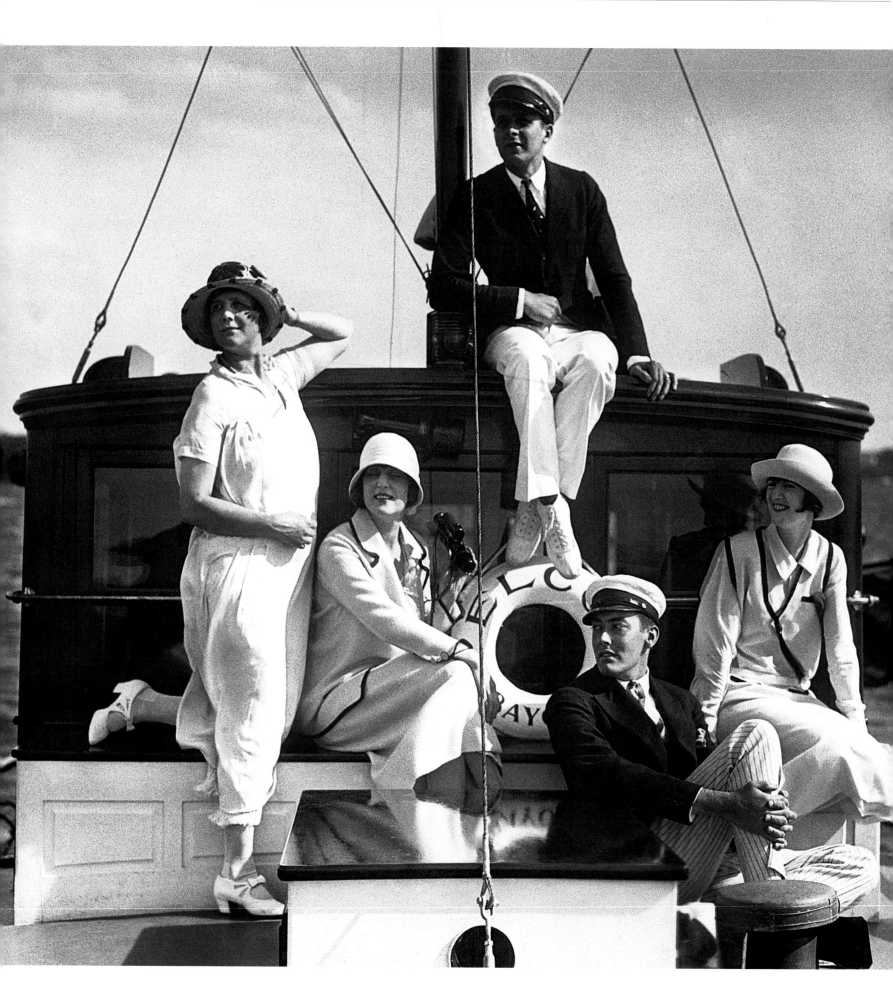

MODELS ON THE DECK OF AN ELCO, 1926

Shot for Motor Boating *magazine, these fashion models pose on the bridge of an Elco cruiser.* (1984.187.17470F)

The Rosenfeld images provide evidence of changes in women's fashion over the twentieth century. The photographs from the teens and twenties provide an image of the well-to-do class—sporting Edwardian style hats that beautifully frame women's faces, projecting an image of grace and glamour. Other photographs here show the evolution of swimsuit styles, even though that was not the likely intent of the photographers.

Many of the images of women in the Rosenfeld Collection are taken in commercial venues as part of commercial photo shoots, at boat shows, or at other maritime venues. In these shots, women are accoutrements—there to seize your attention, but not the subject of the photo per se. Models small in size were typically used to enhance the apparent size of boats and their interiors, a gimmick deliberately used to fool the viewer. These images also illustrate a point made by contemporary feminists—that women are used in advertisements to sell everything from cars to batteries to boats. While contemporary feminists decry the use of women as objects in such marketing endeavors, seeing the history of such images documents the various representations of womanhood over time. Indeed, women's marketing appeal has been used by advertisers to sell not just products, but modernity itself.

In the earliest photographs in the Rosenfeld Collection, we see women as subjects in their own right, reflecting the portrait style that Morris Rosenfeld used when shooting boats and people. He tended to compose his photographs around a single, whole subject, reflecting the possibilities provided by the cameras of the time. Stanley Rosenfeld later wrote that, as cameras were produced with longer lenses and faster shutter speeds, you could capture more fleeting moments and brief expressions. This change in photographic technology thus created a different interaction between the photographer and his subject (Rosenfeld, S. 2006). But in the early years, picturing women, like picturing yachts, produced portraits of an age—an age of transformation in women's beauty and displays of womanhood.

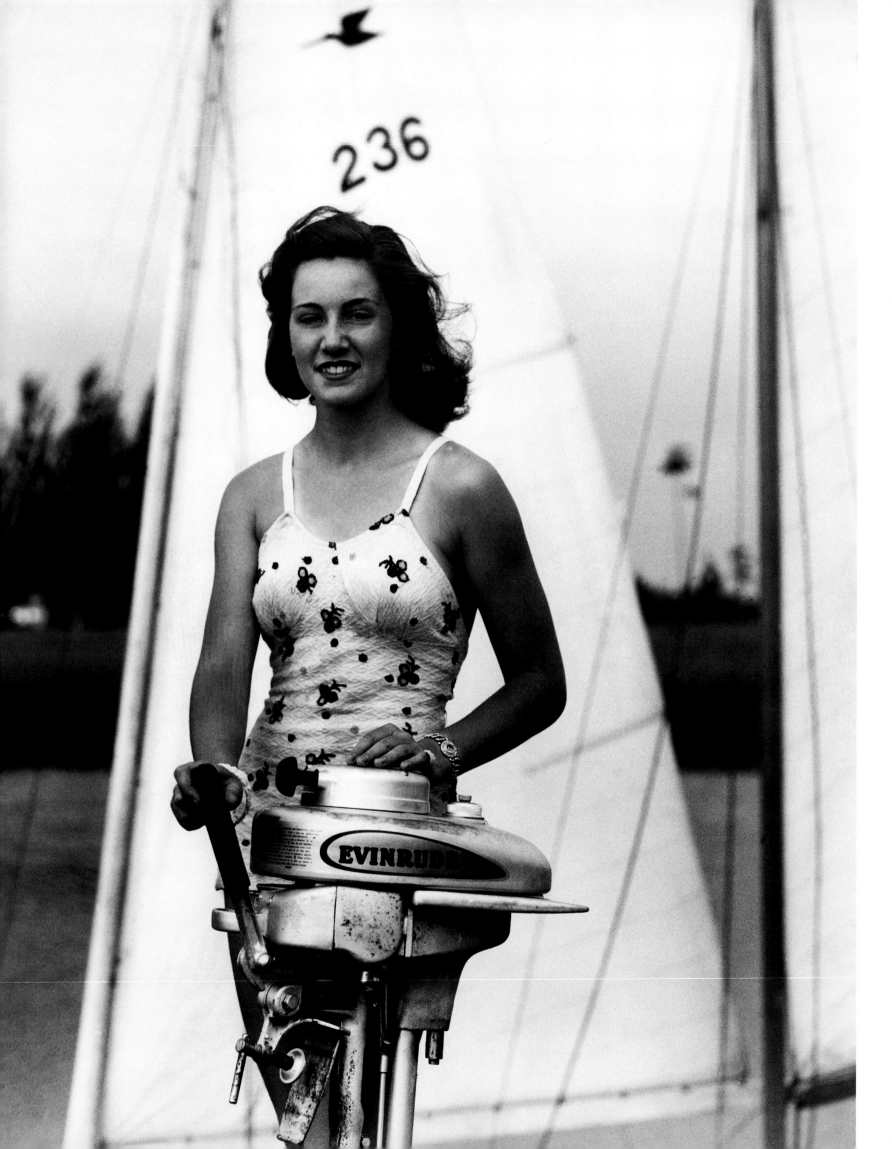

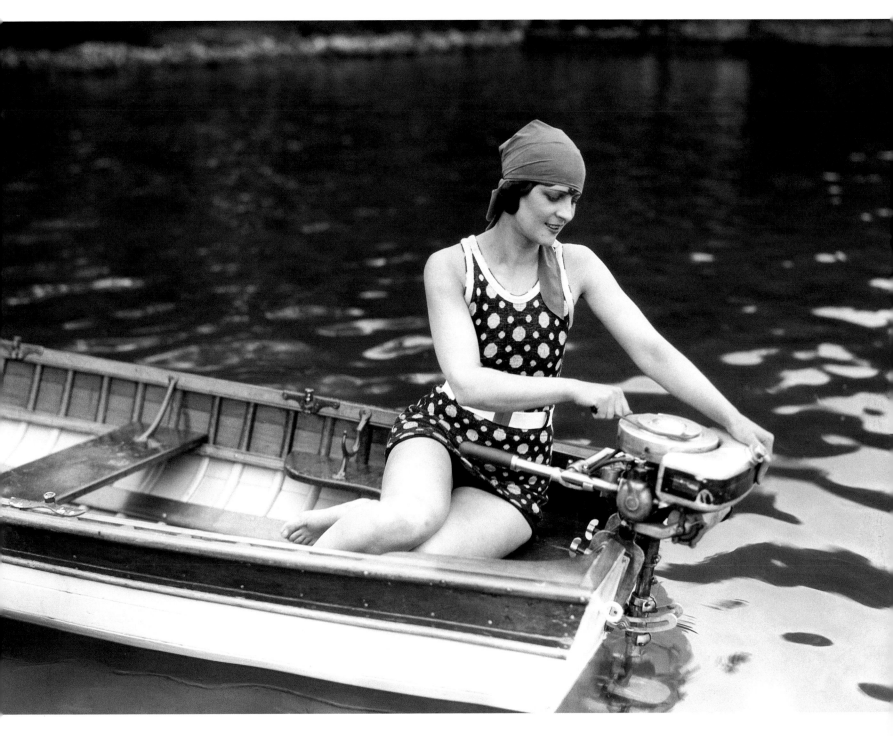

MODEL WITH JOHNSON OUTBOARD, 1926:
Although she is only pretending to start the motor, this model looks serene and ready for a short cruise. (1984.187.20559F)

OPPOSITE: EVINRUDE AT THE BILTMORE, 1938
Photographed at the Biltmore Hotel in Miami in March 1938, this advertising shot is taken in front of a Snipe class sailboat with an Evinrude motor. (1984.187.27117F)

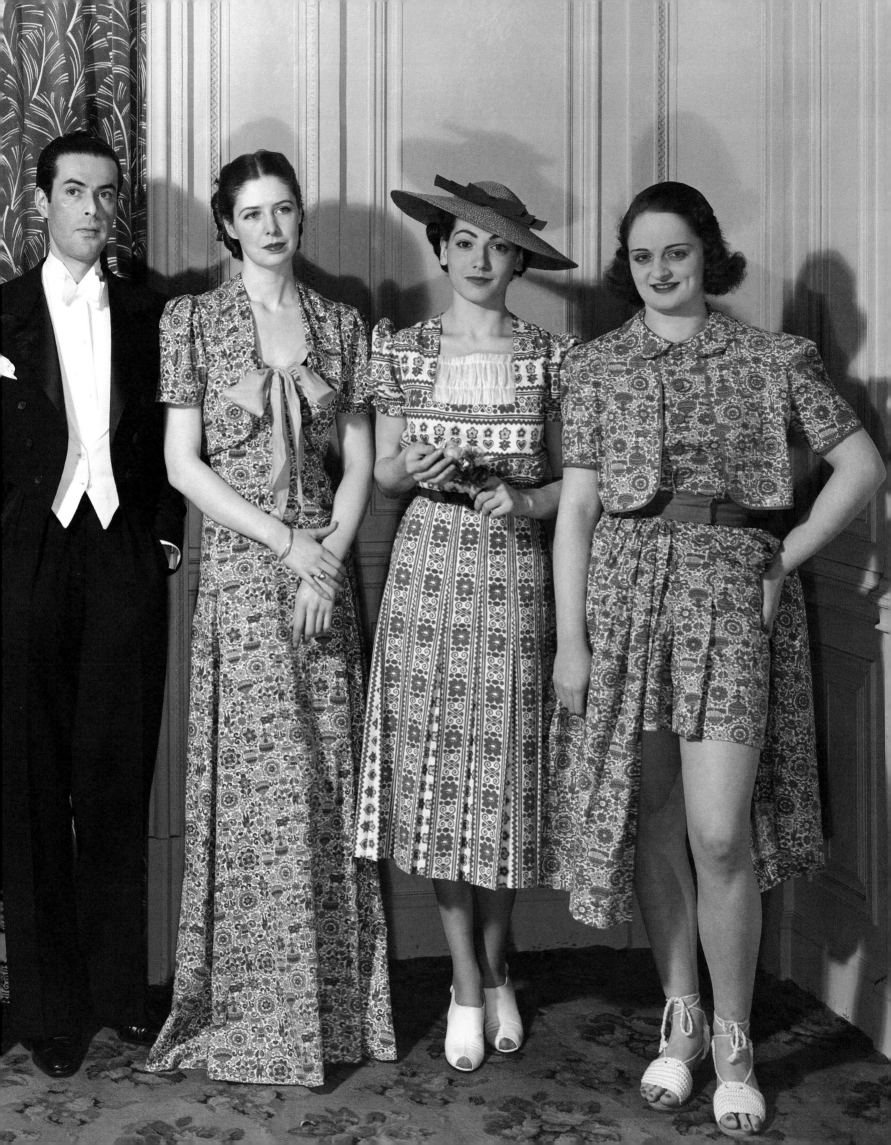

AFLOAT: JOHNSON OUTBOARD MOTOR, 1947
This serene image is an advertisement for the "Sea Horse" outboard motor. (1984.187.117987F)

OPPOSITE: MODEL WITH OUTBOARD, 1951
Also part of the advertising work the Rosenfelds did to earn a living, this work also shows a typical bathing suit style of the 1950s. (1984.187.132439F)

117

MODELS IN RAIN GEAR, 1954
Modeling onboard a utility craft, the women look like they are enjoying themselves. The photograph was part of an advertising job for Evinrude done in Freeport, Long Island, New York. (1984.187.143353F)

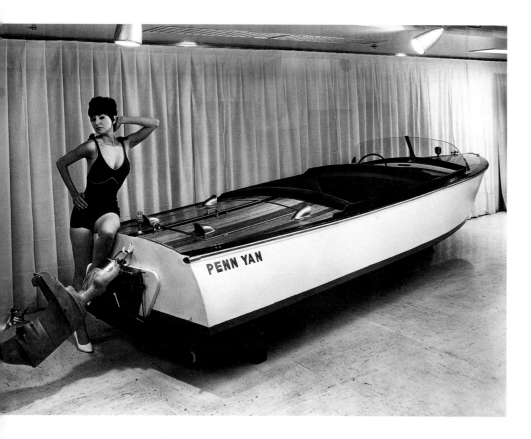

PENN YAN BOAT COMPANY, 1958
A "glamour shot," this was commissioned by the Penn Yan Boat Company to promote their newest model—the boat, that is! (NN.1984.187.1)

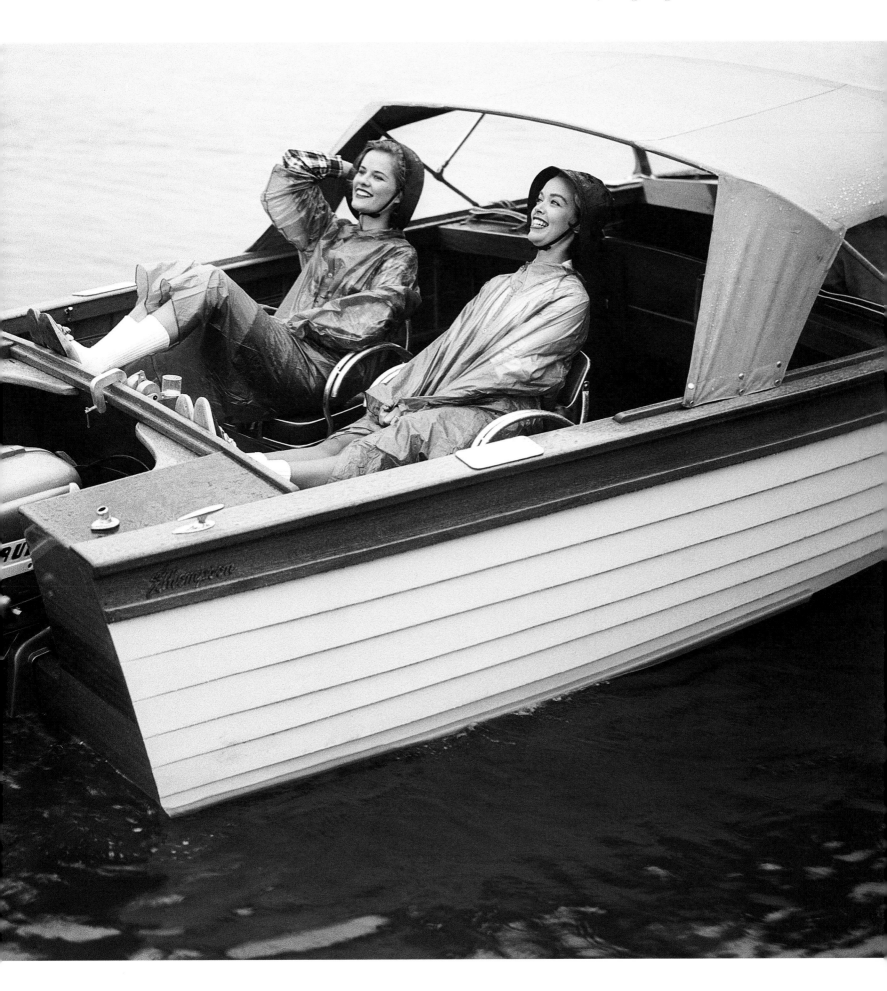

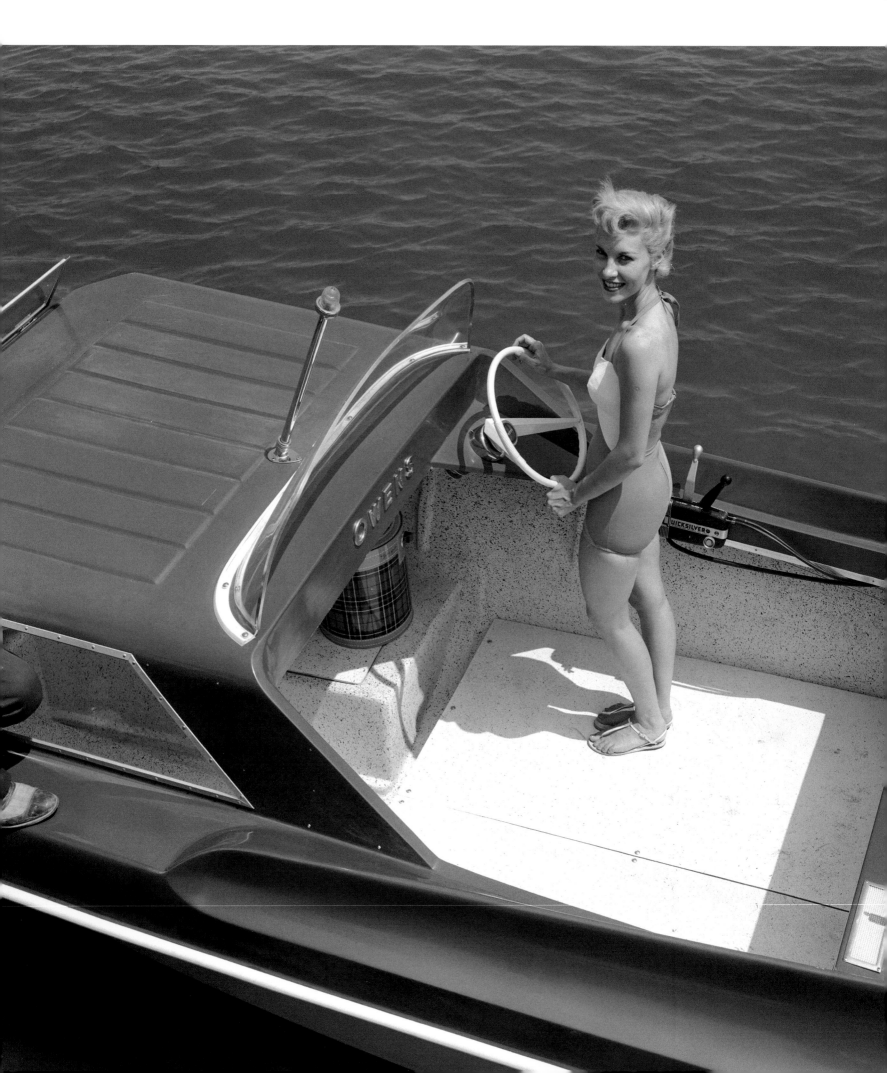

CRUISALONG JOB, 1955
On an unnamed cruiser, these models appear to be enjoying a ride, though the image was an advertisement for Cruisalong. Cruisalong boats were built in Solomons, Maryland through the 1960s. (1984.187.148271F)

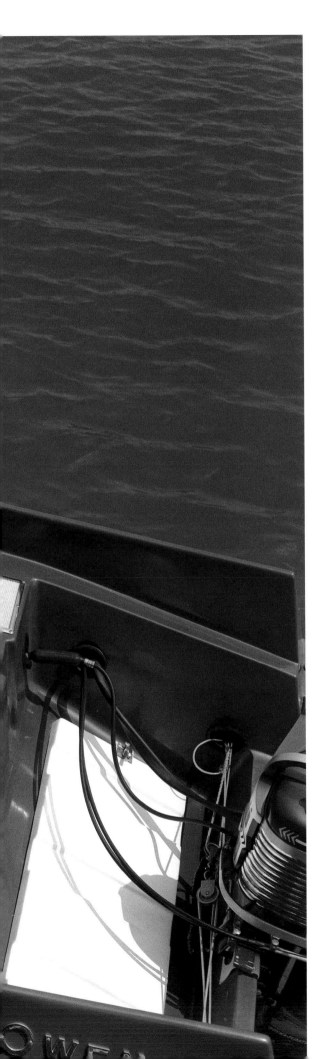

MODEL IN CRUISER, 1958
Advertisements not only sell the boat, but also create images of the ideal woman— images that resonate only in their time. (1984.187.160633F)

GIRLS AND AQUA KING SKIS, 1959

*Taken in Naples, Florida, the image is framed
to show off the spaciousness of the aft deck on
a large catamaran, complete with Aqua King
skis. (1984.187.163324.13)*

MODEL AND TWO MEN IN A CRUISER, 1972

*Who of a certain age can forget the mini-skirts
and high boots of the early 1970s—shown here at
the New York Boat Show?*
(1984.187.189318.34)

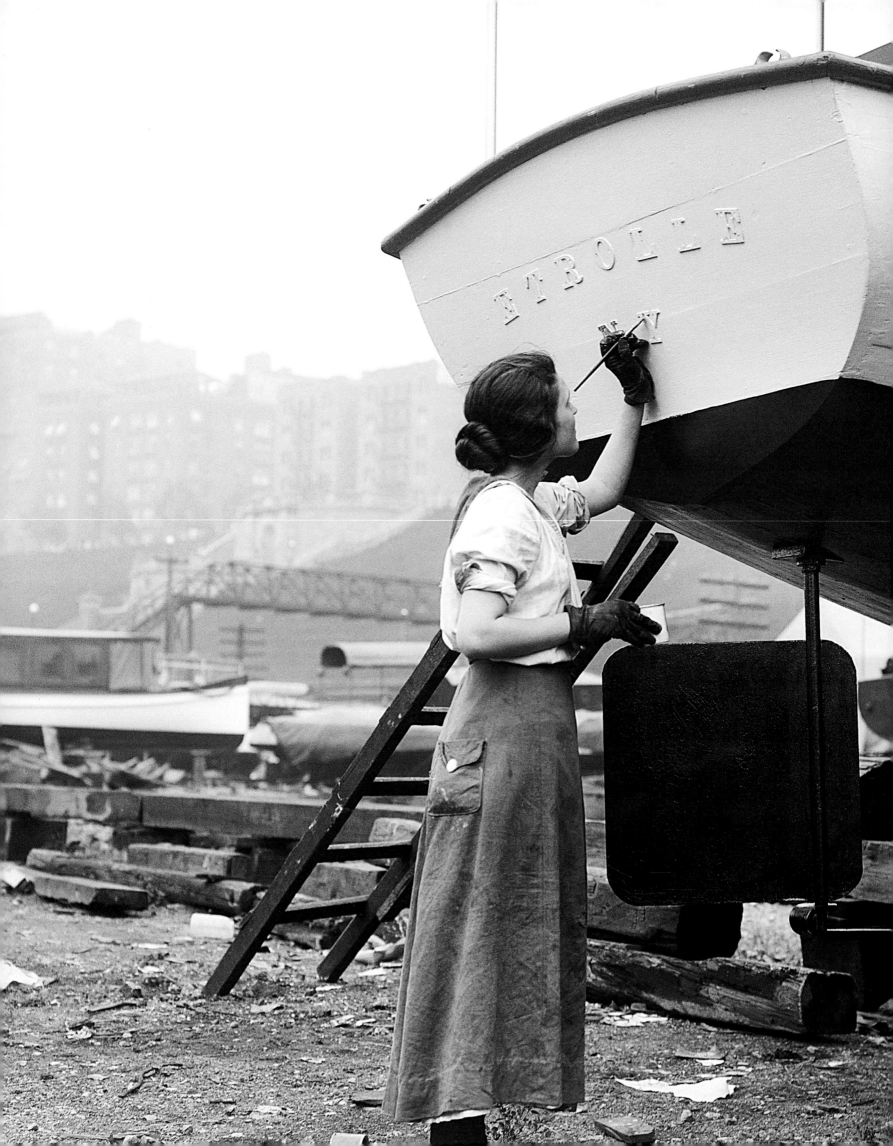

Chapter Six

IN THE YARD

"Kestrel *and I became inseparable….I worked*
on Kestrel *during the two summers I had her,*
building everything into her from a
chart table to a bilge-pump operated sink-drain
system. I learned about fiberglass work and
mixing resin, and I was regularly covered
in bits of polyester and glass.
Almost overnight all my clothes became
covered in materials, but I was happy…
For the first time I really was in charge of
my own ship, and it inspired me to
push the boundaries further."

—Ellen MacArthur, *Taking on the World*

125

nyone who has ever fitted out a boat may marvel at how tidy and clean the women in these photographs look. More usually one would be splattered with paint, covered with dust, and certainly not so dainty. And, while it may not sound like fun to be covered in fiberglass splinters or toxic bottom paint, there is a certain thrill in physically touching, sanding, or grubbily cleaning each nook of one's own boat.

Boating is a world full of men. Men captain the ships, work in the yards, run the race committees, win most of the awards. But women are there too—and, as these photographs show, they have been there all along. Sometimes women are in the background, but, if you look, you will also see them in the foreground, fully engaged in the fine points of boat work. While it may still be the unusual woman who knows the feel of every part of her boat or understands the details of electrical wiring, plumbing, woodworking, and engine mechanics, many women take great pride in the arduous effort of keeping boats afloat.

The work associated with building and maintaining boats has generally been defined as the work of men, even when women are

ON THE PREVIOUS PAGES:
ETROLLE, 1916
On what appears to be a small cruiser, this woman letters the boat's name on the transom. (1984.187.3626S)

RIGHT: SCRUBBING THE HULL OF
HYGEIA, 1917
Spring brings many chores to a boatyard, including, as this woman is doing, scrubbing the hull. (1984.187.3572S)

OPPOSITE: WOMAN PAINTING ENGINE
PARTS, 1920
In an unidentified boatyard, a young woman sits on the ground between two rails of a marine railway, painting a row of six engine mounts. (1984.187.5198F)

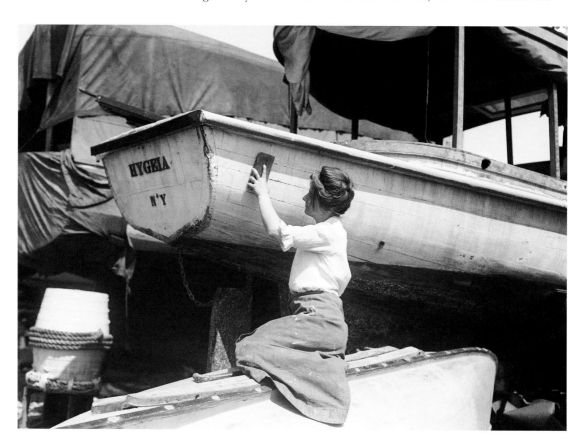

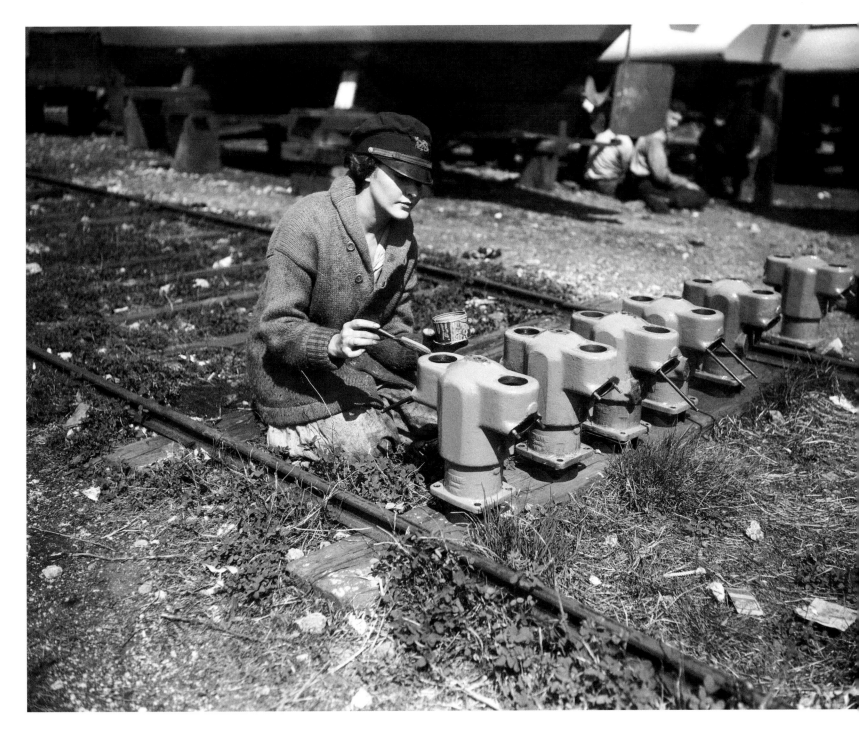

actively engaged in it. And, men have often resisted the inclusion of women in the skilled trades of maritime labor. Even recently on an internet blog about wooden boats, one chauvinist wrote, "There are a few women who care deeply about materials, but they're so rare that they can safely be ignored. As an almost-perfect general rule, the people who care how boats are built and what they're built of are men. So when I say wooden boat people I mean wooden boat men" (civpro.blogs.com 2006).

Perhaps this is extreme, but the exclusion of women from the skilled trades is one of the features of labor history. The first woman admitted to the International Longshore and Warehouse Union (ILWU) was Margaret McDougal of Vancouver, British Columbia, admitted in 1965. Only in the 1970s did the ILWU change its union contract to allow daughters of members, not just sons, to join. It was not until 1974 that women were allowed admission to the maritime academies.

Despite these restrictions, women have long been part of the maritime industry—whether on the ships or on the docks. Even

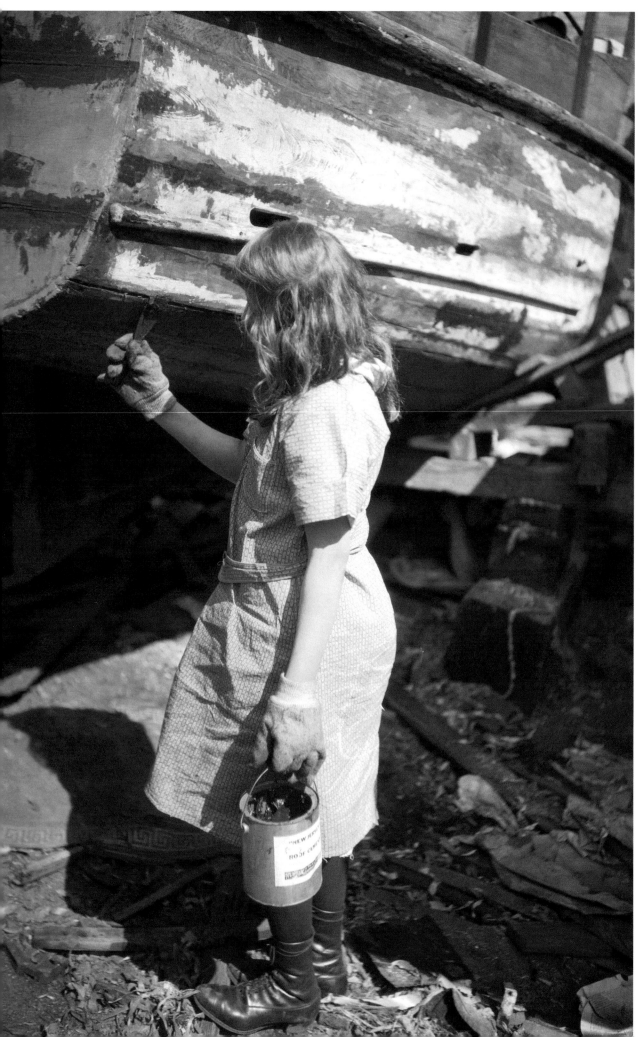

LEFT: GIRL CAULKING HULL, 1920
This image of a young girl caulking the seams of a vessel was likely taken at one of the boatyards on City Island, where Morris Rosenfeld lived. (1984.187.5340F)

OPPOSITE:
NEVINS BOATYARD, 1961
Nevins Boatyard on City Island, New York was very near Morris Rosenfelds' home. Henry B. Nevins was a master yacht builder who wrote extensively about vessel construction. He founded Nevins Boatyard in 1907 where he built custom cruising and racing boats, as well as minesweepers during World War II. Many of the records of the yard are held at Mystic Seaport Museum. (1984.187.168569.10)

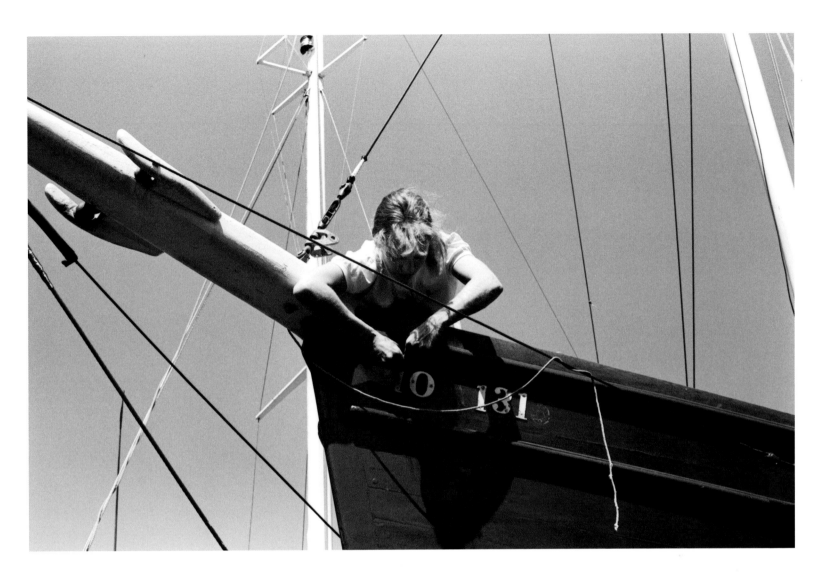

when not admitted to the skilled trades, women played important roles in union politics—mobilizing community support, providing informal clerical support, and marching with strikers (ILWU 2006). In societies where men made their living in seafaring, women also provided the labor at home to sustain their families and keep communities functioning. But, a gender division of labor generally prevailed. Women who went to sea as sailors often had to disguise themselves as men, and women have had to struggle to gain their place in the occupations associated with maritime work.

In the United States, it was during World War I and II that women first entered the skilled trades in any significant number. The need for wartime labor in the absence of men propelled women into new work roles, also raising women's expectations for better jobs. Now, women in the maritime trades report that there are still different standards for women and that women say they have to prove themselves to be accepted by some male co-workers. But, resistance from men can inspire some to try harder. Captain Laura Smith, who drives ferries in the San Francisco Bay reports, "There are so many things women are told they can't do. Sailing was one of these things," she says. "I set out to prove to myself that I could." After she crewed on a 32-foot sailboat from San Francisco to Costa Rica, she learned a new sense of confidence, saying that the trip "confirmed to me that I could do anything that I wanted" (Brooks 2006).

Smith is now a master mariner and knows all about operating a boat. Getting to this level required however making special efforts to be accepted by her male peers. As she puts it, "I had to play games. Men would teach me stuff. I knew they liked working with me because I was cute. I had to use that, so I could learn things. If I hadn't had that opportunity, I wouldn't be here." Other women in the maritime trades say similar things. Marina Secchitano, regional director of the Inland Boatmen's Union (the IBU) in San Francisco, comments, "Some day women won't have to use those vehicles to

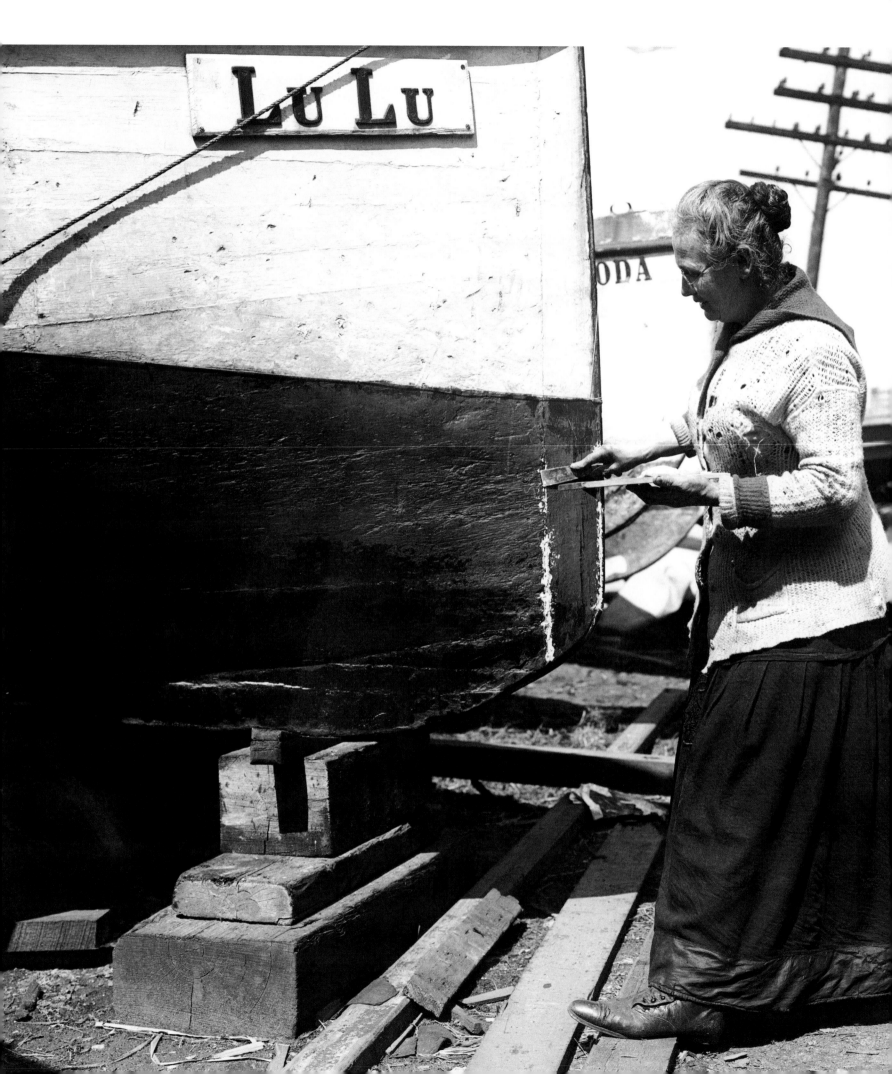

gain skills. As it is now, we have to tone everything down, go along to get along—until we get in a position of power" (Brooks 2006).

How do such skills become identified with men? Certainly some of the fitting out work that falls into a gender division of labor involves skills where women excel—sewing, painting, waxing, cleaning—skills that are developed in activities generally judged to be women's work. If you observe carefully in boatyards, you will see women doing these things, though seldom working on the electrical, woodworking, rigging, or plumbing crews. To this day not many women are employed in the skilled trades. Boatyards reflect the gender division of labor in the skilled trades, more generally. Although the representation of women in such work is increasing, they are only a miniscule percentage of skilled laborers–2 percent of electricians, 2 percent of carpenters, 1 percent of small engine mechanics, 4 percent of machinists, 4 percent of cabinet makers, and about 7 percent of longshore workers.

Even today women would be well advised to think about entering such occupations, as they are likely to be better paid than the work women typically get, even with more education than men. But, from an early age, young girls learn that mechanics and construction are men's work. Rare is the young woman who gets tools for her birthday, wants to talk about plumbing, carpentry, and mechanics. In earlier generations, these preferences were even imposed by the educational system. Schools required most young men to take mechanical drawing, while women were required to take cooking, sewing and other homemaking classes. Women would be making cream puffs while the boys in class were designing cars!

The women depicted in these photographs are not working for wages in maritime jobs. For the most part, they are working on their own boats or, in some cases, working as models for some of the Rosenfelds' commercial shots. Either way, whether working on boats for wages or working on them for pleasure, the photographs show that women can and do participate in the labor of preparing boats for sea.

FITTING OUT *LULU*, 1917
In a boatyard in New York, a woman removes old caulk from the hull of Lulu. *(1984.187.3568S)*

WOMAN CAULKING HULL, 1917

It is not known whether this woman was caulking the bottom of her own vessel or was working in a boatyard. (1984.187.3674S)

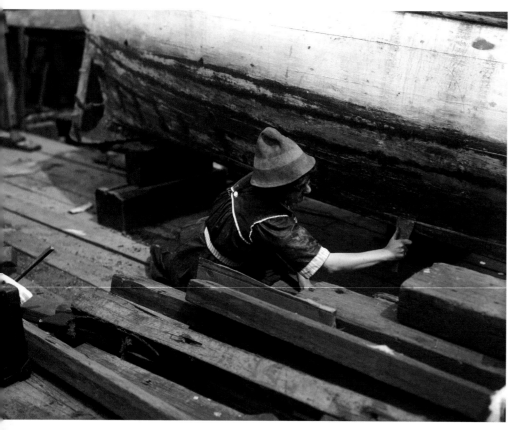

FITTING OUT, 1917

The woman in the center of this image is working at a moveable forge, stirring the embers. (1984.187.3691S)

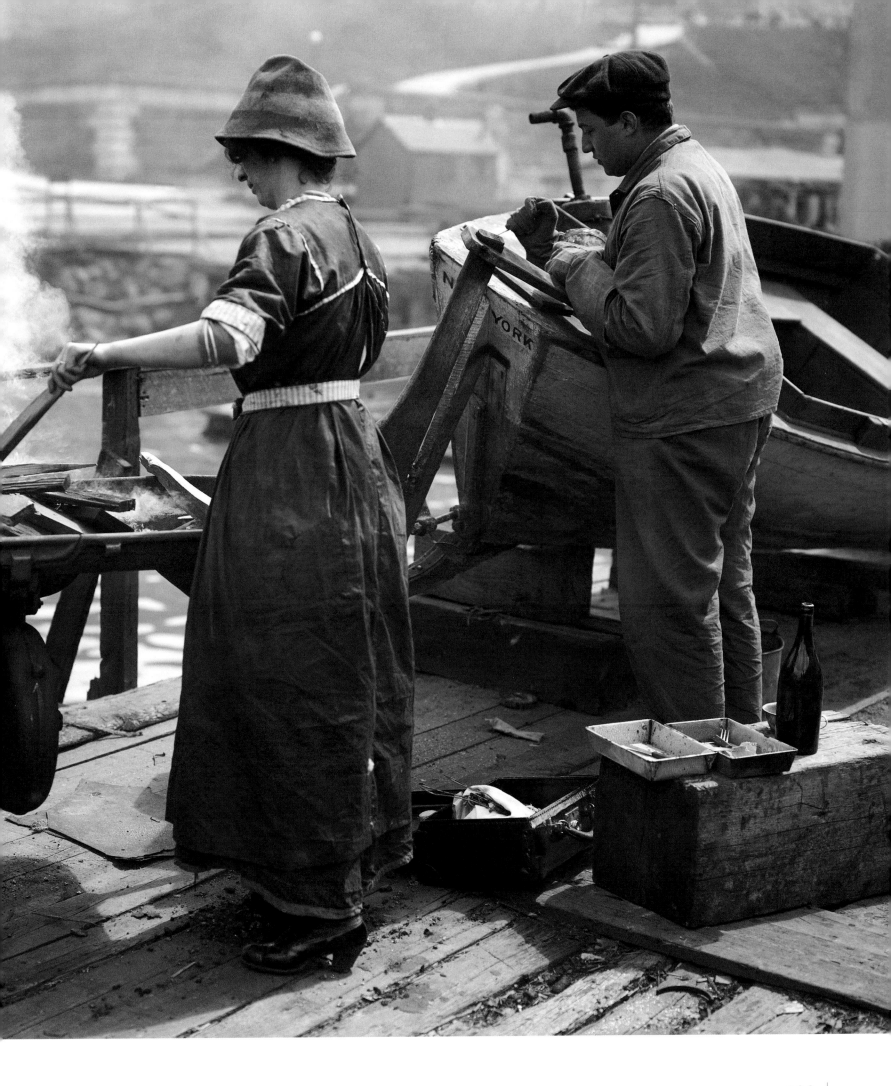

WOMAN PAINTING HULL, 1951
*At the City Island Yacht Club a woman
paints the bow of a boat.
(1984.187.163002F)*

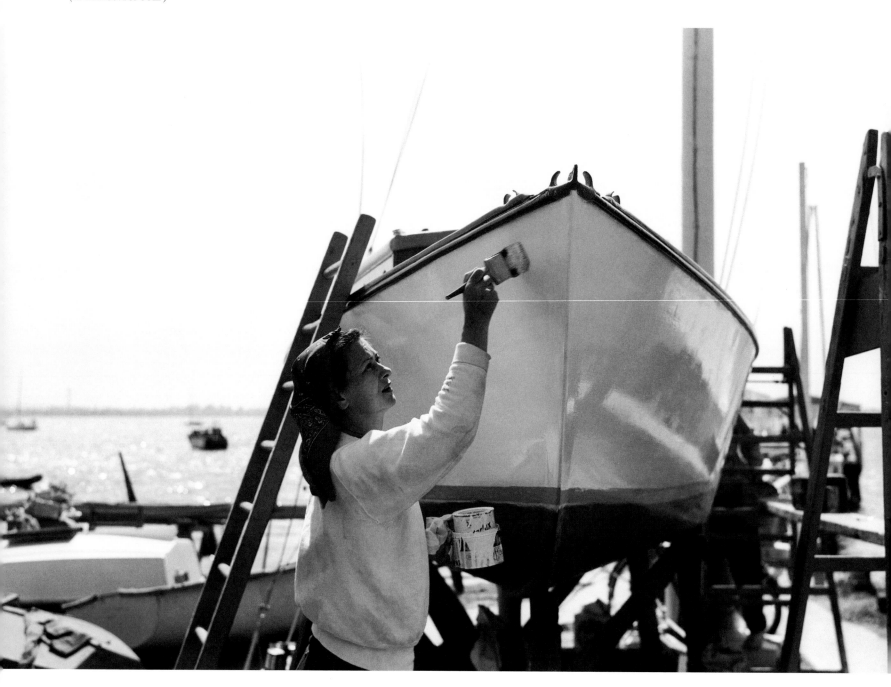

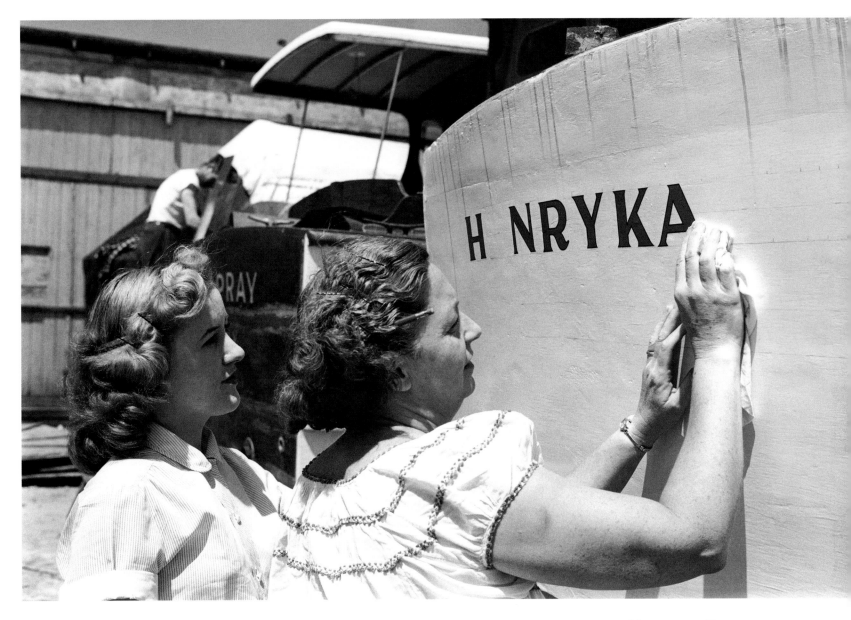

PAINTING THE NAME ON THE TRANSOM, 1954
At the Nassau Boat Basin in Freeport, Long Island, two women paint Henryka *on a 42-foot Chris-Craft cruiser built in 1952.*
(1984.187.140775F)

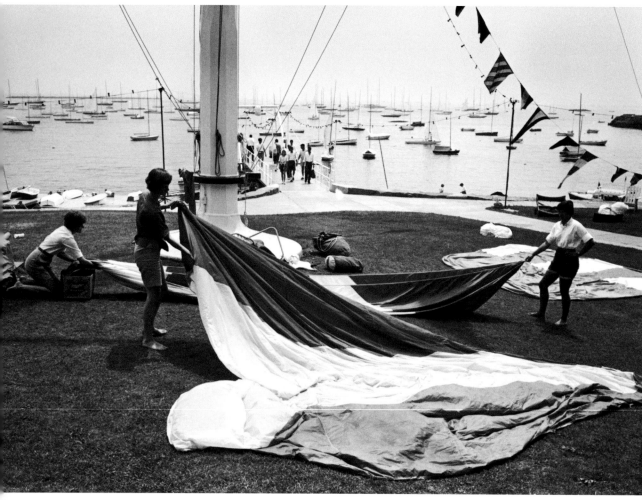

DRYING SAILS, 1961

During Larchmont Race Week, women competitors dry and fold their sails on the clubhouse lawn at the end of the day.
(1984.187.169603.27)

FROSTBITING, 1961

Frostbiting events are a tradition in many yacht clubs when, during the winter, sailors race in very cold weather—so long as the water is not frozen. This event took place on March 26, 1961 at the Larchmont Yacht Club in New York.
(1984.187.168436.13)

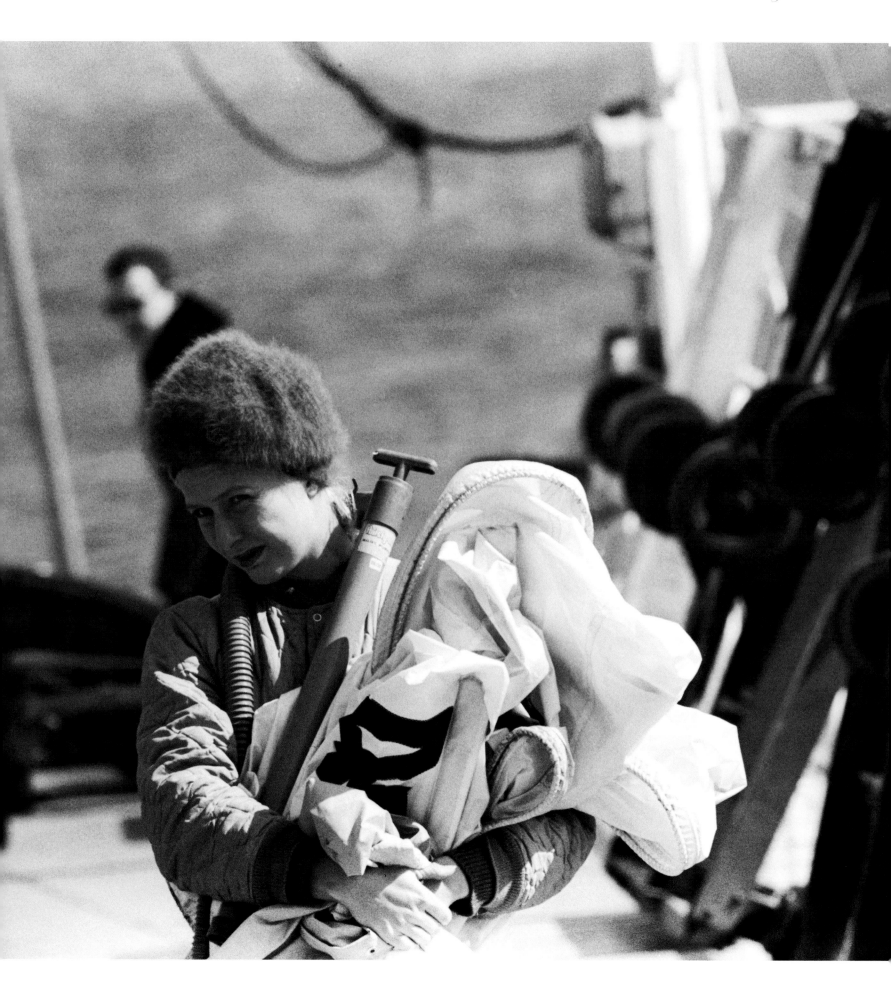

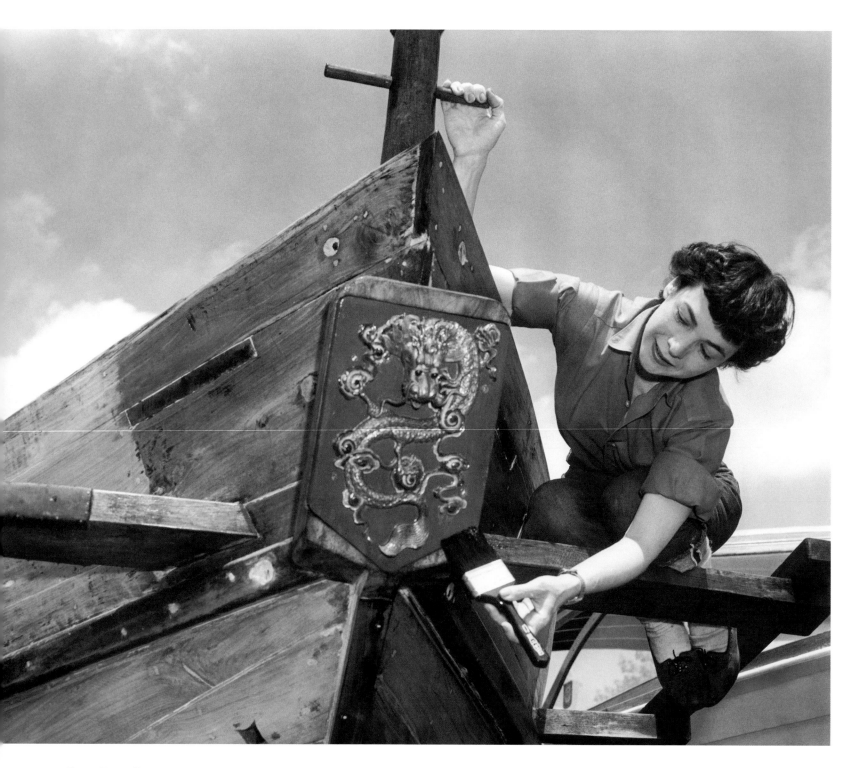

JADED LADY, CIRCA 1957

This young woman, probably Chinese, is painting the bow of the Chinese junk, Jaded Lady, *where there is an intricate carving of a Chinese dragon. The photo is taken by an unknown photographer in Hong Kong, but was acquired by Rosenfeld and Sons and is part of the Rosenfeld Collection, along with other photographs of the construction and out-fitting of* Jaded Lady. *(NN.1984.187.13)*

OPPOSITE:
CHINESE WOMEN WORKING SAILS, 1957
The Chinese junk Jaded Lady, *was built in Hong Kong where her sails were also made. This photograph was acquired, not taken, by Rosenfeld and Sons. (1984.1987.33923)*

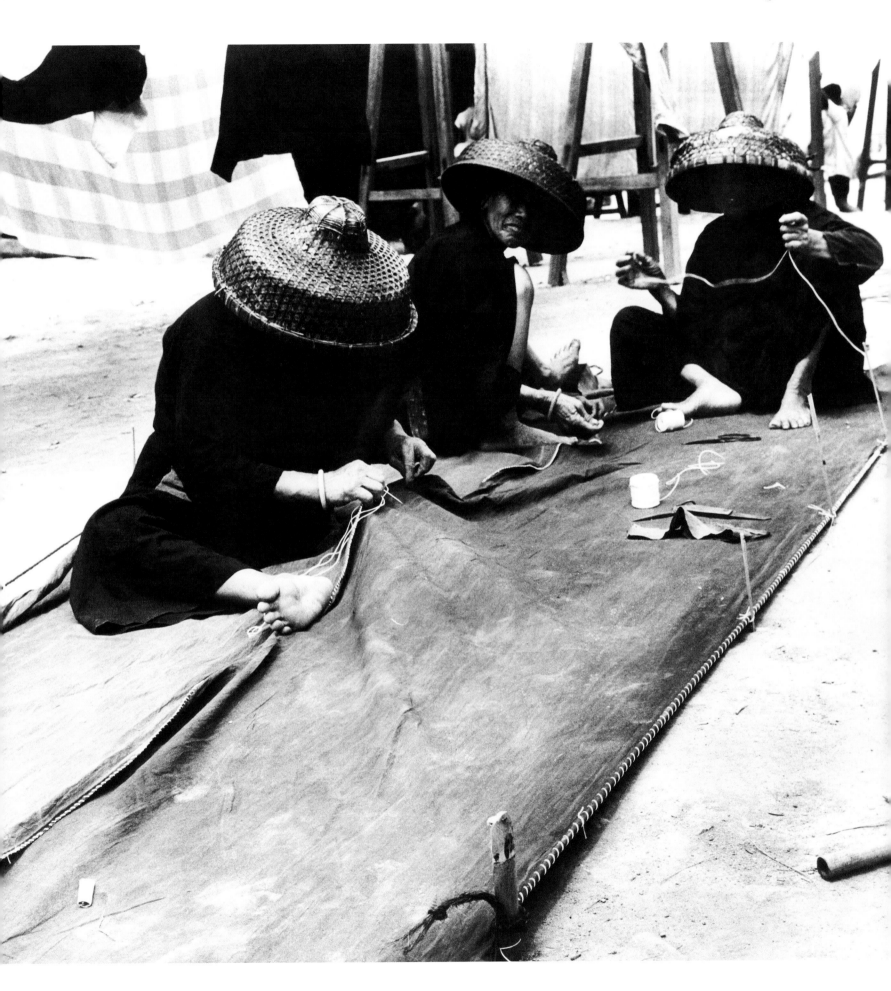

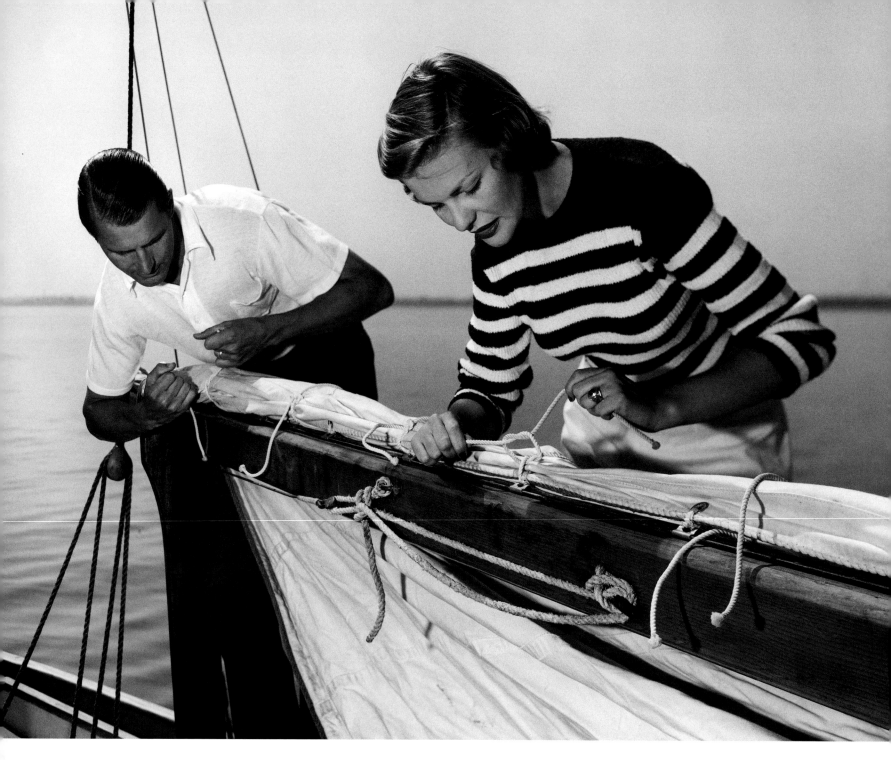

REEFING THE SAIL, 1950

*This woman and man are models for a job for
Texaco Company. What they are doing is a
frequent scene around boatyards—preparing
sails for a boat launching.*
(1984.187.127750F)

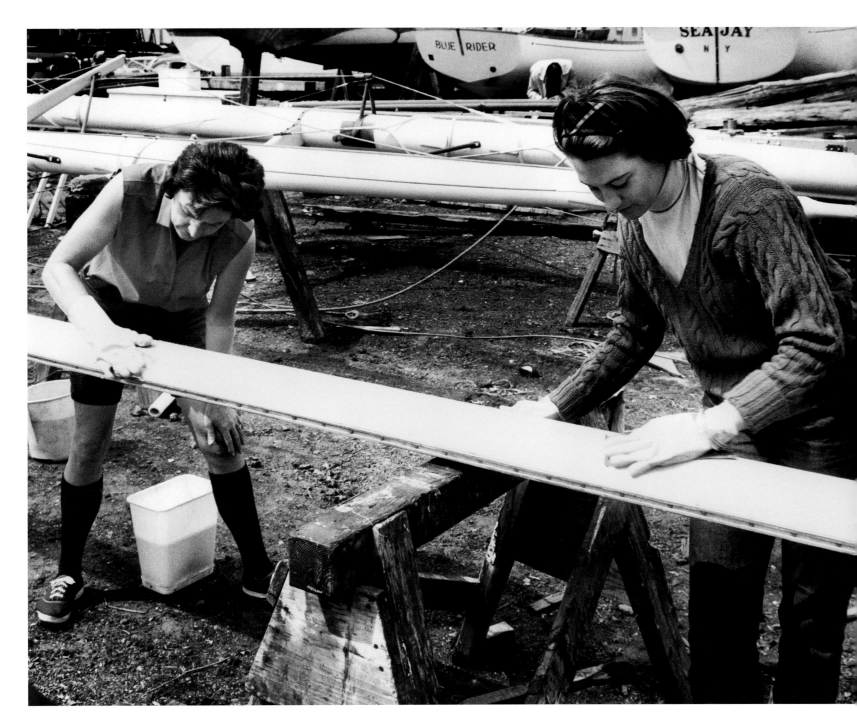

WOMEN SANDING A BOARD, 1964

Sanding is a seemingly endless, though precise, activity in boatyards, as these women are seen doing. The sterns of the vessels Blue Rider *and* Sea Jay *are visible in the background. (NN1984.187.9)*

MRS. SOPWITH SUPERVISING THE FITTING OUT OF *ENDEAVOUR II*, 1937

Here Mrs. Phyllis Sopwith and her husband Thomas supervise the crew and officers working on the boom and mainsail. (F406)

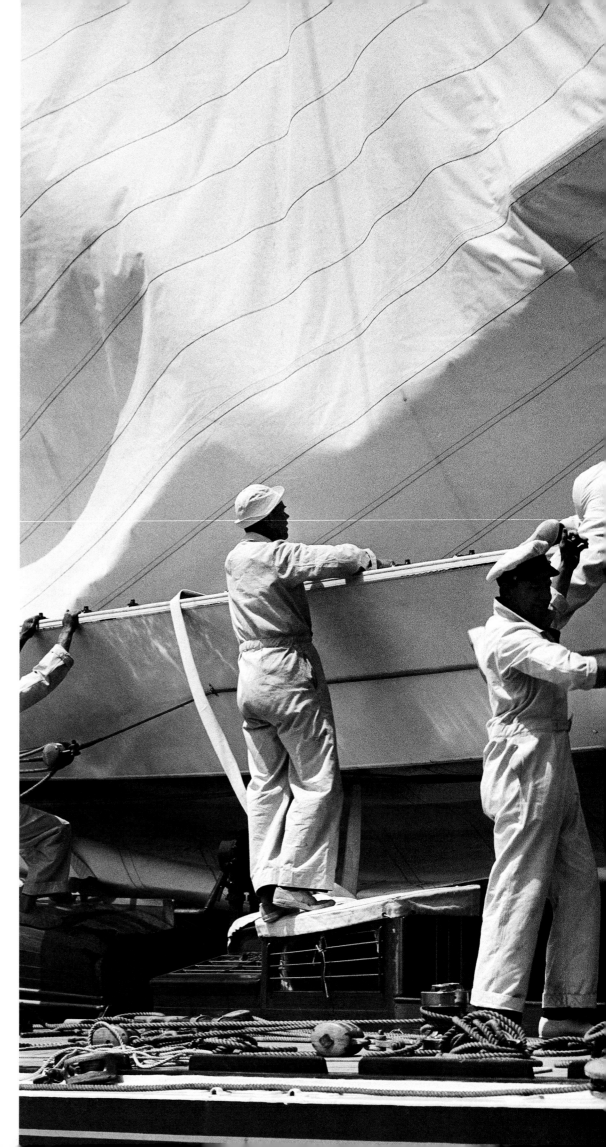

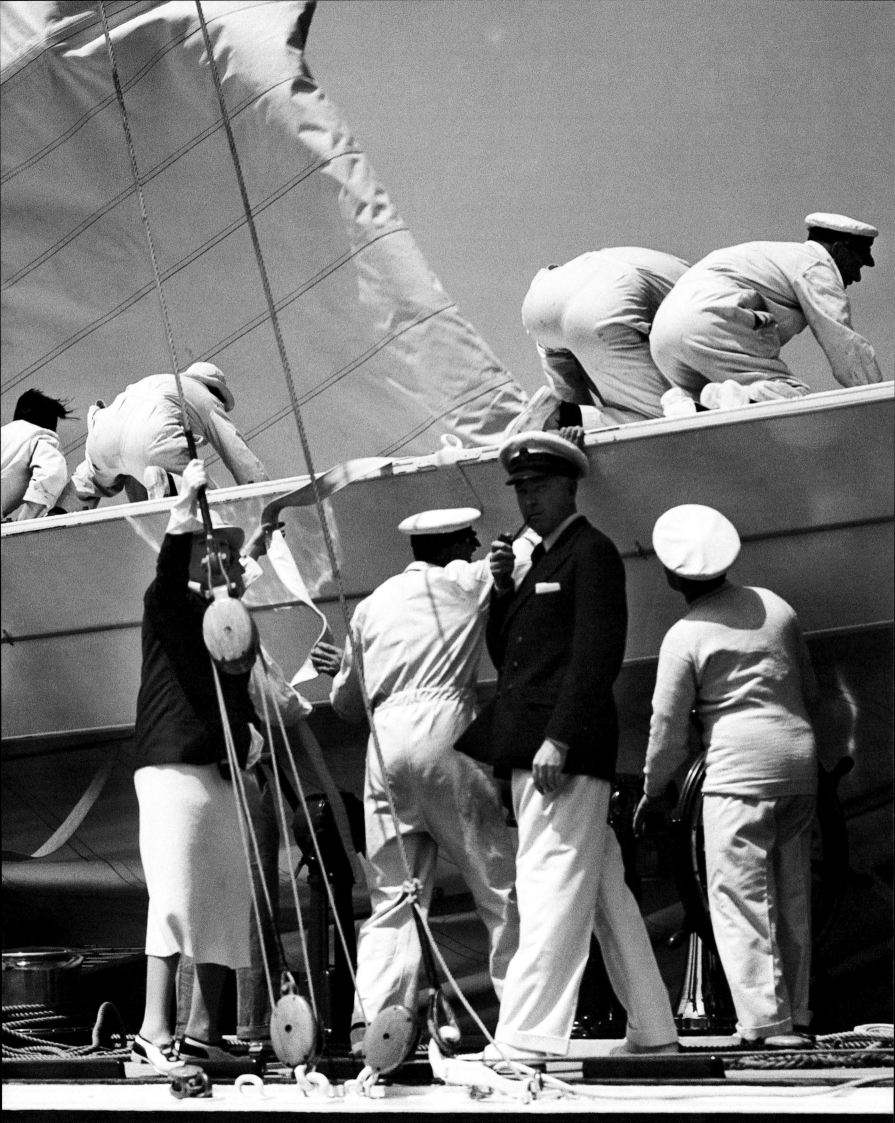

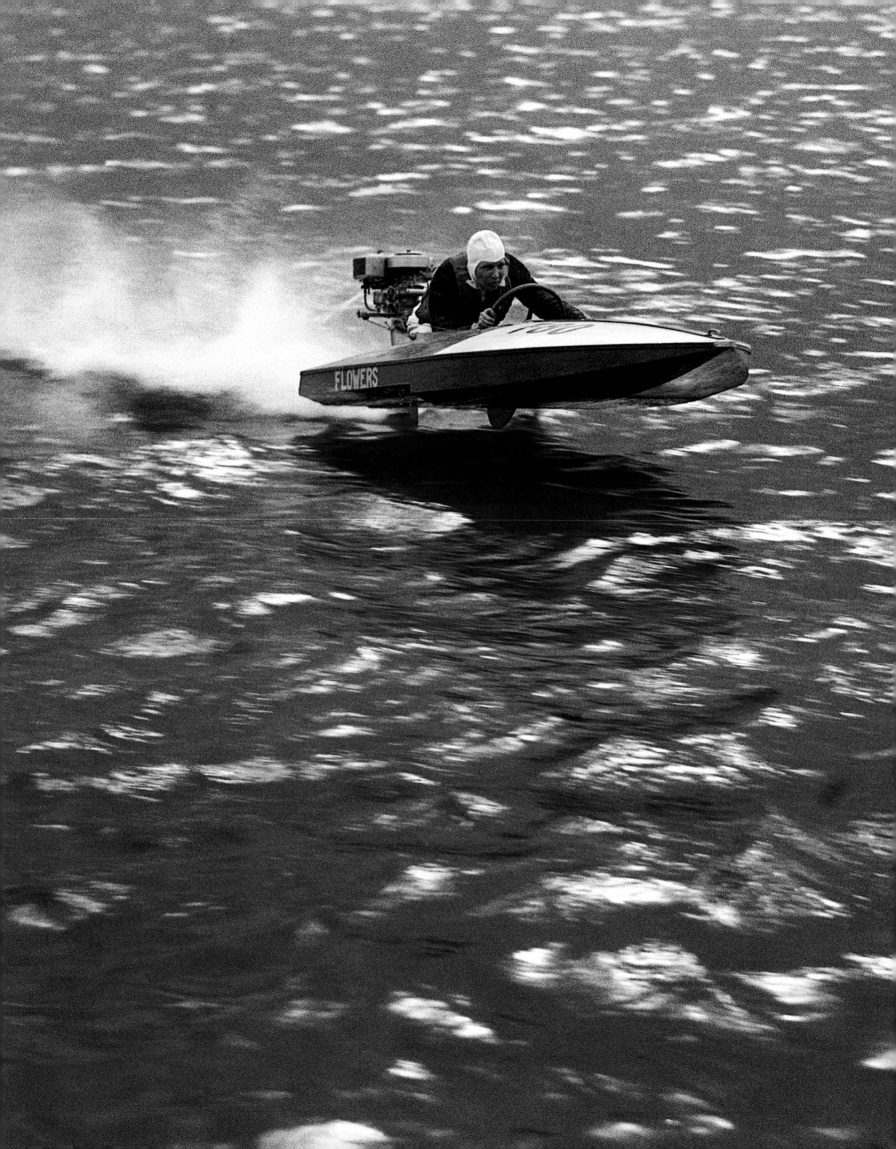

ROSENFELD COLLECTION
MYSTIC SEAPORT.

Chapter Seven

WOMEN AT THE WHEEL

"I really like doing the physical stuff

on the boat. I'm not good at sitting around

and telling people what to do.

I work on my shoulders and chest

because I'm grinding a lot on the winches.

I also need to be flexible and coordinated

because I'm always reaching and

pulling things behind me."

—Dawn Riley, Captain of *America 3*, 1995 America's Cup

The sea and the boats that sail it have long been associated with women. Boats are named for women. Women's torsos are elaborately designed as figureheads at the bow of ships. Superstitions about women haunt sailors' minds, including the belief that women on board bring bad luck, but also that bare-breasted women bring calm seas. Women are believed to have power over the sea and are also associated with the seas' mysteries. The sea itself is perceived as a woman—cruel, deceitful, and unpredictable. To this day, it is considered bad luck to launch a boat or begin a journey on Friday—a superstition believed to be derived from the Norse goddess Frigg for whom Friday is named and who was credited with the ability to see the future. Also, the notion of Davey's Locker luring drowned sailors to the bottom of the sea, is thought to be named for the Hindu goddess of death, Deva Lokka. And, it was long believed that menstruating women and virgins should be kept away from ships under construction because menstruating women were thought to harm anything they were near (DePauw 1982).

Women are rarely talked about in maritime studies, unless as captain's wives, whores, mermaids, figureheads, or the women left behind onshore. Some maritime historians have begun to address this omission,[1] but how many people know, for example, that women sailed in the America's Cup—the classic of all yacht races—as early as 1937? In that year Phyllis Sopwith (wife of Thomas Octave Murdoch Sopwith) and Gertrude Vanderbilt (Mrs. Harold Vanderbilt) both crewed as navigators on their husbands' boats (*Endeavor* and *Ranger*, respectively). They were the first women to do so in the America's Cup.

In years long past, women frequently accompanied their husbands as navigators on ships. In 1851, Eleanor Creesy was the navigator on *Flying Cloud*, a clipper ship on a voyage from Manhattan to San Francisco around Cape Horn, one of the most treacherous passages in the world. At the time, most merchant ships could sail only about as fast as a person could walk, thus making the passage from New York to San Francisco takes about 200 days time (Shaw 2000). The clipper ships were designed to be faster, about the pace of someone riding a bicycle. *Flying Cloud*, known as one of the fastest of the clipper ships, made the 16,000-mile journey in 89 days, setting a new

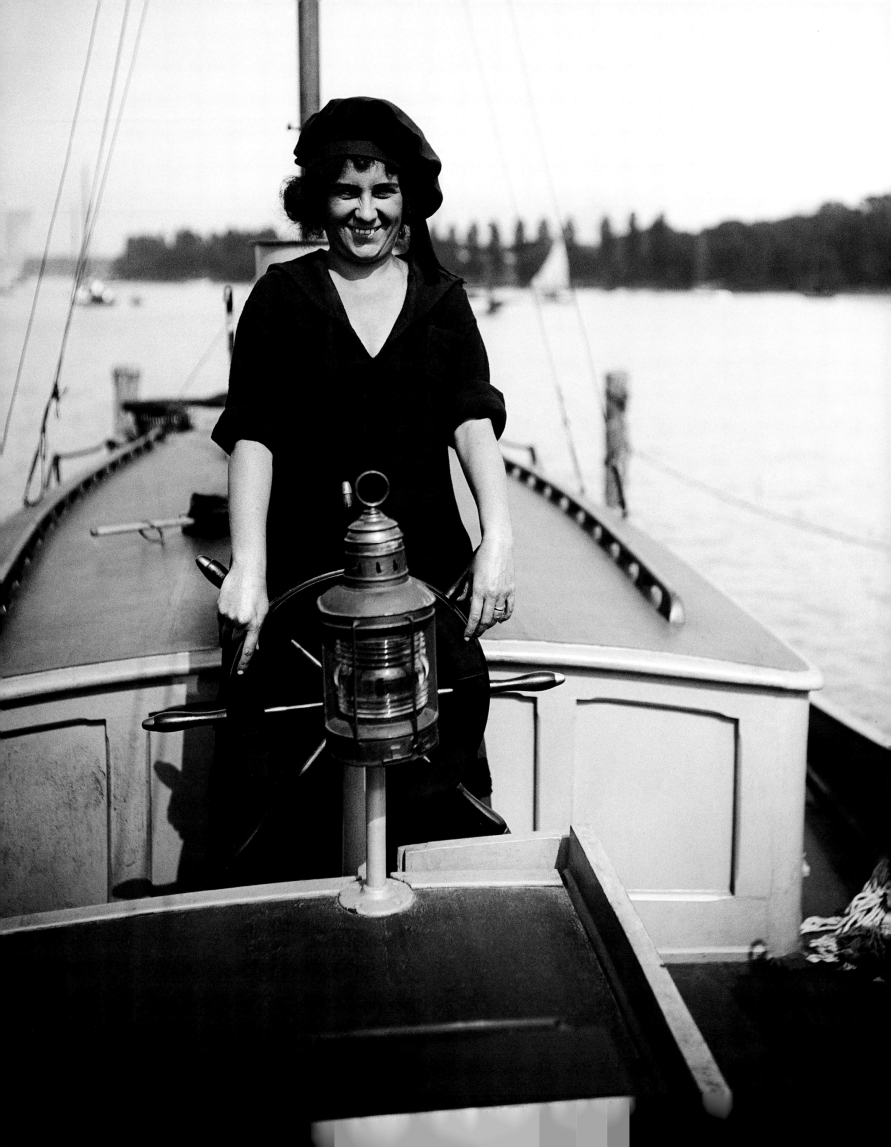

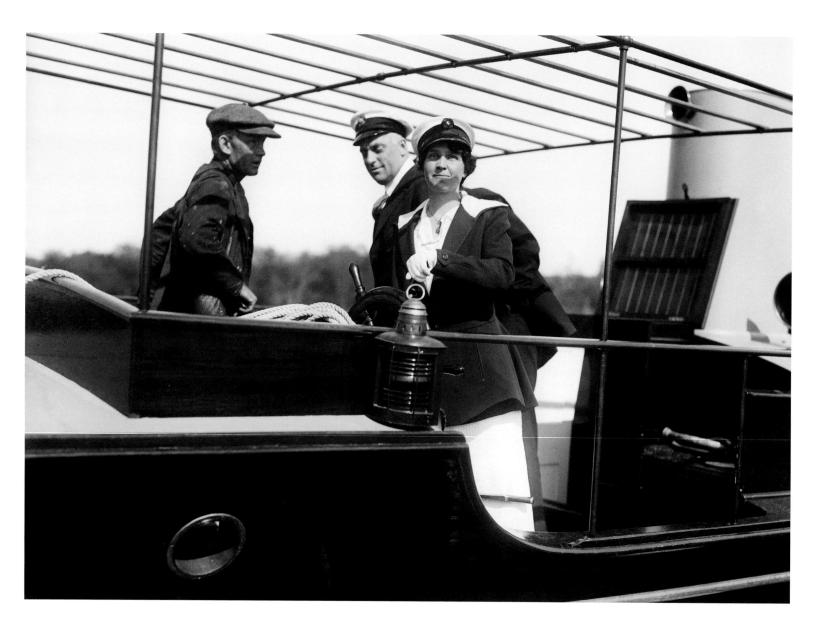

world record. Using the meticulous ship's log, sailor and writer David Shaw has reconstructed this voyage, revealing that Eleanor Creesy's role as navigator on *Flying Cloud* was vital to the ship's record-setting performance. *Flying Cloud* broke her own record again in 1854—a record not broken again until 1989.

There are numerous other accounts of women who have accompanied their husbands to sea, sometimes taking over command when their husband as captain became sick or disabled. Mary Patten, for example, nineteen years old and pregnant in 1856, accompanied her husband on the journey from New York to San Francisco. She assumed command of the ship, *Neptune's Car*, when her husband fell extremely ill near Cape Horn and some of the crew were threatening to mutiny (Cordingly 2001).

Other women have sailed in their own right, with many historic examples of women having to disguise themselves as men to crew on ships. And maritime historians are increasingly documenting the rare, yet known, participation of women in pirating, the whaling industry, as lighthouse keepers, and as other seafaring workers (see Cordingly 2001; Creighton and Norling 1996; DePauw 1982). Studies of seafaring communities are also now revealing the significant role of women in the economic, social, and cultural life of these historic locales (Norling 2000).

Despite women's participation in maritime life, seafaring adventures have typically been construed as masculine activities. In both literature and academic accounts, sailors are shown as rough and ready. Women are rarely seen, except perhaps in voyeuristic depictions of them as prostitutes or as other caricatures: "stylized sweethearts weeping on the docks" (Creighton and Norling 1996).

Even with the growing interest in women at sea, sailing is still largely perceived as a man's world, perhaps well-captured by a description of the first all-women's America's Cup crew (1995), described as: "a pony-tailed band of yachting fraternity interlopers" (Edwards 1995:26)! High rolling seas, fierce winds, clanging sounds, whistling lines, the possibility of being washed overboard: What woman in her right mind would want to experience this? Apparently many, because once you look past the masculine maritime world, you find numerous accounts of women's adventures at sea—some of them record-breaking. Although women have long been at sea, as far as we know, not until the 1950s did women begin setting world records in competitive sailing, such as in sailing around the world alone.

Anne Davison was the first woman to cross the ocean alone, when she completed a solo race in Miami in 1953, having departed from Plymouth, England on May 19, 1952. Naomi James, a British woman, was the first woman to sail solo, around the world—a 27,000 mile journey around Cape Horn, the old "clipper route," in 1978. Since these world records, other women have set other records. Many think of Tania Aebi who in 1986-87 at age eighteen sailed solo around the world on her 26-foot boat, *Varuna*. Yet, she lost the opportunity to be the first American woman to set a record by doing so because she brought a friend onboard for one 80-mile leg of the journey in the South Pacific.

The first woman to ever sail single-handedly around the world in a nonstop race was Ellen MacArthur. In 2005 she set a new record for sailing single-handedly around the world, finishing her incredible journey in 71 days and under 15 hours, beating the previous record of 72 days and 22 hours set by Francis Joyon in 2004. Previously, Ellen MacArthur had also made sailing history by being the first woman to finish second in the 2000-01 Vendée Globe—a race of 24,000 miles which she completed in 94 days and four hours.

For those who don't know about Vendée Globe, it is extraordinarily grueling. You sail non-stop, without assistance, and single-handedly through the most difficult seas in the world. It means sailing around both the Cape of Good Hope and Cape Horn—where there are fierce gales and where the world's weather is unobstructed by land masses, thus producing tremendous winds and seas. Sailors have also dubbed the South Atlantic, nearing the 40th parallel, as the

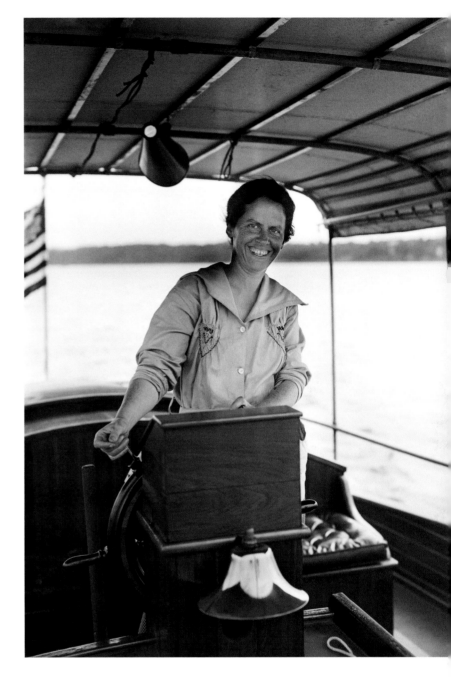

OPPOSITE:
SEAWOLF III, **1916**
Dressed in her fine yachting clothes, this woman (unknown) stands at the console of Sea Wolf III—*a 44-foot cruiser.* *(1984.187.738C)*

ABOVE: AT THE WHEEL OF *SUNRAY*, 1917
Mrs. F.T. Lander takes the wheel of the 36-foot launch Sunray, *designed by her husband in 1917. (1984.187.507G)*

149

"Roaring Forties" and the "Screaming Fifties" because of the ferocious conditions. To top it off, the weather can be so cold that sailors dodge huge icebergs. In Ellen MacArthur's case, some appeared to be hundreds of feet high. MacArthur describes sailing through the high waves in the Roaring Forties as "like pushing a toboggan at the top of a hill" (2003: 251). It was so cold during her passage through this area, even in the boat's cabin, that she feared she would be unable to defrost her freeze-dried food, much less her feet.

Ellen MacArthur is the first woman to have circumnavigated the globe alone. Since then, two others, Anne Liardet and Karen Leibovici have done so (in 2004-05) and more are bound to. Although not in the Vendée Globe race, Donna Lange is now attempting (in 2007) to be the first American woman to circumnavigate the globe alone (see www.donnalange.com).

Other women have set records and recorded "firsts" in other challenging ways. Dawn Riley is perhaps best known as the captain of the first all-women's America's Cup team on *America³* (*Mighty Mary*) in 1995. This was the first time, after 143 years of America's Cup racing, that an all-women's crew entered the America's Cup trials. Although beginning as an all-women's crew, they added Dave Dellenbaugh as helmsman and tactician to later increase their advantage. They were narrowly defeated in the Cup trials by Dennis Connor on *Stars and Stripes*. He later lost the America's Cup to New Zealand. But, when you think that women have been left out of this race for over a century and thus have far less experience, it is quite a feat to have even been a serious contender during the first entrance. Dawn Riley had previously crewed on an America's Cup boat when in 1992 she was the backup "pitman" on *America³*, skippered by Dennis Connor. She broke history again by being the first woman to manage an America's Cup syndicate when she entered the Cup with *America True* in 2000—also the first co-ed America's Cup team. Dawn Riley is also the general manager of a French team that will participate in the trials to challenge the Swiss boat, *Alinghi*, in the 2007 America's Cup races.

Riley is also, to date, the only American (and the only woman) to

WHIFF, **1968**
At the 5.5 U.S. Championship Races, this woman steers the 35-foot, 9-inch sloop, Whiff. *(1984.187.185267.14A)*

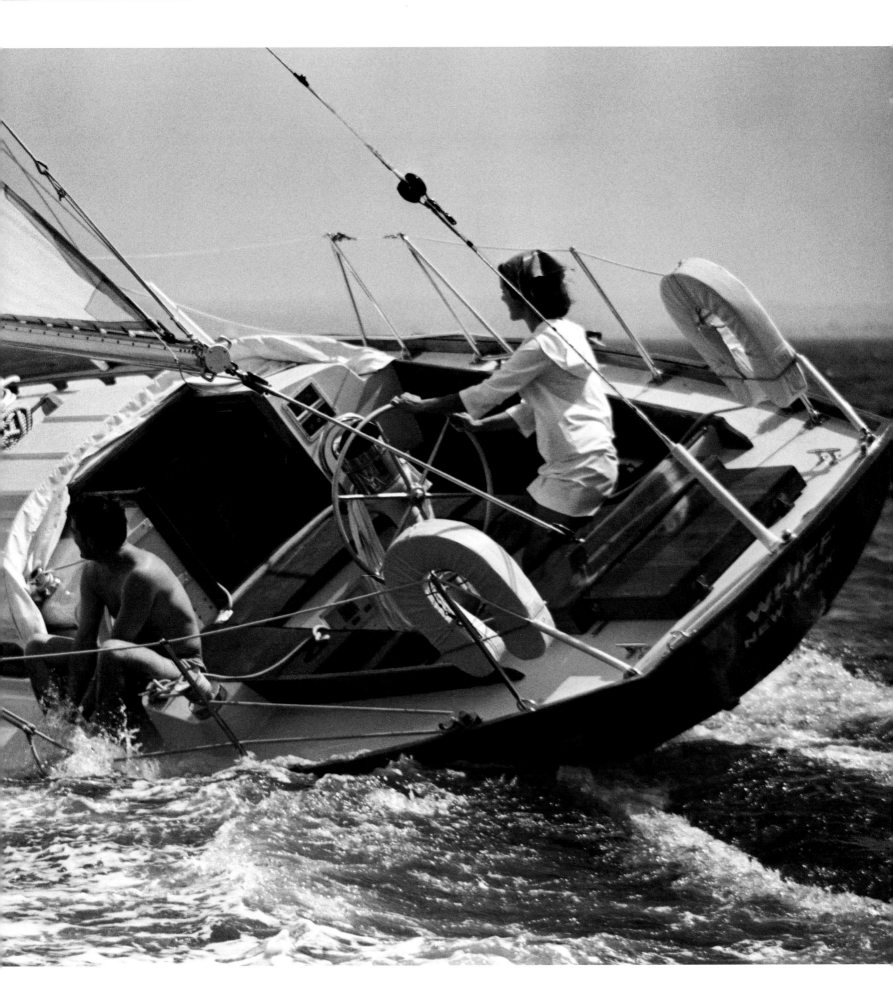

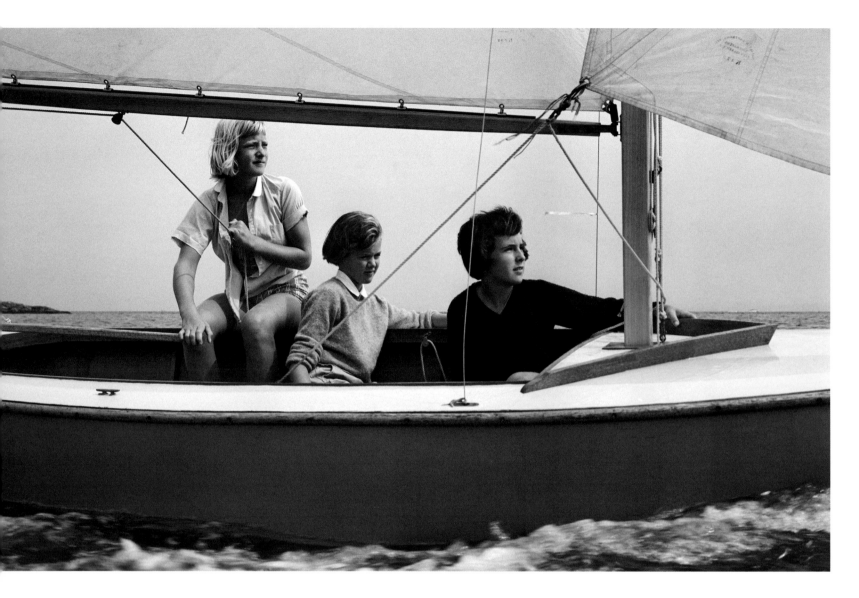

have sailed in three America's Cup races and two Whitbread races (now the Volvo Ocean Race). Riley first participated as crew on *Maiden*, captained by Tracy Edwards. In her second run in 1993-94, Dawn Riley took over command of the first all women's crew in the Whitbread, one of the most challenging sporting events in the world. First held in 1973, the Whitbread is a race that has been described as the Mount Everest of sailing. Sailors who participate in the Whitbread are onboard for eight months, taking very little with them to keep the boat light. Weight limits are so strict that sailors may even break off the ends of their toothbrushes, keeping only the bristles!

Stanley Rosenfeld did not photograph the women's crew of the America's Cup races in 1995. By then, he was getting older and, although he continued to work well into his eighties, by 1995 he said he no longer wanted to be hanging out of helicopters, bouncing hard over waves, or flying so much to get to the races. But he had

also concluded that the America's Cup yachts had become so commercialized—their hulls and sails emblazoned with corporate logos—that they had lost some of their beauty and grace. Although it would have been appropriate to conclude this book with a Rosenfeld photograph of the women's crew, alas, it does not exist.

In a world associated with intense machismo, women have shown that they are not just spectators or handmaidens in the sailing world. Women like Ellen MacArthur, Dawn Riley, and, earlier, Isabelle Autissier and Catherine Chabaud, have demonstrated that they have the guts, courage, and a passion to compete in a man's world. While women are continuing to take on new challenges and record new "firsts," the Rosenfeld Collection photographs document a long history of women's accomplishments at the wheel. Here we see women racing in speedboats, enjoying the thrill of being at the helm, heaving the lines, or simply enjoying a course made good.

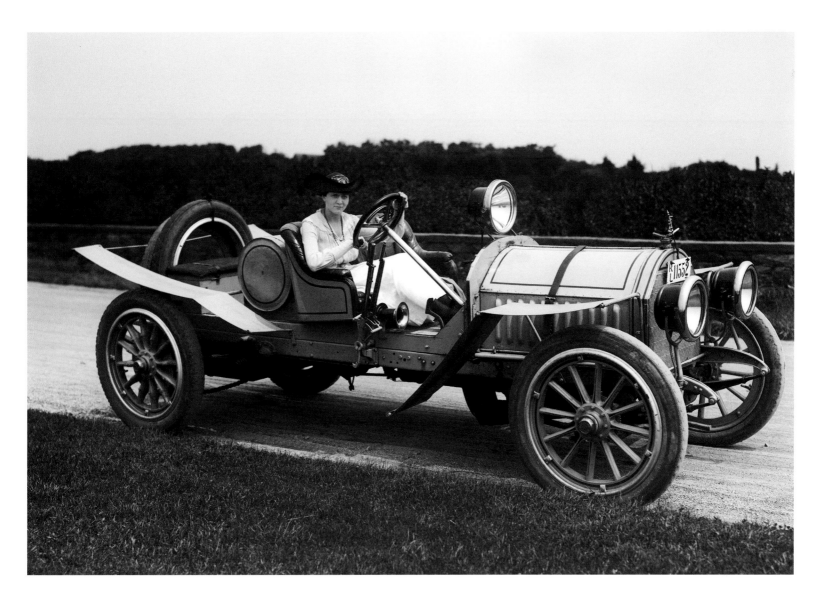

Stanley Rosenfeld has written, "Just as I have tried to understand the yachts, I have tried to understand the crews who sailed them. A photograph afloat is an image captured in an instant, and—to be successful—it must reflect more than one surface aspect of the complicated whole" (Rosenfeld, S. 2006). Understanding the women who take the wheel means learning about the many ways that women have literally or figuratively captained their own ships, set their own course, or stood at the helm. This book honors those achievements—and the achievements of all women who work in worlds where they challenge old ways, navigate tricky waters, set new marks, and chart new courses.

[1]See, for example: David Cordingly, *Women Sailors and Sailors' Women*; Margaret Creighton and Lisa Norling, *Iron Men, Wooden Women*; Linda DePauw, *Seafaring Women*. (Full citations can be found in the bibliography.)

OPPOSITE: JUNIORS SAILING, 1956
*During the juniors' races at the American Yacht Club in Rye, New York, these three girls race in a Blue Jay class sloop.
(1984.187.152479)*

WOMAN AT THE WHEEL, 1917
*Photographed in Newport, this seems to be a Hood Otho gasoline car.
(ANN 1984.187.6762)*

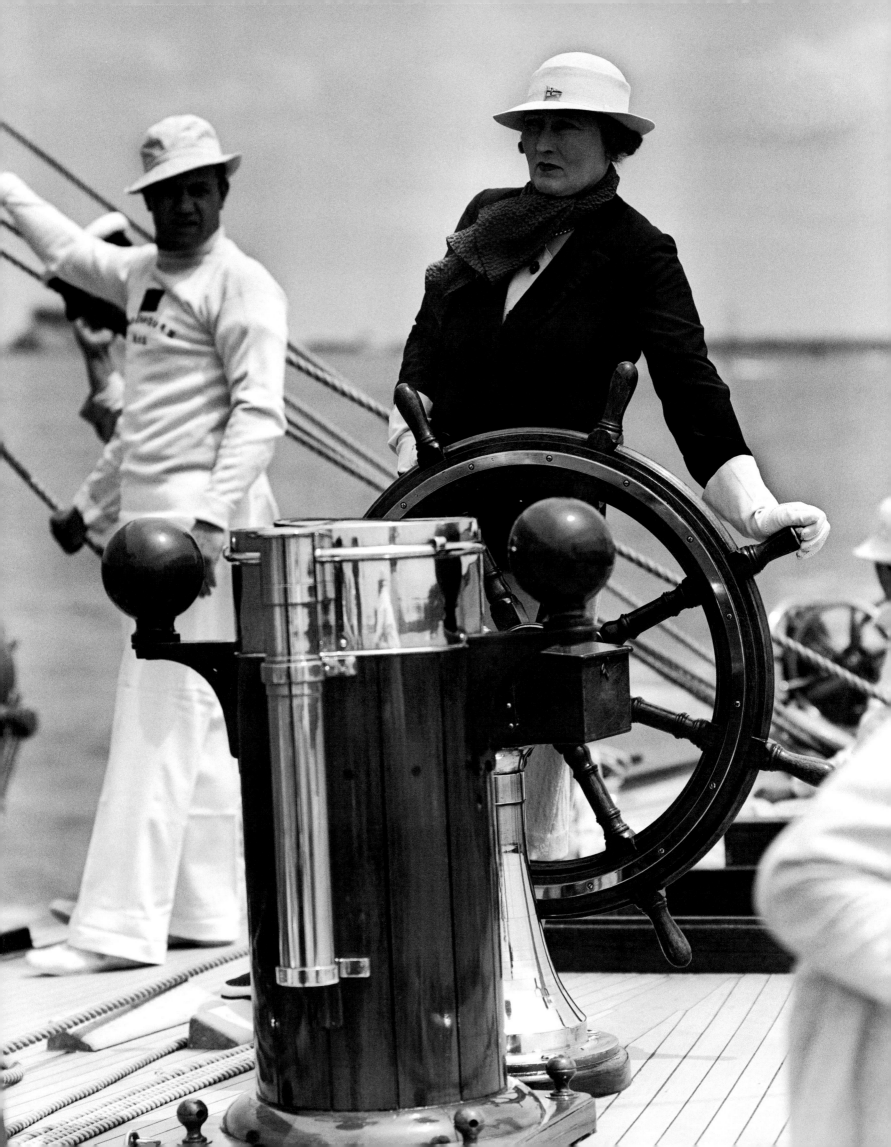

BLUE BEARD, 1935
Photographed from the starboard side of this small sloop, Blue Beard, *these young girls command their ship during Larchmont Race Week. (1984.187.72244F)*

OPPOSITE: MRS. SOPWITH, 1937
Undersail off Newport, Rhode Island, Mrs. Sopwith takes the helm of Endeavor II. *(1984.187.80885F)*

MISS PEGGY WOOD, 1923

*In the seat of a Belle Isle "Bear Cat" runabout,
Miss Peggy Wood (1892-1978) is seated at the
wheel. She was a well-known actress with a
stage career of more than fifty years.
(1984.187.10447F)*

OPPOSITE: BATHING GIRL, 1921

*Identifying the time period by the style
bathing suit, this woman is ready to c
the lines at the Detroit Yacht Club.
(1984.187.7130F)*

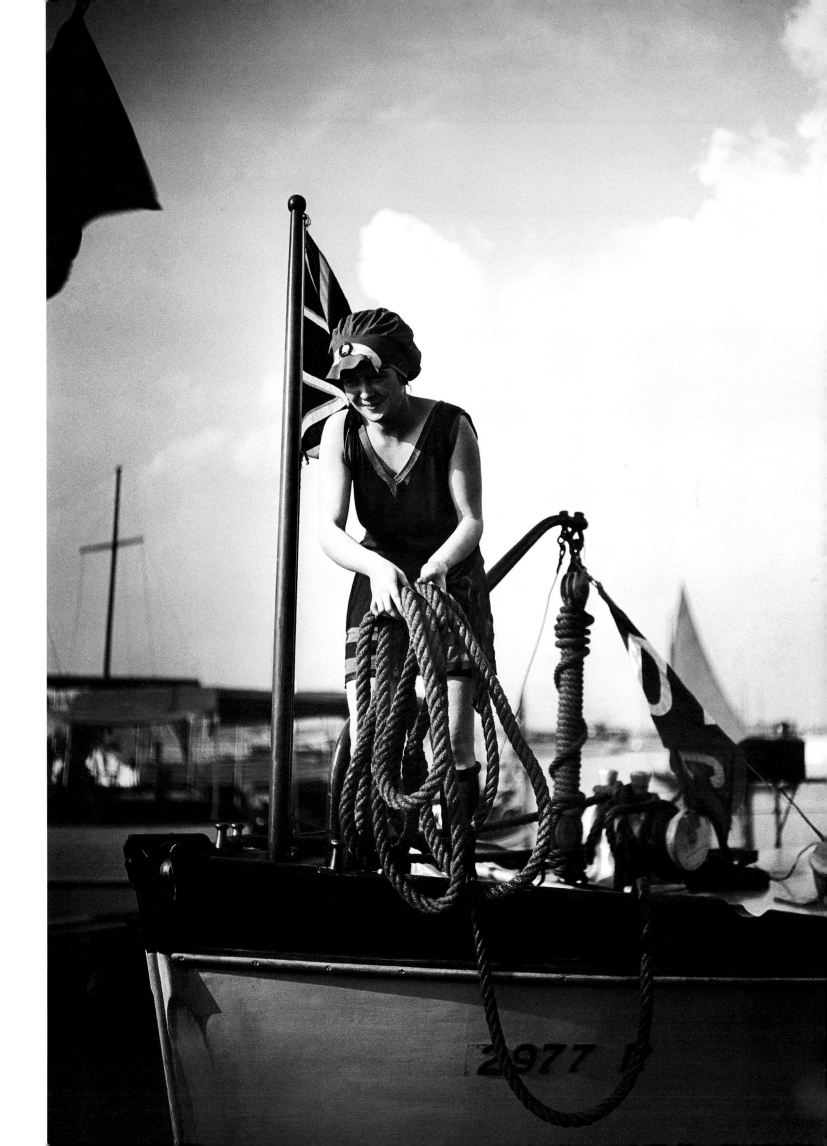

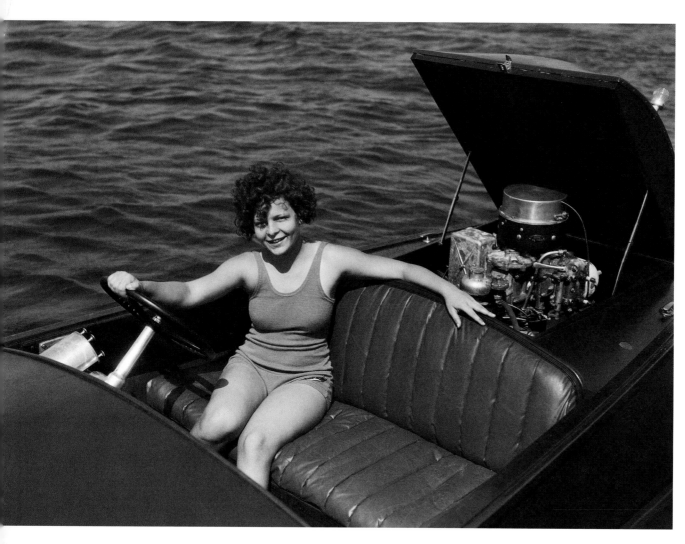

YOUNG GIRL AND JOHNSON MOTOR, 1930
Photographed for an advertisement, this young girl seems to be enjoying her place in the cockpit. (1984.187.38184F)

CENTURY RASCAL, 1933
Although a model, this young woman seems determined to get where she is going. (1984.187.65472F)

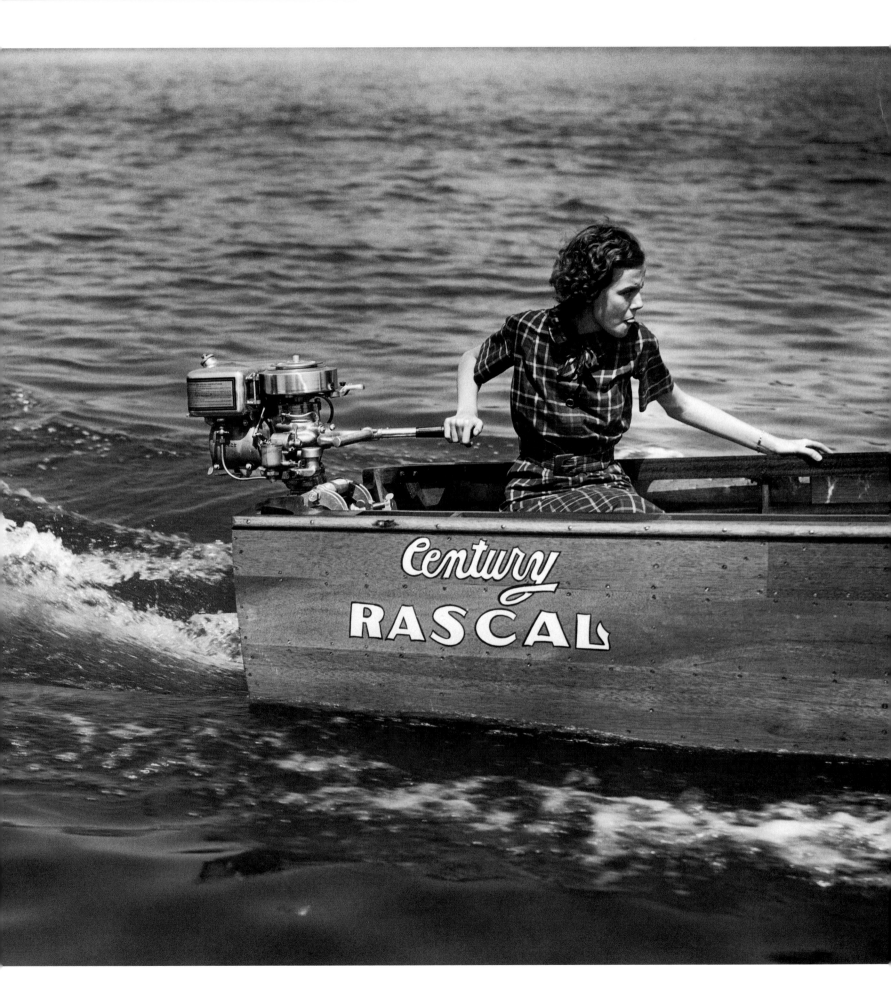

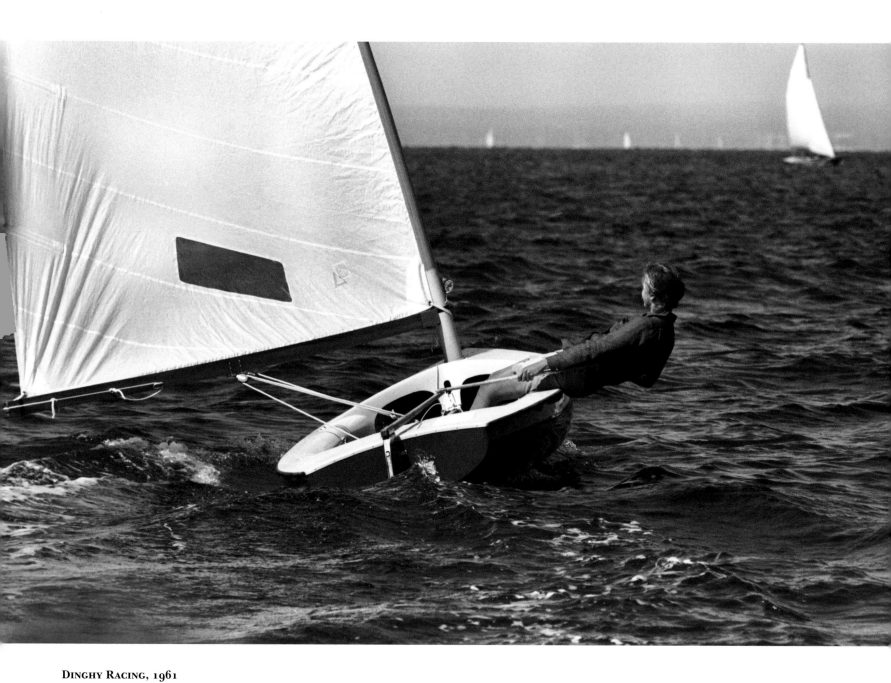

DINGHY RACING, 1961
*This unidentified woman hikes out. She is
believed to be "M. Dubois," as written on a
notation on the print.
(1984.187.170231.3)*

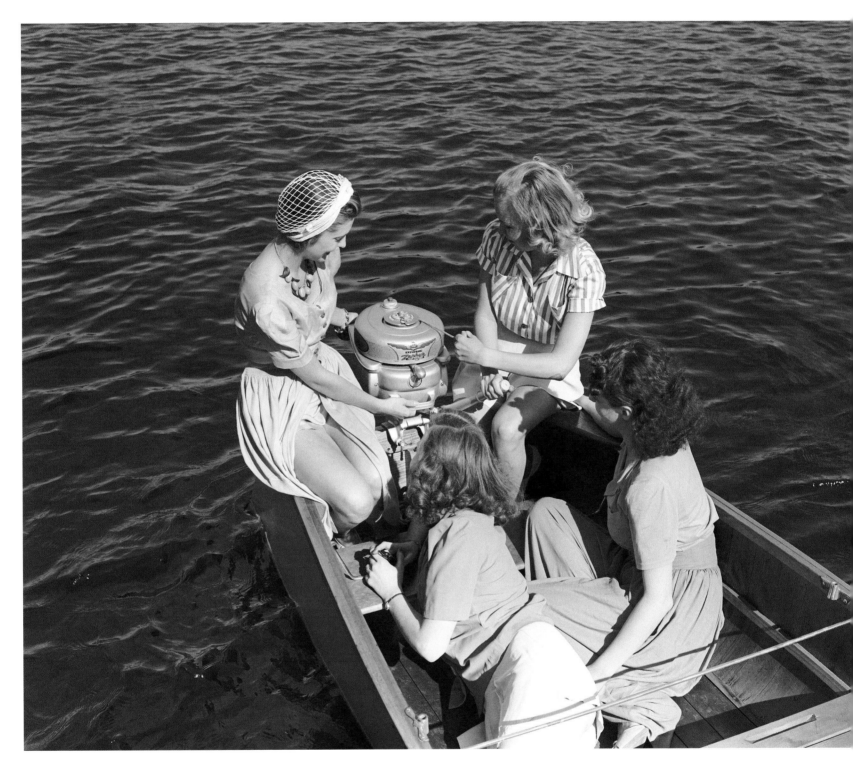

EVINRUDE ZEPHYR, 1940

Four models demonstrate an Evinrude
"Zephyr" outboard motor.
(1984.187.95436F)

RACE CREW, 1957

Photographed at the SYCE (Seawanhaka)
Cup Race in Oyster Bay, New York, this crew
from the American Yacht Club includes Mrs.
Allegra K. Mertz, Mrs. Rosamund W.
Corwin, and Miss Ellen Kelly.
(1984.187.155601F)

SYCE Cup Races, 1957
*Representing crew of the the Seawanhaka-
Corinthian Yacht Club are Miss Nancy
Sharp, Mrs. Torrance Watkins (skipper),
and Edith Buck. (1984.187.155604F)*

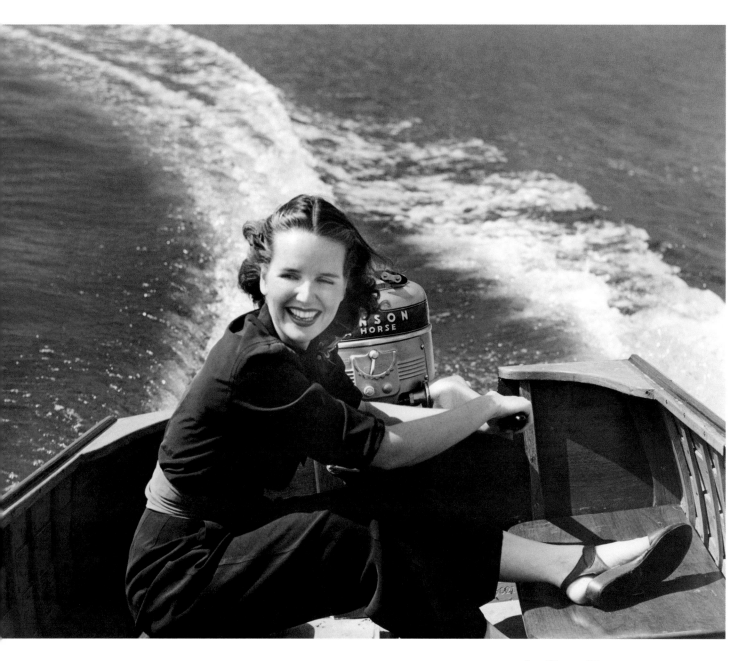

SEA HORSE MOTOR, 1930s

*Done as a job for Johnson Motor Company,
this closeup view of a model provides a
partial view of the Johnson Sea Horse Motor.
(RD.1984.187.27585)*

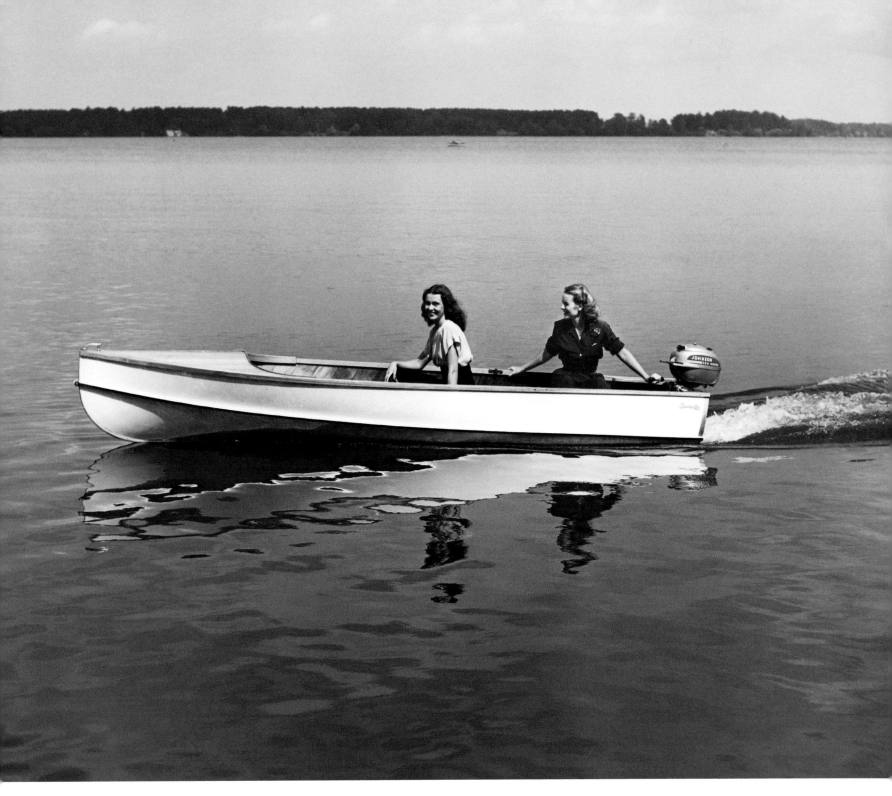

SEA HORSE, DUNPHY HULL, 1930s

*Two young models show off a Dunphy utility
boat with a Johnson Sea Horse motor. Built
as outboard pleasure crafts, Dunphy boats
were made of molded plywood with mahogany
or spruce veneer. (RD.1984.187.27583)*

OPPOSITE:

ONBOARD *RANGER*, 1937

Gertrude Vanderbilt at helm of
Ranger *during the New York Yacht*
Club cruise in July 1937. Rod
Stephens, renowned yachtsman and
yacht designer, is kneeling on the deck
and, in front of her, is Professor Zenos
Bliss (further identity unknown).
Ranger *won the America's Cup in*
1937, defeating Endeavor II.
(1984.187.83415F)

WORKING THE RIGGING, 1954

Eyeing something in the rigging, this woman
works at fixing the problem. The image was
photographed at the Frostbite Regatta at
Larchmont Yacht Club on January 10, 1954.
(1984.187.139287F)

FROSTBITING AT MAMARONECK, 1961
*On a cold and windy day in January at
Mamaroneck Yacht Club, New York, these
women brace themselves on the starboard side
of their dinghy, surely hoping not to turn over
in the freezing water. (1984.187.168056.21)*

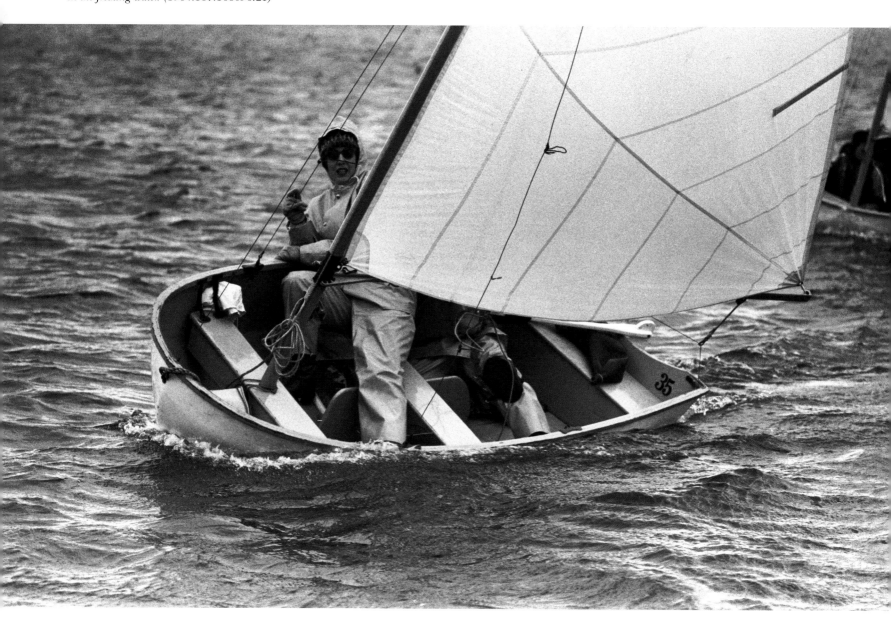

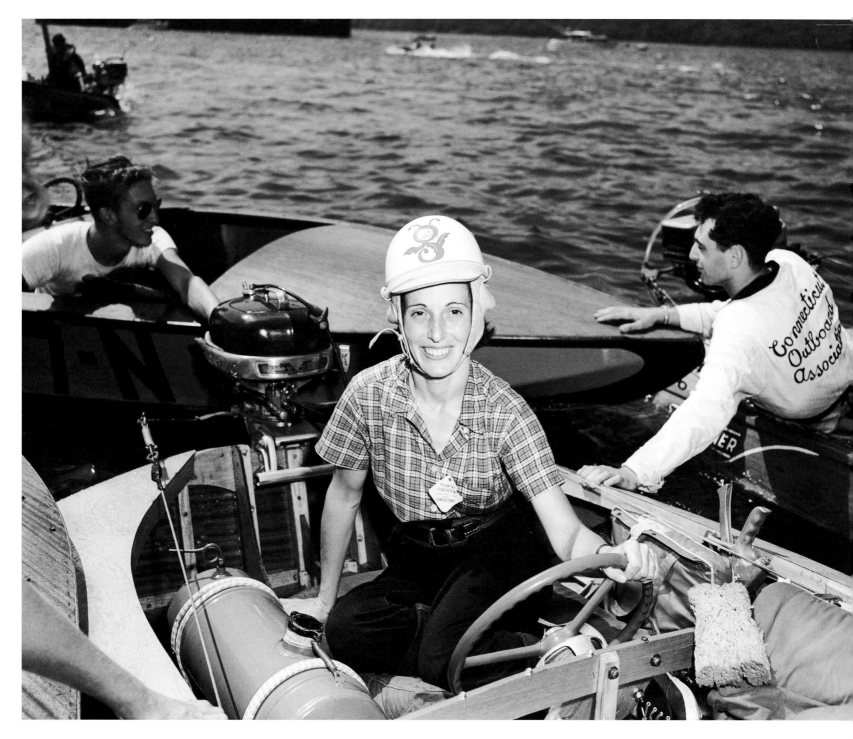

EVELYN SAROSSY, 1952
*Seated in her outboard hydroplane, Mrs.
Evelyn Sarossy was the first woman to finish
in this Albany to New York Race on Sunday,
August 17, 1952. (1984.187.133969F)*

AT THE WHEEL OF *ENDEAVOR*, 1934
Mrs. Phyllis Sopwith and Mr. Thomas Octave
Murdoch Sopwith are onboard Endeavor,
with Mrs. Sopwith at the wheel.
(1984.187.69546F)

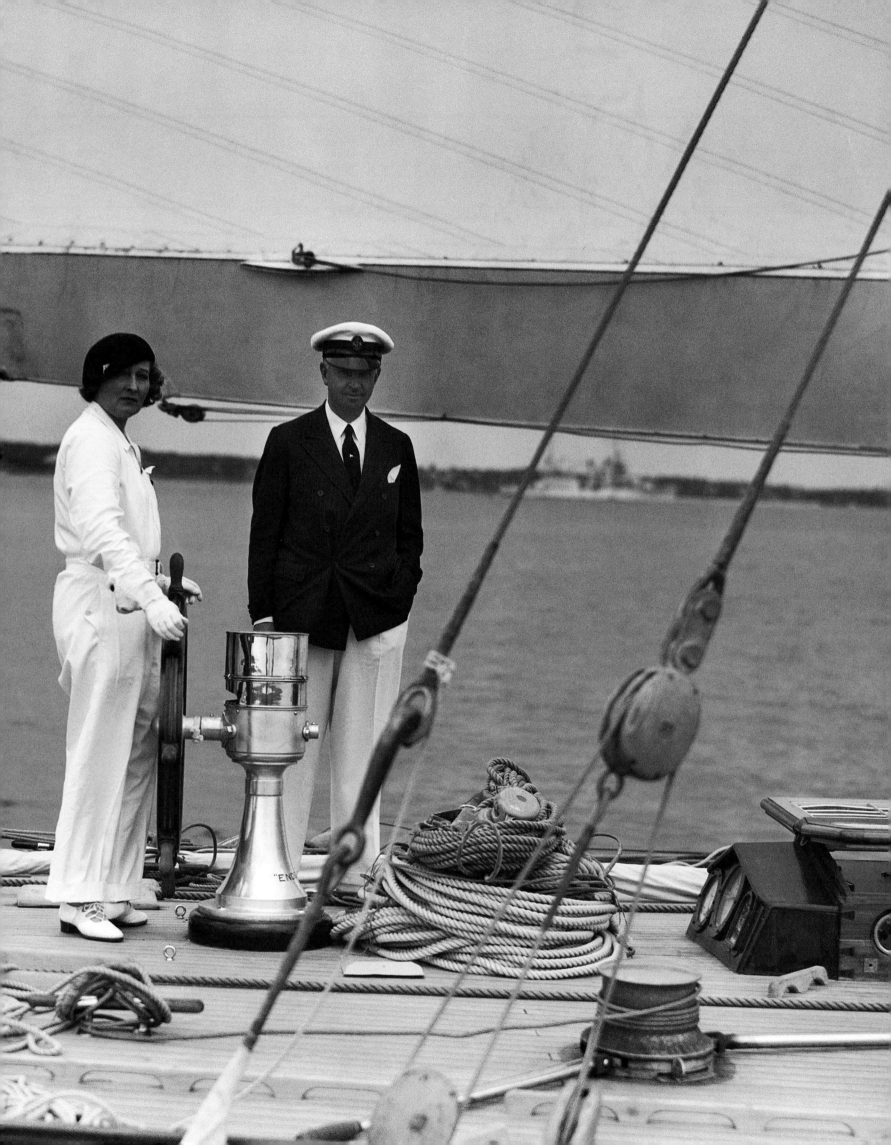

BIBLIOGRAPHY

Abie, Tania (with Bernadette Brennan). *Maiden Voyage*. New York: Ballantine, 1989.

Amott, Teresa, and Julie Matthaei. *Race, Gender, and Work: A Multi-Cultural Economic History of Women in the United States*. Boston: South End Press 1996.

BBC Sports. "Smashing Sailing's Glass Ceiling." June 28, 2001. Web site: www. bbc.co.uk

Bode, Richard. *First You Have to Row a Little Boat*. New York: Warner Books, 1993.

Brooks, Maria. "Women on the Waterfront," 2006. Web site: www.ilwu.org

Browne, M. K. "Fit To Win." *Collier's* 78, 1926 (October 16): 16.

Burton, Valerie. "Whoring, Drinking Sailors': Reflections on Masculinity from the Labour History of Nineteenth-Century British Shipping" 1999, 84-101 in *Working Out Gender: Perspectives from Labour History*," edited by Margaret Welch, Hants, England: Ashgate.

Cahn, Susan K. *Coming on strong: Gender and Sexuality in Twentieth-Century Women's Sport*. Cambridge, MA: Harvard University Press, 1994.

Cordingly, David. *Women Sailors and Sailors' Women: An Untold Maritime History*. York: Random House, 2001.

Creighton, Margaret S. and Lisa Norling. *Iron Men, Wooden Women: Gender and Seafaring in the Atlantic World, 1700-1920*. Baltimore, MD: Johns Hopkins University Press, 1996.

Davis, Annette Brock. *My Year Before the Mast*. Toronto: Hounslow Press, 1999.

Davison, Henry P. *The American Red Cross in the Great War*. New York: The Macmillan Company, 1919.

DePauw, Linda Grant. *Seafaring Women*. Boston: Houghton Mifflin Company, 1982.

Dulles, Foster Rhea. *The American Red Cross: A History*. New York: Harper & Brothers Publishers, 1950.

Edwards, Larry. "The Women's Team." Official Program, Citizen Cup, Supplement to *Yachting Magazine*, New York, 1995.

German, Andrew. "Introduction" in *The Art of the Boat: Photographs from the Rosenfeld Collection*. Mystic, CT: Mystic Seaport Museum, 2005.

Green, Venus. *Race on the Line: Gender, Labor, and Technology in the Bell System, 1880-1980*. Durham, NC: Duke University Press, 2001.

Greenlaw, Linda. *Lobster Chronicles: Life on a Very Small Island*. New York: Hyperion, 2003.

Guttman, Allen. *Women's Sports: A History*. New York: Columbia University Press, 1991.

Kessler-Harris, Alice. *Out to Work: A History of Wage-Earning Women in the United States*. New York: Oxford University Press, 1982.

Koerin, Beverly. "The Settlement House Tradition: Current Trends and Future Concerns." *Journal of Sociology and Social Welfare* 30 (June): 53-68, 2003.

MacArthur, Ellen. *Taking on the World: A Sailor's Extraordinary Solo Race Around the World*. New York: McGraw Hill, 2004.

Milbank, Caroline Rennolds. *New York Fashion: The Evolution of American Style*. New York: Harry N. Abrams, Inc., 1989.

Muncy, Robin. "Women in the Progressive Era," web site: National Park Service web site: http://www.cr.nps.gov/nr/travel/pwwmh/prog.htm

Norling, Lisa. *Captain Ahab Had a Wife: New England Women and the Whalefishery, 1720-1870*. Chapel Hill, NC: University of North Carolina Press, 2001.

Norwood, Stephen N. *Labor's Flaming Youth: Telephone Operators and Worker Militancy, 1878-1923*. Urbana, IL: University of Illinois Press, 1990.

Richards, Emma. *Emma Richards: Around Alone*. London: Pan Books, 2005.

Riley, Dawn. *Taking the Helm*. Boston: Little Brown, 1995.

Rogers, Frederick. "Olympics for Girls?" *School and Society* 30 (August 10): 193-194, 1919.

Rosenfeld, Morris. *Sail-Ho!* New York: T. J. Maloney Co., 1957.

Rosenfeld, Morris. *Under full sail*. New York: Grosset and Dunlap, 1959.

Rosenfeld, Stanley. *A Century Under Sail*. Reading, MA: Addison-Wesley Publishing Company, 1989.

Rosenfeld, Stanley. *A Point of View: Photographs of Competitive Sailing with Insights into the Photographer's Mind and Eye*. Mystic, CT: Mystic Seaport, 2005.

Rousmaniere, John. *Sleek: Classic Images from the Rosenfeld Collection*. Mystic, CT: Mystic Seaport, 2003.

Schatzki, Stefan C. "The Floating Hospital of St. John's Guild." *American Journal of Roentgenology* 167: 380, 1996.

Shaw, David. *Flying Cloud: The True Story of America's Most Famous Clipper Ship and the Woman Who Guided Her*. New York: Perennial, 2001.

Stone, Robert. "The Soloists: Why? Not Even They Can Tell Us." *Outside Magazine* (October) 1997. web site: http://outside.away.com

Von Drehle, David. *Triangle: The Fire That Changed America*. New York: Grove Press, 2003.

OPPOSITE:
FIRE DRILL AT TREMONT SWITCHBOARD *(1984.187.1635)*

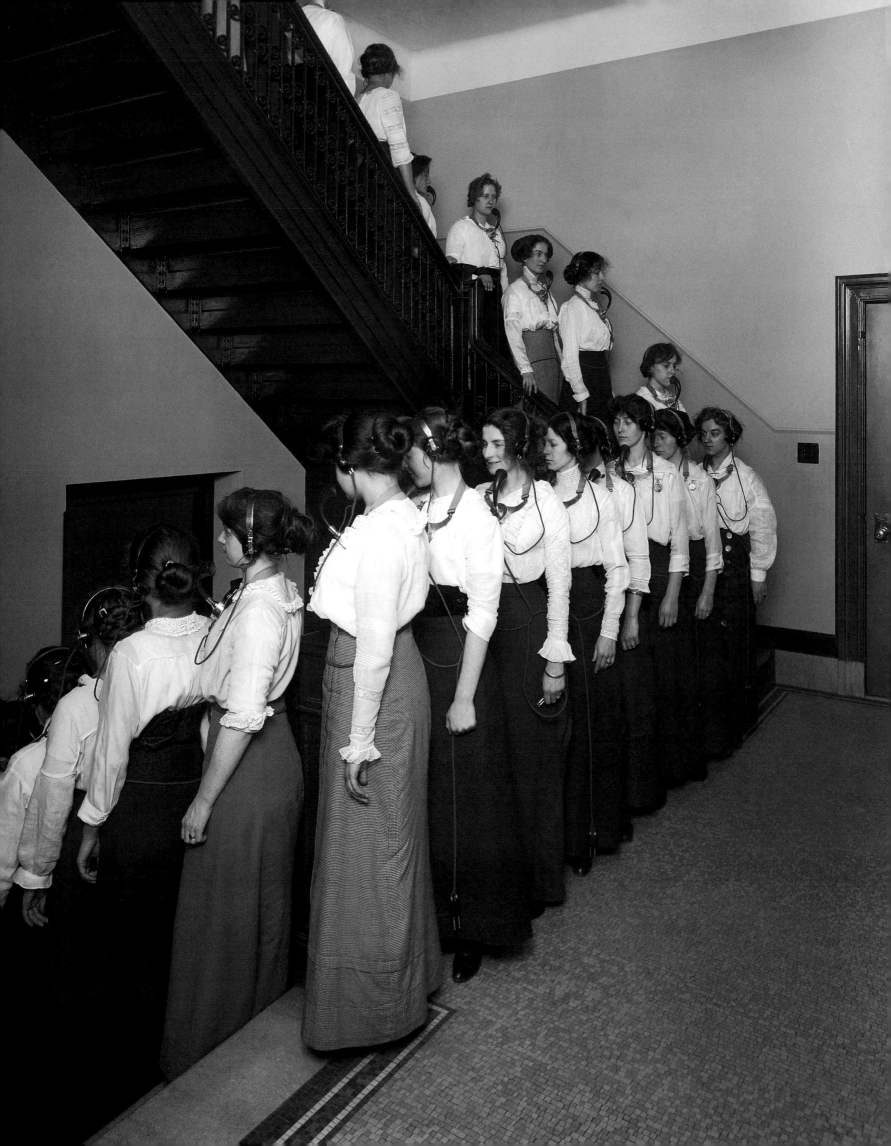

INDEX

OTHER BOOKS FROM THE ROSENFELD COLLECTION:

A CENTURY UNDER SAIL
Text by Stanley Rosenfeld

This exquisite collection of over 200 black-and-white photographs celebrates the marriage of great yachts and the sea from the unique perspective of Morris and Stanley Rosenfeld, renowned throughout the world for their award-winning nautical photographs.

(1988) 10" x 12", 287 pages, 200 illustrations, index.
ISBN 0-939510-71-5 (hardbound)
$50.00

A POINT OF VIEW
Stanley Rosenfeld

These striking color photographs, arranged around the competitions for the America's Cup, represent the mature vision of the great maritime photographer Stanley Rosenfeld. In its 168 pages, the book contains more than 180 images from the Rosenfeld Collection at Mystic Seaport, which are accompanied by Stanley's "insight into what I saw and what my mind made of the action in front of my camera."

This is more than a collection of beautiful and engaging photographs. "Each photograph is not just an instant out of the stream of time. It is the accumulation of a lifetime's experience afloat reflected in the action of the passing instant."

In this, his final book on the subject of marine photography, Stanley Rosenfeld has left a treasure trove of information and images for lovers of that art.

(2005) 10" x 12", 168 pages, 180 illustrations
ISBN 0-939511-08-8 (hardbound)
$50.00

SAILS AND SAILING
Franco Georgetti

A large-format book of photographs from Mystic Seaport's Rosenfeld Collection, *Sails and Sailing* was published in 1998 in a best-selling Italian-language edition. This English-language version, with chapters titled "Cruising," "Working," "Racing," and "America's Cup," includes full descriptive captions for the 85 images reproduced, as well as introductory text for each chapter. The images, many of them double-page size, are printed in duotone process by Mondadori, one of Italy's best printers. Many of them are reproduced here for the first time, and they include fishing schooners, scenics, people, and yacht interiors, as well as the dramatic photos of racing yachts that made the reputation of the Rosenfeld firm. In this book, some great nautical photography is given the production values it deserves.

A Rusconi Libri/Mystic Seaport Book
(1999) 13-1/4" x 9-3/4", 176 pages. 85 illustrations
ISBN 0-913372-88-9 (hardbound)
$50.00

SLEEK
Classic Sailboat Photography From The Rosenfeld Collection at Mystic Seaport
John Rousmaniere

The Rosenfeld Collection at Mystic Seaport contains a million images emphasizing classic yachting. But even more than photos of boats, the collection represents the epitome of the art of maritime photography, just as the subjects represent the ideals of the art of naval architecture. Here, taken between 1890 and 1954, yachting historian John Rousmaniere interprets 79 images that speak to the artistry of boats and the photography that captures them. Sleek and elegant describes both the vessels themselves and the striking photographic images, printed in duotone from original prints.

(2003) 9-1/4" x 11-3/4", 144 pages, 79 illustrations
ISBN 0-939510-90-1
$50.00

The Rosenfeld Collection, purchased in 1984 by Mystic Seaport, is one of the largest archives of maritime photographs in the United States. This Collection of nearly one million pieces documents the period from 1881 to the present. Images are captured in a variety of formats, from glass plate negatives to color transparencies, and from glossy prints to photographic murals. The Rosenfeld Collection represents the evolution of photographic technology and developments in the maritime industry over the last century. To browse or to purchase books or prints, visit us on the Web at www.rosenfeldcollection.org